PHOTOGRAPHY

HISTORY OF AN ART

PHOTOGRAPHY

HISTORY OF AN ART

by Jean-Luc Daval

SKIRA

RIZZOLI
NEW YORK

Library of Congress Cataloging in Publication Data

Daval, Jean-Luc.
 Photography, history of an art.

 Translation of: Histoire d'un art, la
photographie.
 Includes bibliographical references and index.
 1. Photography — History. 2. Photography,
Artistic — History. I. Title.
TR15.D23713 1982 770'.9 82-60033
ISBN 0-8478-0460-7

Published in the United States of America in 1982 by

RIZZOLI INTERNATIONAL PUBLICATIONS, INC.
 712 Fifth Avenue/New York 10019

Translated from the French by R. F. M. Dexter

Library of Congress Catalog Card Number: 82-60033

ISBN: 0-8478-0460-7

Printed in Switzerland

CONTENTS

I

REPRODUCING

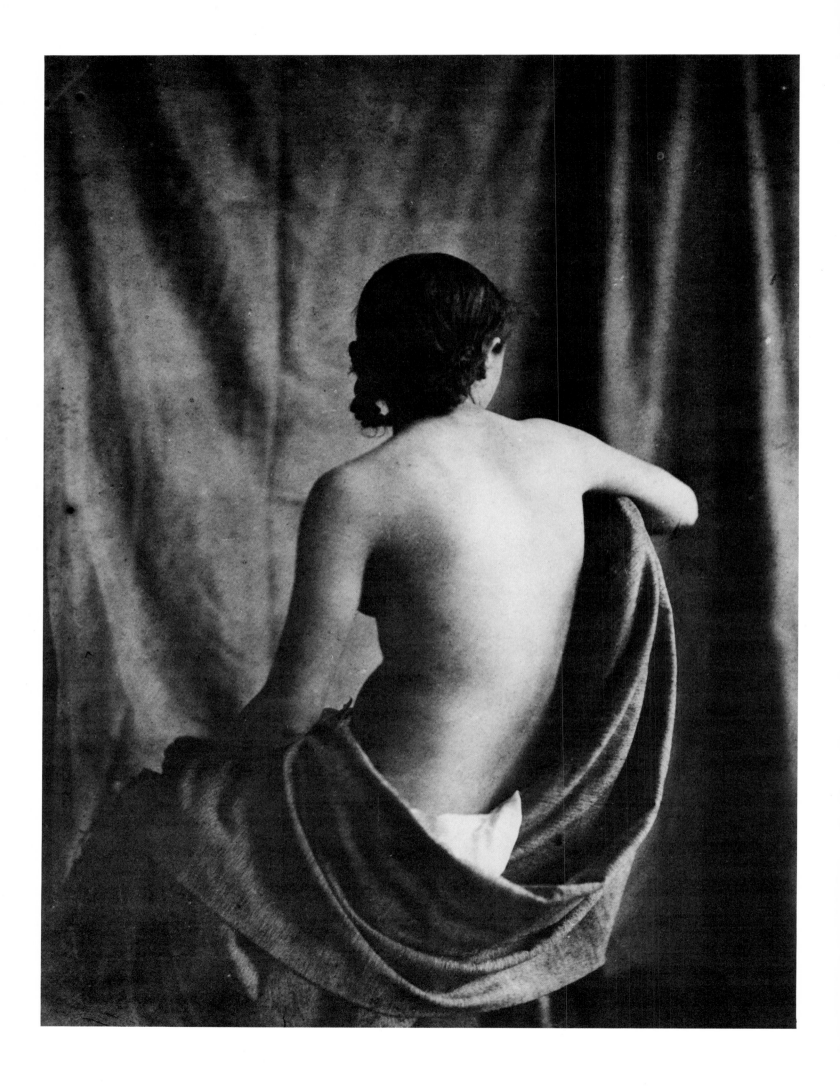

Eugène Durieu (1800-1874):
Nude, 1853-1854.
Salted paper print.

▷ Edouard Manet (1832-1883):
Study for *Olympia*, 1863.
Red chalk.

8

THE IDEA
OF
PHOTOGRAPHY

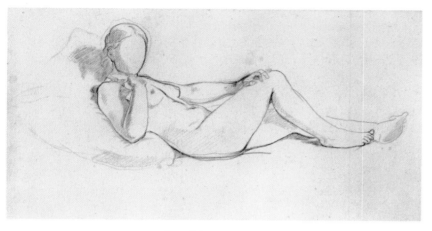

Of all the means of reproduction available today, photography seems the most obvious, the most impartial. And yet its appearance was not accidental and our present familiarity with it must not be allowed to blind us to the fact that it is a creative medium, an artistic technique. Looking back over the history of photography makes us realize that it was the outcome of long-standing dreams and desires, that it answered needs which it soon transcended, that for its inventors and creative users it crowned a long sequence of experiments. For it was not a chance invention, it was bound up and is still bound up with a period of history, our own; but its uses, its specific qualities, resources and limits, had to be found out over a long period of time. It would be simple-minded to take the camera for a mechanical device and nothing more.

Photography: the word comes from the Greek and means "writing with light." It first appeared in February 1839, when the German astronomer J. H. von Mädler used it to describe the experimental processes then designated as heliography, daguerreotype, or photogenic drawing. The term was taken up (or coined independently) in England by Sir John Herschel, and the French scientist François Arago used it in his report on the daguerreotype process, given in Paris before the Chamber of Deputies on 3 July 1839. The name was invented and it stuck. But when we try to define it, things get a little more complicated. Thus the French historian of photography, Georges Potonniée,[1] at once raises a question in his definition of it: "Photography is the art of making permanent the images perceived in the camera obscura, by means other than those of manual drawing. It was invented by the Frenchman Nicéphore Niepce in the year 1822." Potonniée here puts the emphasis on "doing" at the expense of "seeing." But one can hardly go without the other, and the specific feature of photography is to make them inseparable and simultaneous. Potonniée attempts to justify photography as an art when he describes it as "only a new way of drawing." He then sets a limit to that art when he suggests that "the photographic image should be the exact representation of space." The fact is that in studying the rise of photography it is impossible to separate technique from art—i.e. from *vision*.

The history of photography has for too long been bound up with the history of photographic techniques. The reason is that science and art had never before been so closely associated as they were in photography. The thought processes of Western man since the Renaissance had led him to separate art and technique, and while a photograph is not *a priori* a work of art, some photographs may become so—those which permit the figuring of relational systems which transcend common experience and refer to a signifying manner of seeing. The technique, being a mechanical photogenic process, becomes at once drawing and design. On the strength of these premises, the history of photography has its place, and a very prominent place, in the history of our ways of seeing, and therefore in the history of art. The discovery of a new means of expression is not the inevitable consequence of scientific progress. It comes into being in response to different needs which it not only satisfies but extends or displaces.

Since the early Renaissance, Western man has placed the emphasis on seeing to the detriment of other means of perception, to the point of taking it as the universal standard of measurement and making the eye the prime model of knowledge. The invention of scientific perspective in the fifteenth century was one of the great conquests of mankind. This scientific norm of pictorial representation, though based on a theoretical assumption which strains the possibilities of perception (i.e. on the use of a single, immobilized eye), gave man at last a means of reducing the world to the human scale; and being

a construction strictly based on geometry, on mathematical principles, it produces an optical illusion. In using this perspective construction artists have always known that they were doing more than merely enabling the viewer to see a three-dimensional object. To represent implies a series of choices, from the choosing of the subject to the choosing of the means of its pictorial realization, and it is these choices which give the work its expressive and signifying dimension. The public, however, has always complacently accepted the illusion of a picture mirroring the external world.

As a rule we see only what we are capable of seeing. Because seeing habits are shaped by *cultural* influences, the evolution of our vision is inseparable from the history of our culture: it is oriented by the problems, desires and possibilities of a particular moment of history. And until the invention of photography, the fine arts alone (in the traditional sense of the term) had been deemed capable of *picturing* an idea, the more so since for several centuries artists had been seeking not so much to demonstrate as to represent what they wished to see or what they imagined. From the time of its appearance, photography implied this question, a question which became increasingly obvious and urgent: does the camera record reality or does it reflect *ways of seeing* reality? Initially photography appeared only as a way of taking over reality, as an objective token of it sought for by the age of "realism" which contrived to invent it. But if photography amounted to no more than the act of taking pictures which reduce all realities to the same level and the same format, the quality of a photograph would be limited to the quality of the subject represented and to the technical competence of the operator. It is precisely this illusion which the great painters of the nineteenth century struggled against.

Photography might have been invented much earlier, but the need for it had not yet been felt. The camera obscura or image-projecting apparatus—of which the modern camera is the ultimate outcome—was known in principle at least in ancient times; its existence is recorded in the Middle Ages and Leonardo da Vinci used it as an instrument of demonstration and knowledge. But in his *Treatise on Painting* Leonardo warns artists against the temptation of mimesis: only bad painters set out to copy nature; the true painter must know how to invent, to reproduce by imagination. The first written account of the camera obscura appeared at the end of the sixteenth century, in Giovanni Battista Della Porta's *Magia Naturalis* (1589). Della Porta describes it as a device for optical observation and also as a drawing instrument. From then on it was taken up widely. Scientists used it to observe the sky and stars, painters to draw landscapes and still lifes, fair-booth showmen to produce optical illusions. The camera obscura ("dark chamber") consisted of a box or room with a small hole on one side through which light entered, casting an inverted image of the subject on the opposite side. By the seventeenth century a mirror was installed, reflecting the image the right way up on a ground-glass screen. Here was the initial idea of the photographic plate. But no one had yet found a way of fixing this "naturally" produced image.

The role of chemicals in the invention of photography must not be exaggerated. Niepce himself stated that they were the means and not the cause of its invention. In any case, by the beginning of the eighteenth century the scientific properties of silver salts and their sensitivity to light were already well known.

The French Revolution and the ideal which it expressed in the Declaration of the Rights of Man (1789) quickened that general eagerness for knowledge which characterized the nineteenth century. By recognizing the equality of all men and the right of each to fulfil himself in his own way, this new ideal broke with the past, at the very time when European society and economic life were being revolutionized by industrialization. The consequences of this upheaval were felt first of all in England and France, but soon spread all over the West.

The collapse of the Ancien Régime condemned many assumptions based on religious and moral principles. It brought a new sense of individual freedom and individual responsibility. The impact of the French Revolution on art and artists was immediate. The traditional clientele was swept away in the tidal wave of egalitarianism. Gone were the patrons who had given artists their livelihood, but who had also imposed on them certain ideas of form, subject matter and taste. Painters found themselves unexpectedly free, but they had to seek out another clientele and another function of the artist in a democratic context, in a different social framework. History painting and large picture cycles had had their day. Painters turned to other art forms, the portrait, the still life, the landscape, which appealed more to the taste of the new bourgeoisie. Portraiture enjoyed an unprecedented popularity, the Declaration of the Rights of Man having implicitly given every man the right to become a subject for painting. The demand was such that inventive minds set out to devise a means of making economical portraits—silhouettes, cut-outs or mechanical likenesses, such as the physionotrace invented by

Gilles-Louis Chrétien in the 1780s, a system which produced multiple impressions of a profile portrait and simplified the theoretical data behind the "perspective window" of Leonardo and Dürer.

The French Revolution gave a stimulus to the spread of education and general information to an ever wider public of observers and consumers, who were more anxious to understand and interpret events than to remain passive spectators. Other factors of change were military service (made compulsory in France to defend the principles of the Revolution and then to spread them throughout Europe) and the beginnings of industrialization: together they profoundly disturbed traditional ways of life. The horizons of most people in France had been limited to their village and trade. The Revolution shook up that pattern. It brought more movement and travel, and an expanding economy widened the scope of a man's trade or profession, made him more aware of the wider world of business and labour. The success of the *images d'Epinal* in early nineteenth-century France is to be accounted for by the fact that they pictured the events of the day—the Revolution and the campaigns of Napoleon all over Europe and even in Egypt. In the same way, the information media were led to study and report on the countries brought into relation with France through the movement of the armies or through economic and financial ties. The individual was forced to look beyond his country, to rise to that international dimension which, paradoxically, culture was assuming just as the cult of the nation and patriotism was gaining ground. Information became a necessity. Images and texts had to convey as graphically as possible what it was not yet possible for everyone to experience for himself.

The vision of the early photographers kept to the vision imposed by the painters; and it was the painters who continued to set the trend in all changes in the way of seeing, down to the generation of the Impressionists. For that reason attention must first be focused on developments in the history of painting. And here, again, the desire to inform, bear witness and educate gradually wrought a change in the subjects and spirit of what was then considered the highest form of painting: history painting. Even before he was elected as a deputy to the Convention, the French neo-classical painter J. L. David had felt the need to choose from the past such moralizing themes as might have a beneficial effect on his contemporaries: *The Oath of the Horatii* (1784) and *Lictors Bringing to Brutus the Body of his Dead Son* (1789), for example. And it was naturally from David that Napoleon ordered the huge painting commemorating his coronation as emperor. Since Napoleon owed his position neither to his ancestors nor to divine right, he wanted a picture whose pomp and ceremony would impress the imagination with his imperial might. But he also wished it to have a democratic and realistic character.

The *Coronation of Napoleon* (1807) is the first picture which may be described as reportage—a graphic representation of contemporary history. David's task was to record an actual scene. He was given a good seat in Notre-Dame from which to observe the ceremony (it took place on 2 December 1804); he had already assisted at the preparations and rehearsals; and he spent several months making portrait sketches of the major participants and sketching the main features of the setting. By 1807 he had completed this huge picture, which brings the scene before the spectator's eyes as if he were actually present.

Records of contemporary history, of topical events, were also embodied in several paintings of the Romantic period, like Géricault's *Raft of the Medusa* (1819) and Delacroix's *Scenes of the Massacres at Chios* (1824). Géricault's picture was based on a sensational shipwreck of 1816, with political repercussions. Owing to the incompetence of its captain, who had only been given his command because of his fidelity to King Louis XVIII, the French frigate *Medusa* had foundered off the coast of Senegal. A hundred and forty-nine castaways drifted for twelve days on a makeshift raft, with no provisions; only twelve survived. Géricault approached his subject like a news reporter, intent on absolute accuracy. He interviewed two of the survivors, noted down their story in detail and called in the ship's carpenter to build a replica of the raft in his studio. He paid visits to a Paris hospital to observe human suffering at first hand; he studied corpses and decomposing flesh at the morgue; he brought severed limbs back to his studio and carefully painted them. Hence the unexampled authenticity of his picture of dead and dying castaways on their raft. Delacroix's *Massacres at Chios* was also based on a firsthand account of an actual event, widely reported in the European press: the Turkish massacre of the Greek population of Chios in 1822.

The invention of photography perfectly illustrates this reflection by the French art-historian Pierre Francastel: "Only artists and scientists see around them new groupings of phenomena; and they alone express them in transmissible terms capable of development. There is no contradiction between the evolution of science and art and the evolution of modern techniques."[2] This was exactly the case with photography, which arose from the convergence of parallel experiments carried out in different disciplines. Highly significant, for example, is the comparison between a drawing by a scientist, Sir

John Herschel, made with an optical instrument, and a freehand drawing made by Viollet-le-Duc, a man with long experience as a painter and architect. Representing the same type of building, they produced two drawings very similar in their expression and content, though made with very different means.

The idea of photography was a direct consequence of the evolution of drawing—until now the only way of recording observations and visual knowledge—and of reproductive techniques. Utilized for research into an automatic and exact perspective, the camera obscura offered its user the possibility of making a rapid and precise drawing, one based on and demonstrating the rules invented by the Italian painters of the Renaissance. The nineteenth century, in its ever more intensive search for "objective" knowledge, took up the camera obscura and made ample use of it, though no one realized that what it gave was an image "slanted" by a certain manner of being and seeing.

Normal perspective is no truer than any other system; it is convincing because based on geometric rules and because it gives back an optical illusion. But it distorts the size of objects and plays tricks with the picture surface, inasmuch as the picture conveys the impression of being only a window protecting or distancing the spectator from reality. The practice of perspective having become generalized in the course of centuries, it was taken for granted in the West, and Westerners came to see as *reality* what in fact was only a coded *illusion*.

Architects were more alive to the gap between these two terms, since it was that very gap which obliged them to supply two different types of design: a perspective drawing enabling their clients to *see* the work, and ground plans enabling the builders *to do* the work. The latter projections are based on another system of interpretation of space; they appear to be more abstract and yet all the data they embody are real and measurable.

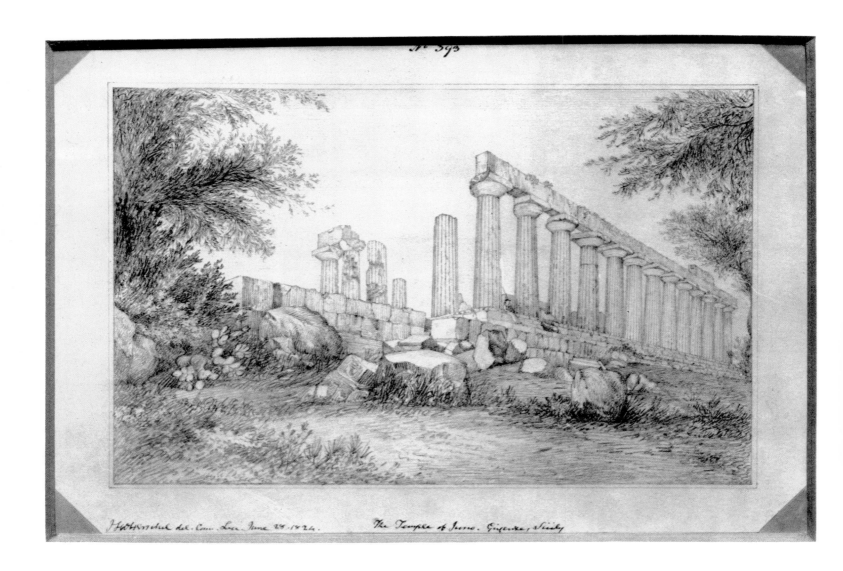

Sir John Herschel (1792-1871):
The Temple of Juno at Agrigento, Sicily, 1824.
Pencil drawing made with the help
of a camera lucida.

One cannot approach the problem of photography without first raising some such elementary question as this: where does the truth lie in the representation of a railway line for example—in a drawing of two rails converging on a vanishing point (which corresponds to what I see but not to reality) or in a drawing of two parallel lines (which corresponds to reality but not to what I see, except in particular circumstances)? Because the reality of the third dimension, of depth, is untranslatable on a plane surface, the choice of any solution will be all the more significant. As Erwin Panofsky rightly pointed out: "The construction which aims at exact perspective disregards the structure peculiar to psycho-physiological space." And he adds this fundamental observation: "Nor does that construction take any account of the enormous difference between the psychologically conditioned 'visual image,' which transmits the visible world to our mind, and the mechanically conditioned 'retinal image' which paints it on the eye, an anatomical organ."[3]

It was in 1810 that the English chemist and research scientist William Hyde Wollaston invented the camera lucida, an optical instrument for drawing in perspective. Its advantages were cheapness, smallness and portability, and its field was much larger than that of the camera obscura. Herschel used it to make his drawings of Agrigento. Its very success showed that the idea of photography (the direct recording of effects of light) was not yet mature. Yet an anticipation of it is to be found as early as 1761, in a story called *Giphantie* by the French writer Tiphaigne de la Roche.[4]

At the beginning of the nineteenth century Thomas Wedgwood, son of the founder of the Wedgwood potteries in Staffordshire, tried to fix images in the camera obscura by bathing the paper in silver nitrate or silver chlorate; but the resulting prints were not permanent. An account of these experiments, written by Wedgwood and his friend Humphry Davy, was published in the *Journal of the Royal Institution* in 1802. It was left to Niepce to solve the problem of making such prints permanent.

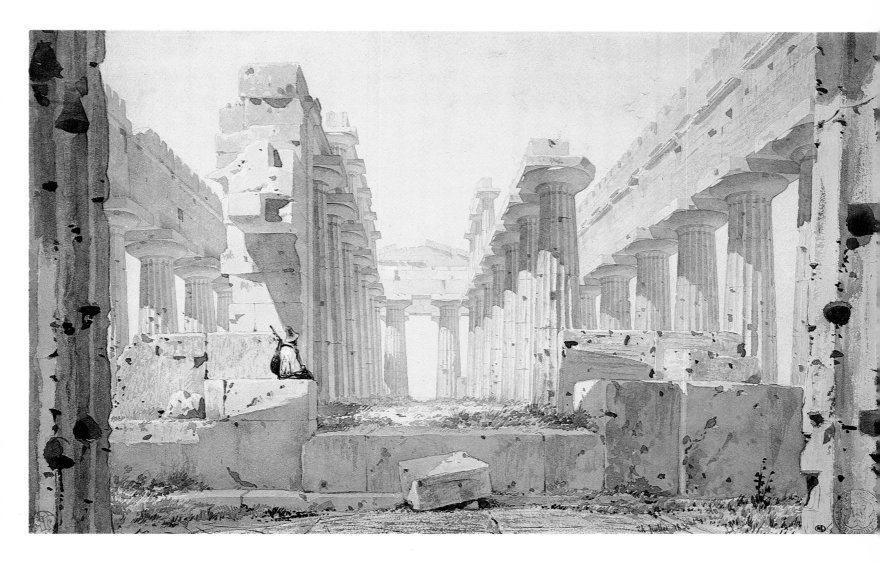

Eugène Viollet-le-Duc (1814-1879):
The Temple of Hera, so-called Temple
of Neptune, at Paestum, 1836.
Pencil and sepia.

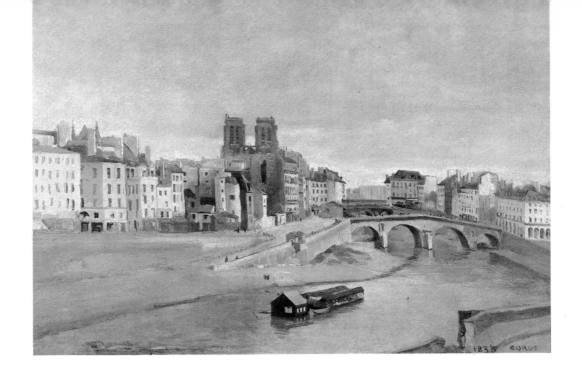

Fixing the image

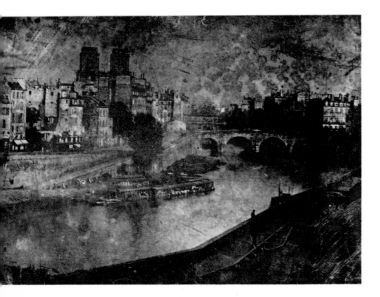

△ Camille Corot (1796-1875):
Notre-Dame and the Quai des Orfèvres, Paris, 1833.
Oil painting.

◁ Anonymous:
View of the Seine and the Ile de la Cité,
Paris, c. 1845. Daguerreotype.

▷ L. J. M. Daguerre (1787-1851):
The Seine and the Tuileries, Paris, 1839.
Daguerreotype.

Speaking of Corot, the critic Jules Castagnary, one of the warmest advocates of realism in nineteenth-century painting, wrote: "With him it is nature herself who sings and becomes her own nightingale." No better tribute could be paid to that *natural way of seeing* which Corot arrived at already in early days, during his first trip to Italy in 1825, and which he never departed from. Corot made some of the first experiments in open-air painting, and in his love of nature he rehabilitated landscape, an art form hitherto slighted in France but one capable of directly expressing the essence of the world.

Handicapped though he was by a heritage of set formulas, Corot overcame them, looking at nature with fresh eyes and recording what he saw with well-observed fidelity and original insight. Seeking above all an accurate rendering of values and light, he discovered the importance of time. He set out to represent only immediately recognizable things, but he saw them from different viewpoints and at different times. Open-air painting for him was a means of recording an impression. "Surrender to the initial impression," he said, "and if you have really been touched, the sincerity of your emotion will move others." Such being his purpose, he was led to choose his motifs, "not for their sentimental implications or their symbolic content, but only for what they are, as seen from a distance, caught in an instant, bearing the stamp of time."

It was Corot's gift to see as apparently no one before him had seen. He soon had a following, and Baudelaire wrote in his review of the 1859 Salon: "The present credo of society people is this: I believe in nature and I believe in nature alone. I believe that art is and can only be the exact reproduction of nature." This was the view taken by Niepce and the early photographers, whom the camera enabled to escape from the virtuosity and abstraction of line. Witness the remark of General Poncet, commenting on the early experiments of his cousin Nicéphore Niepce: "Contours are not indicated by lines, nor colours by hatchings. It is tantamount to colour painting, in which a monochrome and all the shadings are observed."[5] Niepce himself had but one avowed aim: "To copy nature in all its truthfulness."

Born in 1765 at Chalon-sur-Saône, in east-central France, Nicéphore Niepce was a research scientist of a characteristically nineteenth-century type. Curious, resourceful, eager, he pursued many lines of inquiry. Giving up a career in the army in 1794 because of ill health, he devoted himself, with his

brother Claude, to chemical and mechanical researches. They grew textile plants and woad; in 1807 they invented what they called a *pyréolophore*, an ancestor of the internal combustion engine; they ruined themselves in their attempts to devise a machine for propelling boats without sails or oars.

In 1813 Nicéphore Niepce became acquainted with lithography, a technique of surface printing from stone invented by Aloys Senefelder in Munich in 1796. By 1810 it had begun to enjoy an initial success. In 1812 Comte Lasteyrie du Saillant, who had studied lithography in Munich, set out to make it better known in France. Inquiring minds took it up, among them Niepce, who could not resist the temptation to experiment with this new method of reproduction. Images were then exercising a growing fascination, and many attempts were made to multiply copies of works by the old masters or pictures of topical events. Niepce, in his efforts to make automatic copies of prints, soon discovered that a direct imprint of nature could be obtained on paper. On 5 May 1816 he wrote to his brother that he had taken seven negative views of the courtyard of his country house at Saint-Loup-de-Varennes, a few miles south of Chalon; and he sent him some prints obtained with a camera obscura. Niepce commented on them as follows: "I must now do three things: (1) give more sharpness to the representation of the subject; (2) transpose the colours; and (3) fix them permanently, which will not be the easiest of the three."[6] He did arrive at a greater distinctness, but dissatisfied with negative, unstable images he took another line. Working alone he had to invent everything himself, both on the optical side and the chemical side. He devised several cameras, experimented with lenses, corrected their aberrations, invented the diaphragm.

By March 1817 Niepce was already able to reproduce prints on metal by coating the latter with a solution of bitumen of Judea which reacted to light. And so it was that after a long series of experiments he arrived in 1822 at positive images, by means of bitumen of Judea spread over a glass plate: this was the first true photograph. It was produced in a camera obscura and the image was on glass (the plate has been destroyed). Niepce also made use of metal plates for the image. But he still had much to do to perfect his process: the light-sensitivity of bitumen of Judea was low and required an exposure time of eight hours!

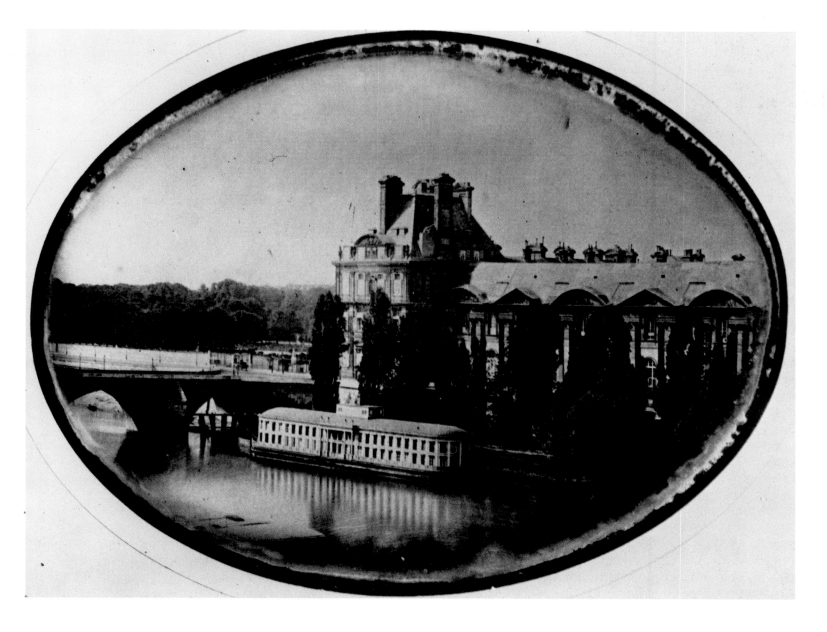

Niepce called his process Heliography, and his main idea was to use it as a means of reproducing originals; the prints he obtained on the basis of negatives corrected the inevitable reversing of a direct photograph. The further development of his invention owed much to L. J. M. Daguerre. Born in 1787 at Cormeilles (Seine-et-Oise), Daguerre went to Paris as a boy and became a scene painter for the opera. In 1822, near the Faubourg du Temple, he opened his Diorama, a sequence of pictorial views of different places seen under changing light effects, giving the illusion of a journey across the world. It was so successful that he opened another in Regent's Park, London. To heighten the effect and accuracy of his views Daguerre resorted to the camera obscura. He was soon trying to fix the images thus obtained, as a source of documentary pictures. Hearing of Niepce's researches, he wrote to him in January 1826, and on 14 December 1829 they signed a contract of partnership in which we read: "M. Daguerre offers to join M. Niepce to work out and perfect together the new means discovered by M. Niepce of fixing the views offered by nature without any recourse to drawing."[7]

Four years later, in 1833, Niepce died and Daguerre pursued alone his experiments with a latent image and means of fixing it. By 1835 he had achieved significant results, but the image was still unstable.

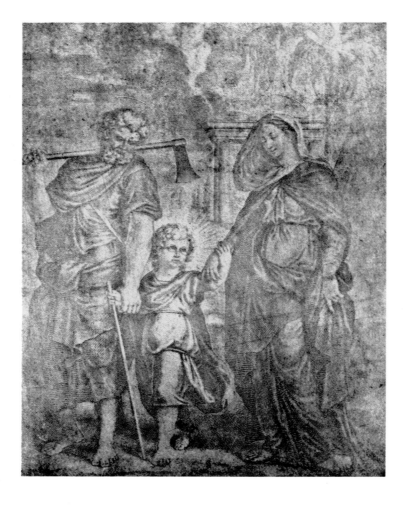

Announcement of the invention

Nicéphore Niepce (1765-1833):
The Holy Family, reproduction of a print, 1827.
Heliograph print on tin plate.

In 1838 he announced the invention that bears his name, but as there was little response he approached François Arago, the famous physicist, in the hope that the French government would purchase his invention. Arago saw its importance at once and on 7 January 1839, at a meeting of the Academy of Sciences in Paris, he gave an account of the daguerreotype. Coming from him, the announcement aroused great interest, both in France and all over Europe. From England, on 29 January, William Fox Talbot wrote to Arago, drawing attention to his own experiments of previous years, in particular the early photographic process which Talbot called photogenic drawing. In June, ruined by a fire which had just destroyed his Diorama and all the work on which he was then engaged, Daguerre pressed the French government to grant him a life pension in return for the disclosure of his process. The chambers passed a bill to this effect, Daguerre got his pension (of 6,000 francs, another of 4,000 being granted to the heir of Niepce), and on 19 August 1839 Arago explained the invention at a crowded meeting of the Academy of Sciences.

This constitutes the birth certificate of photography—which as yet was still the daguerreotype process. It yielded a direct print on a silvered plate, one difficult to read, always reversed as if seen in a mirror, requiring an exposure of ten to thirty minutes, and giving unstable values. Daguerre himself published a detailed account of the process in his book *Historique et Description des Procédés du Daguerréotype et du Diorama* (1839) and gave several public demonstrations of it.

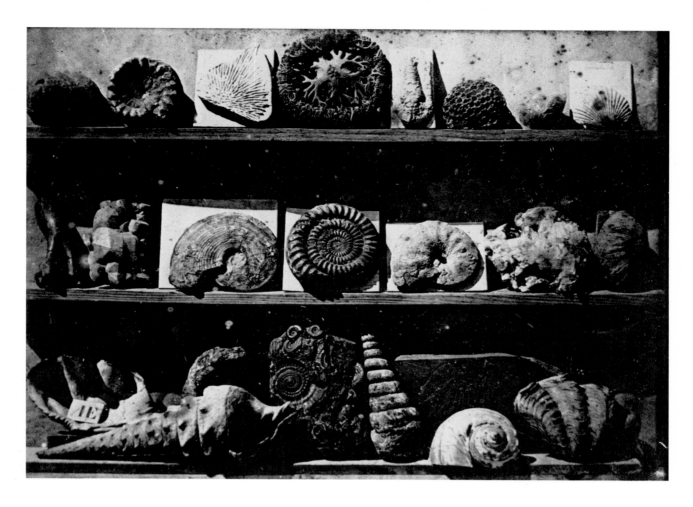

△ L. J. M. Daguerre (1787-1851):
Composition with Fossils and Shells, 1837-1839.
Daguerreotype.

◁ Georges Fortier (?-1882):
Still Life in the Studio, c. 1840.
Daguerreotype.

From then on, photography entered the public domain and could be freely taken up by anyone. It promised at once to become an indispensable instrument, as noted by Gay-Lussac in his report to the Chamber of Peers: "The chief advantage of M. Daguerre's process consists in obtaining the image of objects promptly and yet with great accuracy. The image may thus be preserved, or it may then be reproduced by the medium of engraving or lithography." It had the disadvantage of being a unique image, only one print being possible. The process spread fast, however, being already practised in New York by Samuel F. B. Morse and John William Draper in September-October 1839, and improvements were soon made. Baron Séguier contrived to reduce the size and weight of the apparatus by two thirds. H. L. Fizeau improved the sensitivity of the plate by toning it with a solution of gold, reducing exposure time fifteenfold in 1841. Daguerre's plates were large (6½ × 8½ inches); they were soon miniaturized and made more easily portable.

The first panoramic daguerreotype camera was invented by Friedrich von Martens in 1845. Such was the craze for it that in 1846 2,000 cameras and 500,000 plates were sold in Paris alone. A double lens admitting sixteen times more light was designed by Professor Josef Petzval and produced by the Viennese lens-maker Peter Voigtländer. This reduced exposure time, whose inordinate length had been a great drawback. Still life remained a favourite subject because of its immobility, but landscape had the advantage of being more brightly illuminated.

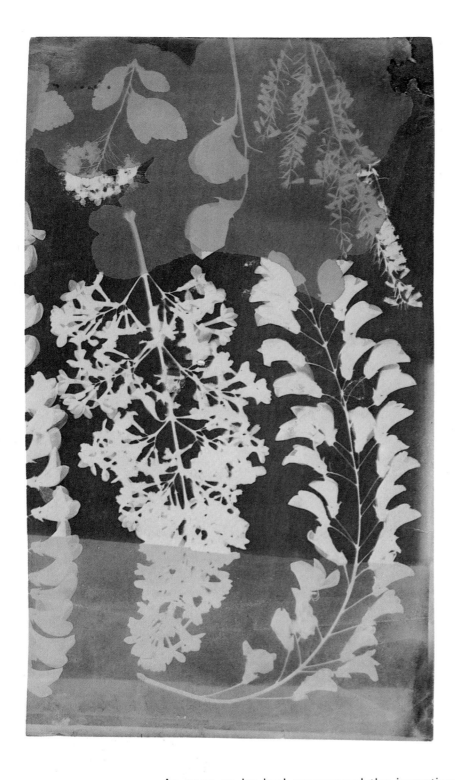

Bayard,
a solitary pioneer

Hippolyte Bayard (1801-1887):

△ Still Life with Flowers, 1845-1848.
Paper negative.

◁ Photogram of Flowers, 1839-1841.
Photogenic drawing.

▷ Self-Portrait with Statues.
Paper negative.

As soon as he had announced the invention of photography, Arago received many protests from would-be inventors of it, claiming priority for their processes. All these claims were unfounded, except those of Talbot and Bayard. It is striking and significant to find that in 1839 three men had actually invented photography; knowing nothing of each other, each using different means, they arrived at like results. It had taken centuries for the idea to ripen; then, simultaneously, three men brought it to fruition, because their time had made them aware of it as a necessity. This pressing need for objective reproduction found expression in the theories of Taine, the defender of the positivist aesthetic: "I wish to reproduce things as they are or as they would be even if I myself did not exist." [8]

The announcement and demonstration of Daguerre's invention excited so much interest, impressed the public imagination so strongly, that little attention was paid to the other French inventor, Hippolyte Bayard. The academician Turpin expressed the general feeling: "When we were first told about the pictures of M. Daguerre, we found it hard to believe and we should have brushed the news aside as a fable invented to amuse us, were it not that men of the highest position and ability had seen the thing with their own eyes and assured us that it was true." The metal plate on which Daguerre captured the imprint of light was not the usual ground for a drawing, but the general craze was such that metal was accepted at first as being more suitable than paper; and the advantage of other processes using a negative was not realized.

Born in 1801, Hippolyte Bayard was a man of wide interests and inquiring spirit. Employed as an official at the Ministry of Finance, he frequented the Paris art world in his spare time and it was in these artistic circles that he first heard about Daguerre's researches. He made some experiments of his own,

18

and by February 1839 he had produced some photographs, which he submitted to the Institut de France. These were positive prints on paper, obtained directly from the camera obscura and requiring an exposure of one hour. Bayard had learned of Talbot's methods, but he got better results and got them sooner, his secret lying in his way of sensitizing the paper. Experimenting with the effects of light, he began by producing collotypes (the direct imprint of objects on the proof paper), which Talbot also made.

It was also Bayard who held the first exhibition of photographs, showing thirty of his own prints in Paris on 24 June 1839. They were much admired, but Arago advised Bayard to keep his process to himself for the time being, so as not to compromise the negotiations then in course between the French government and Daguerre. And it was not until its sitting of 2 November 1839 that the Académie des Beaux-Arts of the Institut de France took due note of the superiority of Bayard's process and his prints on paper. But for him it was too late: for the public, photography meant the daguerreotype, and the latter completely overshadowed Bayard's invention. He published his formulas in 1840, but his method was too slow (twenty minutes' exposure) and ill-suited to the portrait, despite the good results he achieved in still life and landscape. He made the mistake of wishing to substitute positives for negatives, even though he obtained some excellent ones. Bayard was one of the founding members of the Société Héliographique in 1851 and of the Société Française de Photographie in 1854; to the latter, on his death in 1887, he bequeathed a valuable collection of 900 photographs. Too unassuming to push his claims, he never enjoyed the fame which his invention deserved, but his pictures are among the most interesting of early photography.

An inventor who got little credit at the time, whose results however were decisive for the further development of photography, was William Henry Fox Talbot. A well-to-do amateur with a country house at Lacock Abbey, Wiltshire, he began optical researches with the camera obscura in the early 1820s and became acquainted with Niepce's work during the latter's visit to London in 1827. Beginning in 1833 he tried to fix the image formed by light in the camera obscura. In 1835 he obtained his first paper print and multiplied his "photogenic drawings." This process he described in a paper to the Royal Society in January 1839. His next process he called calotype, and this he protected with a patent in 1841. It may be briefly described as a negative obtained after a very brief exposure in the camera obscura, the latent image being brought out with a developer. From this negative he was able to obtain positives on sensitized paper. To improve the fixing of the prints, Talbot used hyposulphite of soda as a fixing agent, at the suggestion of his friend Sir John Herschel; it was also Herschel who suggested the terms "negative" and "positive." The great advantage of Talbot's process was that prints could easily be multiplied from the negative.

While his photographic process was perfectly workable by 1840, Talbot did not get the response enjoyed by Daguerre because he jealously kept the process to himself, patenting it and seeking to commercialize it. But the calotype process was introduced into Scotland, and there it was taken up and developed in the 1840s by Robert Adamson and David Octavius Hill. A little later two Frenchmen,

Invention of the negative
and
methods of multiplication

William Henry Fox Talbot (1800-1877):
The Open Door, plate VI of
The Pencil of Nature, London, 1844.
Calotype.

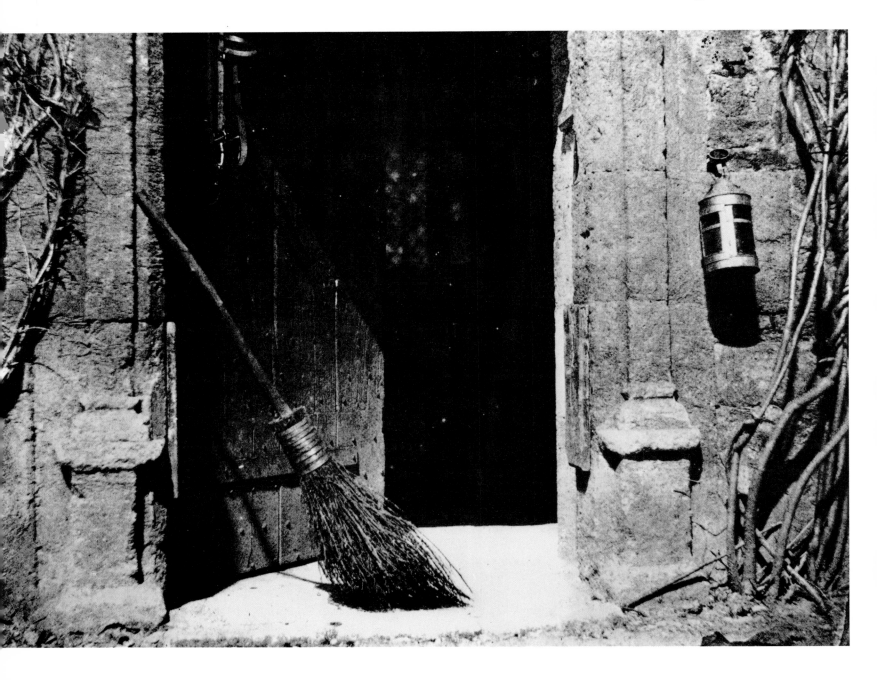

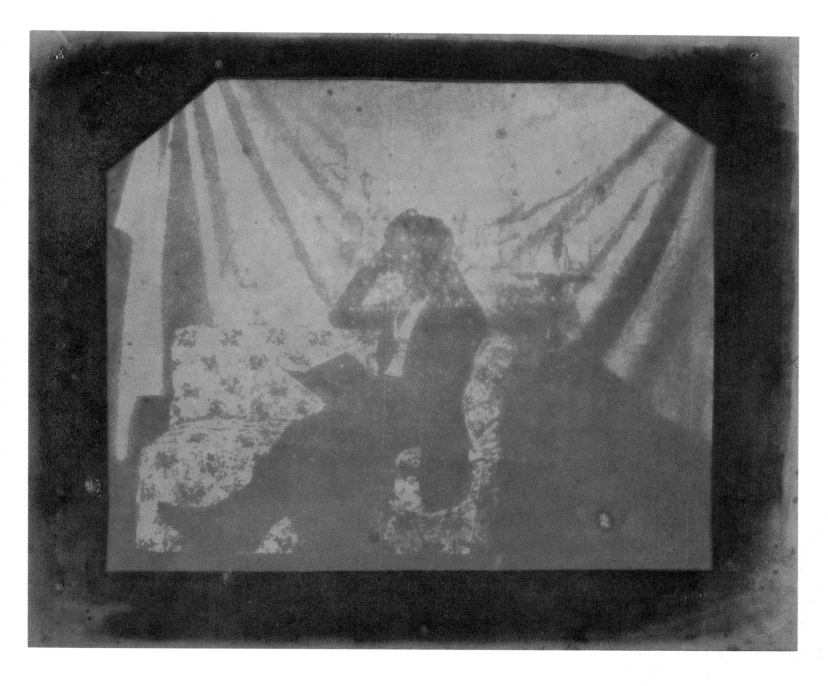

William Henry Fox Talbot (1800-1877):
Reading, 1841.
Calotype.

Blanquart-Evrard and Le Gray, took over the ideas of Talbot—and it was Talbot's ideas alone which fully correspond to what we mean by photography today. By October 1840 Talbot had reduced exposure time to eight seconds. To him too is due the first book entirely illustrated with photographs, *The Pencil of Nature* (1844), which tells the story of his discoveries and describes his process. In it Talbot refers repeatedly to drawing and art; he presents photography as a pencil moved by nature and requiring no special gifts to get good results. He wrote: "One advantage of the discovery of the Photographic Art will be, that it will enable us to introduce into our pictures a multitude of minute details which add to the truth and reality of the representation, but which no artist would take the trouble to copy faithfully from nature." The illustrations consisted of twenty-four mounted calotypes, mostly of architecture (Oxford, Lacock Abbey, Paris, Orléans), with a few still lifes and works of art. Talbot justified his choice of subjects with reference to the Dutch school of painting and wrote: "A painter's eye will often be arrested where ordinary people see nothing remarkable. A casual gleam of sunshine, or a shadow thrown across his path, a time-withered oak, or a moss-covered stone may awaken a train of thoughts and feelings, and picturesque imaginings." Taking a photograph like *The Open Door*, plate VI in *The Pencil of Nature*, we find that the connection with painting is indeed very close, the besom being carefully arranged in full sunlight against the darkened interior.

The invention of the wet plate process by Frederick Scott Archer of London, in 1851, marked the triumph of the positive-negative system over the daguerreotype, reducing exposure time to two seconds.

The demand for portraits very soon made photography popular, and this subject alone accounted for the bulk of its early production. Portraiture answered to an individual need powerfully felt from the late eighteenth century on, and indeed painters had already devised some technical shortcuts—the miniature, silhouette, cut-out, physionotrace—in order to satisfy the demands of a growing clientele who could not afford the price of an oil painting. This interest in portraiture reflects the social and political claims of an increasingly wealthy and powerful bourgeoisie which meant to stamp its likeness on the world, as the aristocrats had stamped theirs. Men had always had the desire to leave behind an enduring likeness of themselves, and so had commissioned works of art.

In 1839, when the invention of photography was announced, the exposure time for a portrait was fifteen or twenty minutes, in bright sunlight, with eyes wide open facing the sun. By 1840 portrait studios were being opened and technical progress was rapid. Improved lenses and smaller plates brought exposure time down to a few minutes. But to sit for a daguerreotype was an ordeal, a special head-rest even being invented to prevent the sitter from moving. By 1841 exposure was reduced to a few dozen seconds. Painters were getting alarmed by this upstart competition, since many of them depended on portraiture for a living; some even gave up painting for another profession, and it is no accident that among the early photographers many had been trained as painters.

Initially, photographers were apt to justify their new medium by imitating the themes and devices of painting. Because a lengthy exposure was still necessary, they took their pictures out of doors where lighting conditions were best. But because tradition called for the sitter to be portrayed indoors,

Portraiture imposes photography

◁ J. G. Eynard:
Figure Group Posed Outdoors, 1850.
Daguerreotype.

▷ Charles Nègre (1820-1880):
Family of Three Posed Outdoors
against a Sheet, c. 1855.
Collodion negative, salted paper print.

complicated settings and props were introduced. Attempts were made to develop the photographs on a surface considered nobler than paper—on canvas, for example. In the 1860s the French photographer Disdéri found a way of preparing the canvas for a camera image; it was little used, but over a century later it answered to an essential need of Pop artists and Hyperrealists. The portrait photographer was intent on recording an attitude, but the pose was all too often more artificial and stilted than in painting; even more important was the choice of setting and frame. Colour still being beyond his reach, the photographer often heightened the print with crayon or watercolour. While the photographer's way of seeing was still that of the painter, his medium had its specific advantage, on which Edgar Allan Poe commented as early as 1840: "In truth the daguerreotype plate is infinitely more accurate in its representation than any painting by human hands." But as Walter Benjamin has pointed out,[9] many people at the time were disturbed by this new medium of portraiture, and voices were even raised in protest, as in an article in the *Leipziger Stadtanzeiger* of 1840.[10]

Portraiture was the first genre to get the benefit of the improvements made by the negative plate developed by Talbot; by the invention of the albumen-coated plate in 1848 by Niepce de Saint-Victor, industrialized by Blanquart-Evrard; and by the wet collodion process of Frederick Scott Archer in 1851. Paper prints in larger sizes and the ease with which they could be multiplied caught the public imagination. The wet collodion process, superseding both the calotype and the daguerreotype, made possible a new and subtler rendering of facial expression and mood, a finer modelling of the face thanks to lighting capable of suggesting the deeper intimations of the sitter's character. Because he made the most of these possibilities, Nadar became one of the great photographers of the nineteenth century, with an international reputation.

Anonymous:
Couple, c. 1845.
Tinted daguerreotype.

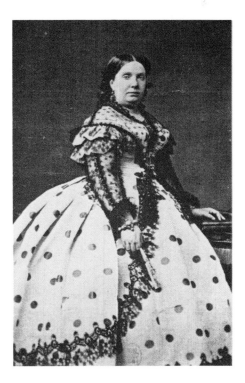

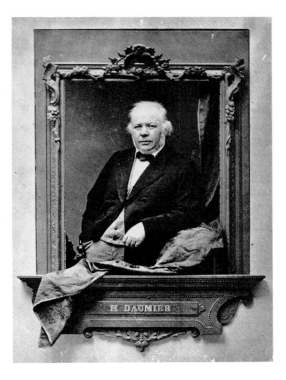

Adolphe-Eugène Disdéri (1819-1890):
Portrait of a Lady, 1861.
Silk print.

Adolphe Dallemagne:
Honoré Daumier, c. 1865.
Collodion negative.

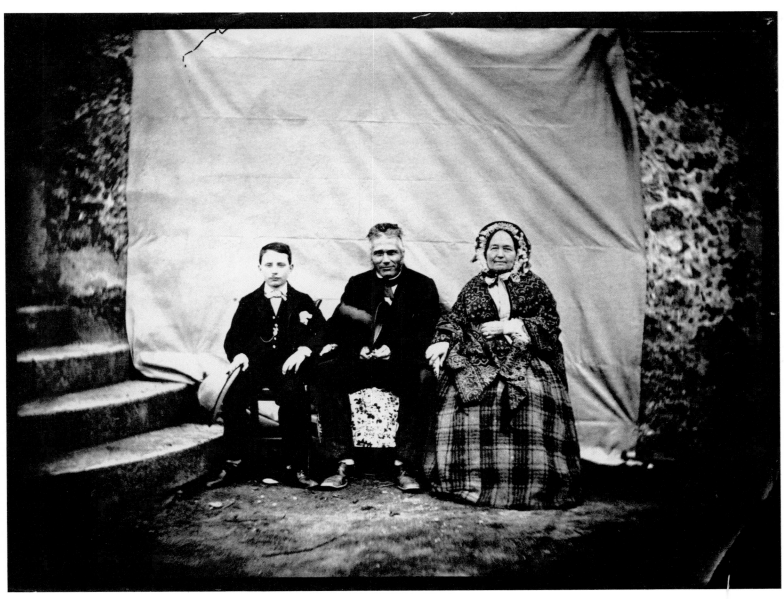

The eye of Nadar

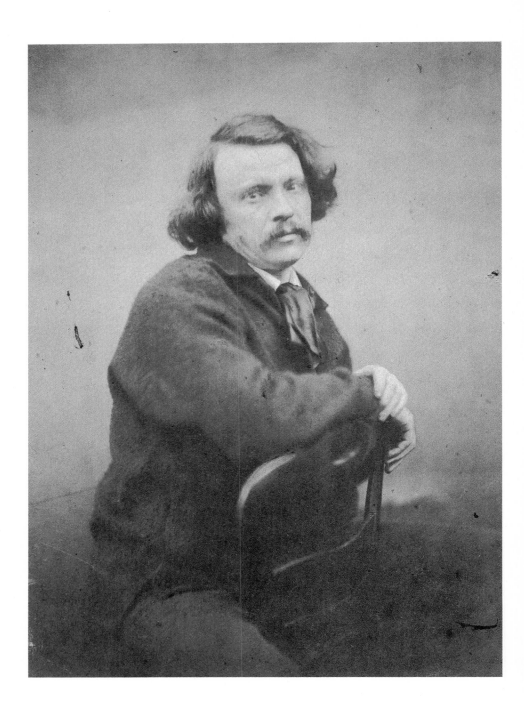

Nadar (1820-1910):
Self-Portrait, c. 1854-1855.
Collodion negative, salted paper print.

Born in Paris in 1820 (his real name being Félix Tournachon), Nadar was something of an adventurer and bohemian, but a man of remarkable talents and a true artist. He wrote articles and stories, founded the *Revue Comique* (1849), drew cartoons, and became a pioneering balloonist. Earning his living as a caricaturist, he had already made a solid reputation with his political cartoons when Napoleon III came to power (1852) and imposed censorship. Political satire being forbidden or too risky, Nadar, in 1853, conceived the idea of publishing a series of portraits and biographies of the most famous men of his day, under the title *Le Panthéon Nadar*. For the documentation of this projected gallery of caricatures, he turned to photography. At the end of his life, in a book of recollections (*Quand j'étais photographe*, 1900), he explained how he came to do so: "It remained to carry out the work, to transform into comic figures these hundreds of different faces, while retaining in each the unmistakable physical likeness of the features, the personal aspect—and character, by which I mean the moral and intellectual likeness. Photography... at least added to my feeble powers the resource of not overstraining the good will of my sitters." With his quick wits and inquiring mind, Nadar soon mastered the techniques involved. He opened a portrait studio at 113, Rue Saint-Lazare in 1853 and the celebrities of Paris flocked to it to have their picture taken: he became the greatest portraitist of the day. But he did not stop there. In 1857 he made use of artificial light to take a series of pictures in the Paris catacombs and that same year he began taking aerial photographs of the city from his balloon. Nadar achieved note, not only because he was a master photographer, but because he photographed all the great men and women of contemporary France, most of whom were friends of his. Baudelaire, Sarah Bernhardt, Edmond de Goncourt, Théophile Gautier, Daumier, Corot, Guizot—these are only a few of his subjects. Most photographers, wrote Baudelaire, have a ridiculous mania: "They think a good picture is a picture in which all the warts, wrinkles, blemishes and trivialities of the face are made plain and even emphasized; the harsher the image, the more pleased they are."[11] Not so Nadar. He invented the "fuzzy" image, slightly out of focus, comparable to the *sfumato* of the painter, which

can convey the sitter's mood or character. That he knew what he was doing is clear from this note of 1856: "As for the portrait, it is time to have done with the reproach that the photographer cannot convey so well as the painter the intimate and artistic feeling of his sitter. The photograph takes the law into its own hands. Psychological insight is not reserved for painters alone and they know it." Nadar was the first to show that photography is not simply a matter of recording a mirror effect; behind the camera is an eye, a sensibility, an intelligence which choose and decide. This is what Nadar meant when he said to Villemessant, editor of the *Figaro*: "You are right, there is no such thing as *art photography*. In photography, as in everything else, there are people who know how to see and others who don't even know how to look."[12]

Because Nadar, for the most part, photographed men and women who were friends of his, he multiplied his pictures of them, catching them at odd moments and in different attitudes. And this multiplication of pictures of the same sitter is another specific feature of photography.

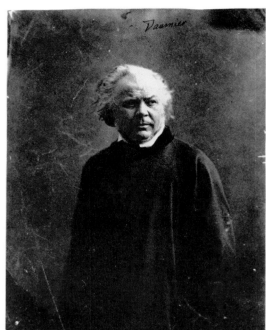

Nadar (1820-1910):
Portraits of Honoré Daumier, 1855-1856.
Collodion negatives.

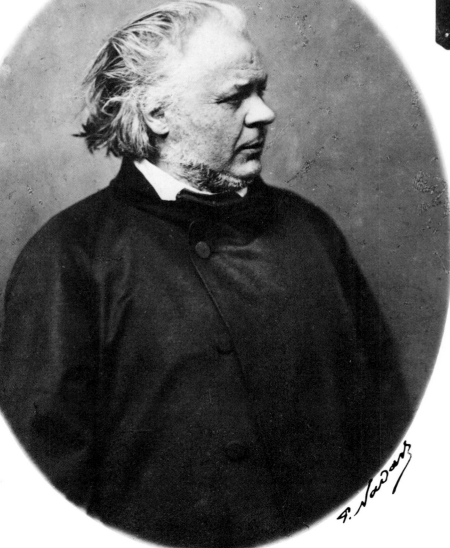

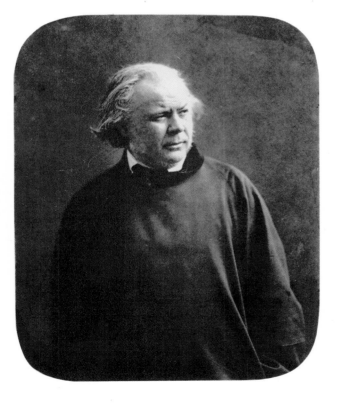

Like Nadar, Etienne Carjat, born in 1828, was a writer and caricaturist as well as a photographer. Trained as a painter and draughtsman, he had many friends in the art circles of Paris and he immortalized them in photography, a medium to which he came late, in 1860; but his portraits of Rossini, Baudelaire, Dumas and others are on a par with Nadar's. Using an abstract background, making play with light and also with the pose and distance, he gives his sitters that aura which Walter Benjamin has described as "a singular interweaving of space and time, a unique apparition in distance, however close it may be."[13] Benjamin dwells on the effect that Roland Barthes admired: "What photography reproduces *ad infinitum* is something that has happened only once: it repeats mechanically what can never again be repeated essentially. In photography, the event is never turned into something else... it is the absolute Particular and the sovereign Contingency."[14]

The pictures of Nadar and Carjat represent portrait photography at its best. Because their sitters were the foremost writers, artists, musicians, actors of France, at a particularly creative period, their portraits have recorded them for us with a finality which has had the effect of limiting the interpretative powers of photography to this function alone, as Susan Sontag has noted: "All photographs are *memento mori*. To take a photograph is to participate in another person's (or thing's) mortality, vulnerability, mutability. Precisely by slicing out this moment and freezing it, all photographs testify to time's relentless melt."[15]

Is photography an art?

Etienne Carjat (1828-1906):

▷ Camille Corot, 1864.

▷▷ Sarah Bernhardt.

Collodion negatives.

But to what extent does the photographic image take over reality? This question has been raised in different terms by artists, philosophers and critics. In the 1843 edition of his *Das Wesen des Christentums*, the German philosopher Ludwig Feuerbach noted already, with premonitory insight, that the modern age prefers "the picture to the thing, the copy to the original, representation to reality, and seeming to being." It is clear that the suppression of hierarchies, of moral and religious references, emphasizes and indeed calls for this direct experience of the world with human means, an experience conditioned by a lens which takes over from the eye and imposes its own optical powers. As a system of nature imitation like the other visual arts of the period, photography may be said to have come at its appointed time. But to limit it to this purpose would be to exclude it from the domain of art, to which it belongs by virtue of the fact that the operator can, through his way of seeing, express ideas. On this level photography does indeed answer to the definition of art given by Taine in his *Philosophie de l'Art* of 1865: "The purpose of the work of art is to bring out some essential or salient characteristic, and thereby some important idea, more clearly and completely than actual objects can do. It achieves this by employing an aggregate of connected parts whose relations it systematically modifies."

Gustave Courbet (1819-1877):
Country Siesta, c. 1850.
Charcoal.

Painters and photographers,
 moved by the same sense of immediacy

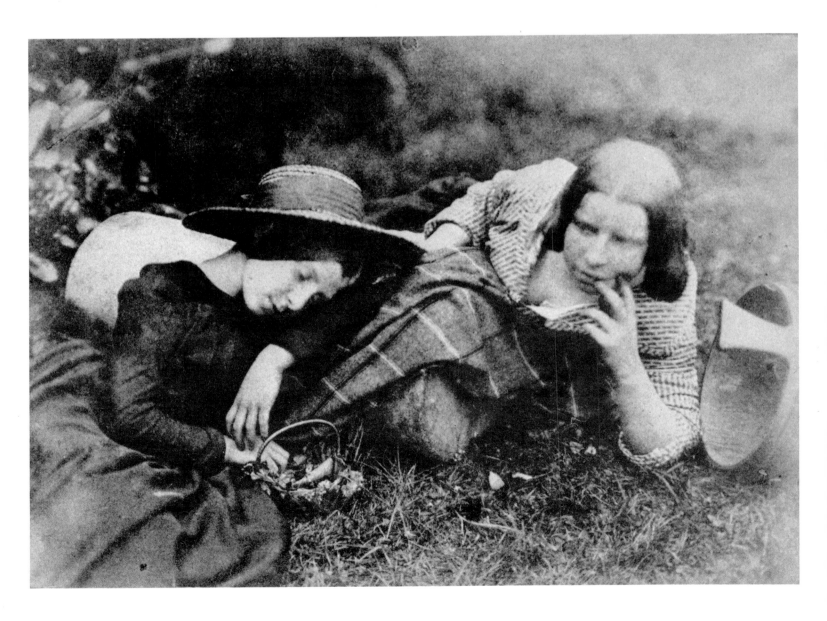

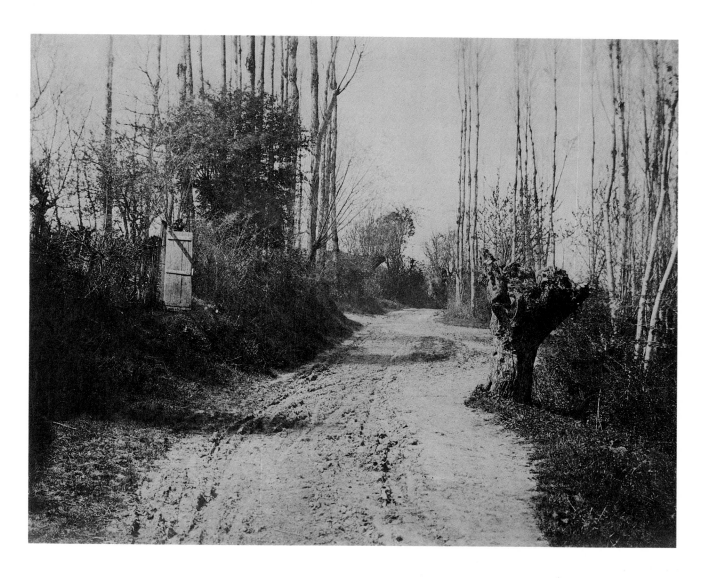

△ Victor Regnault (1810-1878):
Path between the Garenne de Sèvres and Gallardon, 1851-1852.
Salt print from waxed paper negative.

◁ David Octavius Hill (1802-1870)
and Robert Adamson (1821-1848):
Sleeping Flower Gatherers,
Mary and Margaret McCandlish, 1843-1847.
Calotype.

In his *Philosophie de l'Art* (1865) Taine developed two ideas which illustrate the issues then at stake and throw light on the relations between painting and photography: "The work of art is determined by the prevailing state of mind and manners as a whole... For images to arise naturally in the mind of man, they must neither be stifled nor mutilated by ideas... It is characteristic of extreme culture to blot out images more and more in favour of ideas. Under the incessant impact of education, conversation, reflection and science [and above all, he would have added today, of photography and reproduction], original vision is being distorted, broken down and overlaid, giving place to bare ideas, to well-ordered words, to a sort of algebra. Our heads have been filled with a motley, shifting, multifarious mesh of ideas; all cultures, our own and those of other countries, those of the past and those of the present, have come flooding into our heads and there left their flotsam and jetsam."

These comments were highly relevant in the 1860s and account for the deference shown to painting by photographers. They were so much engrossed in the scientific and technical problems of the camera that they failed to see what was before their nose. They composed, arranged and decorated in the manner of this or that artist. Nothing is more difficult than to break away from set habits of seeing. It was only when the camera became lighter and the snap quicker that things began to change. Photographers could then go direct to the motif, just as painters did; they could record this or that play or effect of light. They were attracted by the same subjects as painters—landscape, the representation of modern life. Great artists like Courbet and Millet treated them more searchingly, more memorably, so intense was their feeling for reality; but these artists began now to focus their attention on a certain treatment of shadows, on a precise rendering of texture, which photography better enabled them to study and understand.

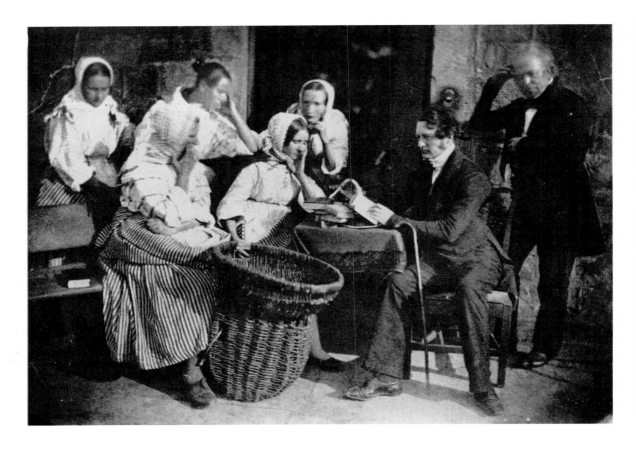

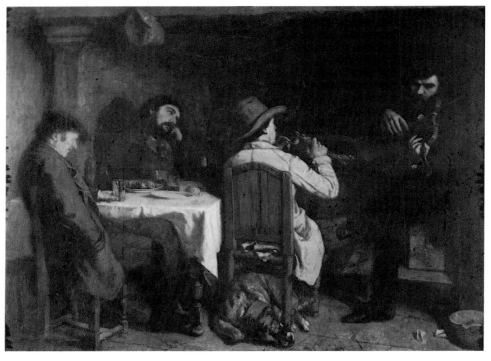

△ David Octavius Hill (1802-1870)
and Robert Adamson (1821-1848):
The Pastor's Visit, 1843-1847.
Calotype.

◁ Gustave Courbet (1819-1877):
After Dinner at Ornans, 1849.
Oil painting.

▷ David Octavius Hill (1802-1870):
Newhaven Fishwife,
Mrs Elizabeth (Johnstone) Hall, 1843-1847.
Calotype.

It is curious and instructive to note the parallels between certain situations. David, preparing to paint the coronation of Napoleon in Paris in 1804, proceeded as a photographic reporter would: he invented the reportage, but as the camera was not yet available he had to depend on his own sketches for his documentation. When, in Edinburgh in 1843, David Octavius Hill of the Royal Scottish Academy was commissioned to paint a large picture commemorating the establishment of the Free Church of Scotland, he decided to use the camera, only just invented, to secure likenesses of the several hundred ministers present at the first assembly of the Free Church: this, he saw at once, would provide the documentary basis for his painting. In collaboration with the Edinburgh portrait photographer Robert Adamson, Hill took up and improved Talbot's calotype process, and together they made a superlative series of individual portraits. The large painting for which Hill used them is forgotten, but the photographs are among the finest of this early period. Some of the Hill and Adamson portraits were brought together and published in *One Hundred Calotype Sketches* (Edinburgh, 1848). After Adamson's premature death in 1848, Hill gave up photography and returned to painting.

The realism of Hill and Adamson's portraits, views of Edinburgh and landscape studies brings to mind the realism that Courbet was just then developing in painting, but with different intentions. While the

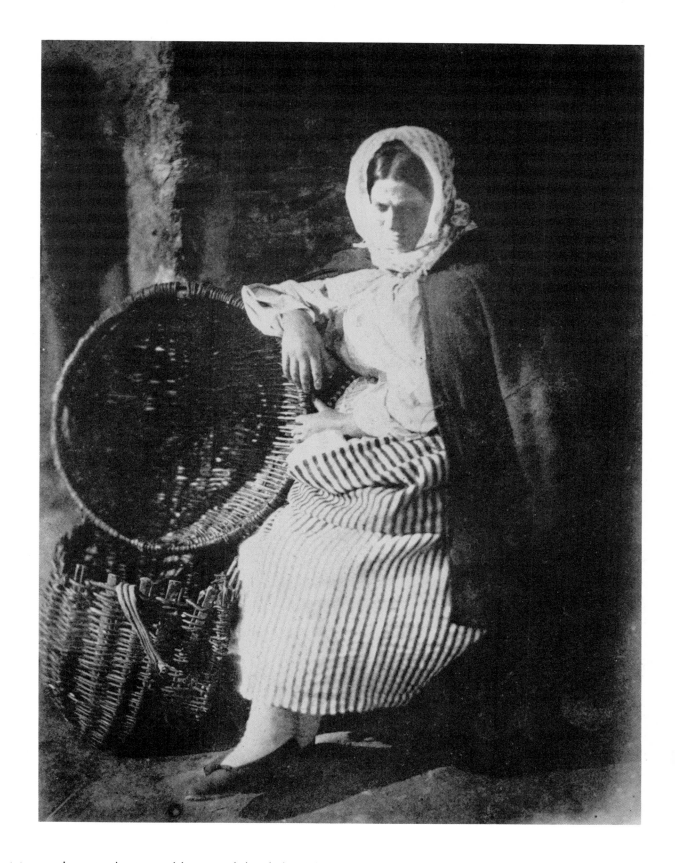

two Scotsmen set out to produce a photographic record (and though their achievement goes well beyond this aim), the French painter had a more ambitious programme. Hill and Adamson give us the common view of things. Courbet imposes a vision, his own vision of contemporary life. According to his friend Champfleury, he invented "modern Beauty." Courbet created a stir by proposing another reading of nature, and his challenge was double-edged, involving as it did both the subject matter and the mode of representation. In a word, he broke with idealism. "To paint the truth of things, that is my ideal," he wrote in presenting his famous one-man show of 1855. He was accused of being "the apostle of ugliness": the truth appeared ugly because unexpected. Whenever a creative artist renews our awareness of reality, he exposes himself to that accusation. "The beautiful is in nature," wrote Courbet in 1861. "It is to be met with in reality in the most various shapes and forms... The beautiful as conveyed by nature is superior to all the conventions of the artist."[16]

Hill and Adamson had the same modesty in their view of people and landscapes. They wished to record what they saw, but Courbet went further. His audacity lay in his refusal to arrange reality, to compose it into a picture, and his sense of reality enabled him to arrive at the sense of immediacy, at a representation of nature as summed up in a piercing glance—without frills.

Nègre, a painter photographer

The work of Charles Nègre offers a good example of the relations between painting and photography in the 1850s. Born in 1820 at Grasse, on the French Riviera, Nègre went up to Paris in 1839 and was trained as a painter at the Ecole des Beaux-Arts, first in the studio of Paul Delaroche, then in the studio of Ingres. By 1850 he was a well-known history painter, exhibiting regularly at the Salon.

In 1844 Nègre saw a demonstration of daguerreotype: ''I was struck with astonishment at the sight of these wonders, and I made up my mind to devote my time and strength to this medium.'' His master Delaroche had been a member of the government committee set up to evaluate Daguerre's invention in 1839, and several of Delaroche's pupils besides Nègre turned to photography: Roger Fenton, Gustave Le Gray and Henri Le Secq. Nègre took up photography on paper after Blanquart-Evrard, in 1847, had improved on Talbot's calotype by introducing a more sensitive printing paper. As a Salon painter Nègre used his photographs as a basis for paintings and also reproduced some of his pictures in photographs. In 1850 he tried unsuccessfully to publish an album of twenty-five photographs reproducing the most important Salon paintings of the year. In 1858 he approached Napoleon III with the project, again unrealized, of publishing a photographic survey of the great works of art of the past, illustrating history and civilization.

His surviving photographs show that Nègre was unusually successful in adapting the camera to his vision as an artist. He was a good observer and to each subject he chose he gave a specific accent, which he achieved by varying the quality and grain of the paper, the make-up of his emulsions and the time of development. He was a sensitive interpreter of light effects. In his prints he smoothed away

the line by merging contours into the values or atmosphere; this was in keeping with the direction taken by painting since the advent of Romanticism. Commenting on the *Little Rag-Picker* series in 1851, in *La Lumière*, the journal of the Société Héliographique, Francis Wey emphasized the points of similarity between Nègre and a number of painters from Murillo to Bonvin: "The rag-picker of M. Nègre is something more than a photograph. It is a studied, thought-out composition, executed with all the qualities foreign to the daguerreotype."

While Nègre practised landscape and portraiture, it was in genre scenes like that of his *Rag-Picker* that he excelled. It was a subject of everyday life, like those of Courbet and Daumier. Nègre and Daumier lived in the same quarter of Paris, the Ile Saint-Louis, and one is struck by the similarity of their vision. Daumier had the bolder eye, but both looked steadily at the world around them, used the same effects of values, treated planes and space with a similar sensibility. Nègre obtained his effects, not directly, but by manipulating the negative or the print; with him, artistic purpose prevailed over photographic objectivity. Retouching is especially noticeable in his *Chimney-Sweeps Walking on the Quai Bourbon*. By an artificial shadowing of the negative, he obtained a strong contrast between the planes; in the same way he reinforced the centre by darkening the corners. Although it looks like a snapshot, this picture was posed, as becomes obvious when one examines the position of the boys' feet.

Nègre also experimented with a different arrangement of the lenses, as he sought for new means of sensitizing the negatives in order to capture movement more effectively.

Charles Nègre (1820-1880):

▷ Chimney-Sweeps Walking on the
Quai Bourbon, Paris, 1851.
Paper negative, albumen print.

◁ Market Scene at the Port de
l'Hôtel de Ville, Paris, 1851.
Paper negative, salted paper print.

▽ Market Scene at the Port de
l'Hôtel de Ville, Paris, undated.
Oil painting.

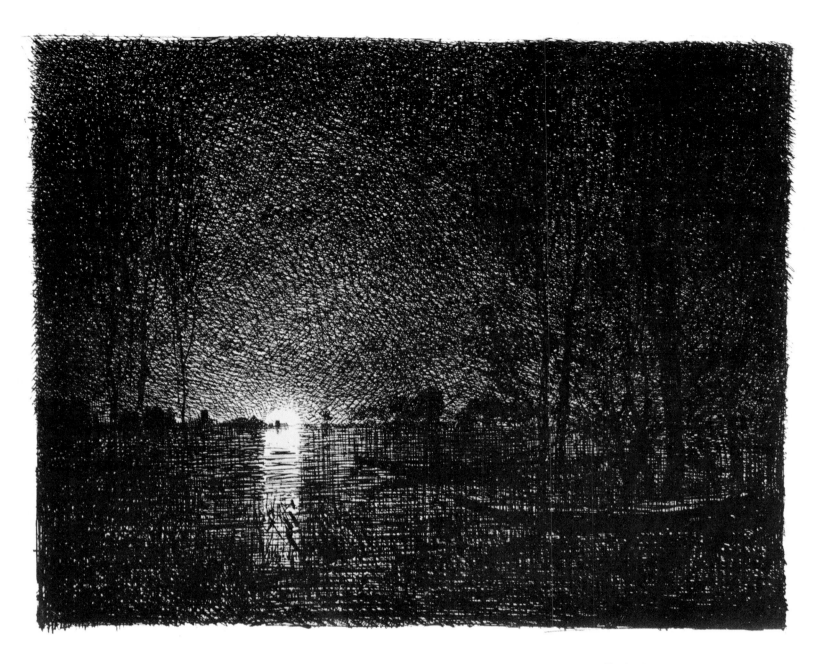

Charles-François Daubigny (1817-1878):
Night Effect, 1854-1858.
Glass print *(cliché verre)*.

Nègre systematically retouched his negatives in order to enhance the expressive power of light. In this he confirms the interest taken by the painters of this period in the problem of light, from Constable who noted how its effects modified the appearance of things, to Monet who showed its extraordinary vitality and made its presence a fundamental principle of his art. Photography came as a means of drawing directly with light. This being so, it naturally reacted in turn on painting, initially in the form of the *cliché-verre* or glass print, a technique which became popular in the 1850s (and one which prefigured the use by painters today of the kodatrace for offset impressions, and which was also used by Man Ray for several works in the early 1920s).

The Barbizon painters were especially interested in the *cliché-verre* as a process midway between drawing, photography and printmaking. Also known as photographic etching, the *cliché-verre* consists of a drawing made on a smoked or coated glass plate which is then placed on sensitized photographic paper and exposed to light, giving a positive version of the drawing, of which many copies can be printed. The evolution of printing and publishing had then set towards the production and multiplication of images. The techniques of reproduction then in use (lithography, wood engraving, more rarely etching) generally represented an interpretation made on the basis of a drawing, painting or photograph. The *cliché-verre* had the advantage of providing a drawing which could be reproduced directly; and it could be produced easily, with instruments familiar to the artist—the stylus, burin, brush, even the fingers. It was launched in France by the painter and lithographer Constant Dutilleux, who gathered around him at Arras a group of friends, including Adalbert Cuvelier, who experimented with the applications of photography to drawing and the reproduction of pictures. An occasional member of the group was Dutilleux's friend Corot, who took up the *cliché-verre* process in 1853 and made many glass prints over the next twenty years.

The handling of light

Théodore Rousseau (1812-1867):
The Cherry Tree, c. 1855.
Glass print *(cliché verre)*.

Eugène Cuvelier (?-1900):
Fontainebleau Forest, Etang de Frochard,
1863. Collodion negative, paper print.

The poetry
of light

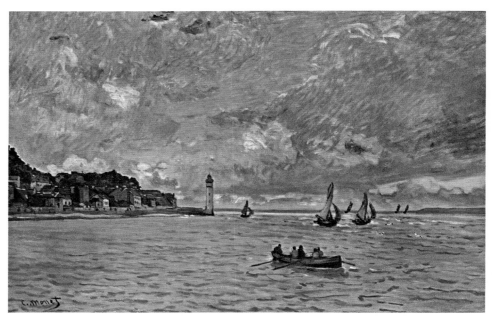

△ Henri Le Secq (1818-1882):
Dieppe, c. 1851-1854.
Dry waxed paper negative.

▷ Claude Monet (1840-1926):
Honfleur Lighthouse, 1864.
Oil painting.

That photography is an art of light is shown by the work of Gustave Le Gray better than any other. As a trained painter, with an eye for this specific feature, he set out to transform a reproductive technique into a creative medium. As early as 1852 he wrote: "The progress of photography lies not in the cheapness but in the quality of its prints. If a print is fine, complete and permanent, it takes on an intrinsic value. My own wish is that, instead of falling into the domain of industry and trade, photography may enter the domain of art. There it has its true and only place, and it is along these lines that I shall always do my best to make it progress." [17]

Born in 1820, Le Gray was trained in Paris as a painter in the classicizing style of Paul Delaroche. Discovering photography in the 1840s, he was converted by it to a natural vision and made some chemical experiments of his own. They resulted in his invention of the dry collodion process which, though slow, gave a very distinct negative on paper. In 1848 he opened a studio on the Boulevard des Capucines and taught such fine photographers as Charles Nègre, Henri Le Secq, Maxime Du Camp and Eugène Piot. His technical improvements, such as the waxed-paper process, gave his pictures their character and force. His *Traité pratique de photographie* (1852) helped to make him well known and he made many portraits; he photographed in Touraine and Aquitaine for the Historic

Monuments Commission; and with his camera he covered the inauguration of the Châlons camp of the Imperial Guard in 1857, one of the first pieces of photographic reportage. For all his success, he had no head for business and had to give up his studio in 1859.

For most artists and critics in the mid-nineteenth century, photography was a useful memory help and a dictionary of nature but fell short of art unless retouching was resorted to. The painter depended on tonal effects of light and shade, as Paillot de Montabert emphasized in 1828: "The effect mainly owes its energy, suavity and charm to the combinations of chiaroscuro; the proof of this is in prints, which achieve great effect without colouring. Colours do produce their particular effect, but one that is optically subordinated to the effect obtained by brighter and darker masses."

It was Le Gray's ambition to make photography an art. After working out the best solutions for toning the print, he went on to adapt the camera for rendering the mobility of the sky. The exposure time was so long that to bring out the sky in a landscape photographers had resorted to drawing in the clouds on the negative or materializing them with cotton when developing the print; or they used an overprinting of two negatives, one for the landscape, another for the sky.

Le Gray scored an unprecedented success in 1856 with his Mediterranean seascapes taken at Sète. He expressly claimed that the clouds were "obtained simultaneously," but it seems probable that he still used two negatives, made *almost* simultaneously of the same motif. Le Gray's seascapes have the luminous poetry of Courbet's and anticipate the plein-air painting of Monet. But while Le Gray composed and arranged light, Monet was to revolutionize painting by breaking light down into its constituent colours.

Gustave Le Gray (1820-1862):
Seascape at Sète, 1856.
Collodion negative, paper print.

The representation of the nude had always occupied a prominent place in painting. Painters and photographers in the mid-nineteenth century usually had a common background, moved in the same circles, shared the same interests. So it was only natural that the early photographers should try their hand at the nude. But the first to do so systematically had the painter's model in mind and their pretext was to provide documentation for artists, saving them the trouble and expense of hiring live models. This practice led to the making of whole sets of photographs in this line, for many years to come. But nude photography was also practised for its own sake.

It enjoyed an enormous success in Paris between 1853, when for the first time a nude photograph by F. J. Moulin was deposited for copyright reasons in the Bibliothèque Nationale, and 1855 when the jury of the Exposition Universelle refused to accept such subjects. Then it was hampered by the same climate of censorship that prevailed in 1857, when Flaubert was prosecuted for *Madame Bovary* and Baudelaire for *Les Fleurs du Mal*; what offended was their too close approach to real life, the "crudeness" of their realism. In a similar way, nude photography necessarily referred back to a living, identifiable model, while painting removed the nude from the contemporary world and put it in a mythological or historical setting. And though photographers justified their "anatomical" pictures by the idealism or heroism of the pose, they could not do away with the presence of the actual model. Where the nude is concerned, too much has been made of comparisons between photography and painting. True, Delacroix was a founding member of the Société Héliographique and collaborated with Eugène Durieu on photographing a series of nude models; true, Courbet seems to have used the

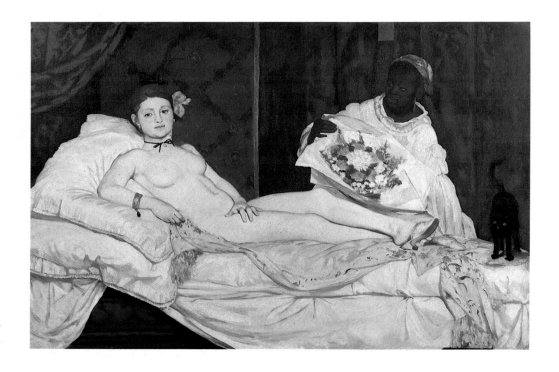

The scandal of modernity

◁ Edouard Manet (1832-1883):
Olympia, 1863.
Oil painting.

▷ Eugène Durieu (1800-1874):
Model in Front View, c. 1853-1854.
Salted paper print.

photographs of Julien Vallou de Villeneuve. But it cannot be said that in their painting they were directly inspired by photographs. Of course, in the period of realism especially, a photograph and a painting based on the same model looked very much alike. But resemblance is not the only element of comparison. More important are the idea and intention which preside over the transformation of a photograph into a painting. Delacroix had this in mind when he wrote: "The study of the daguerreotype, if well understood, can in itself fill the gaps in an artist's schooling. But to make good use of it he must already have a great deal of experience."[18]

The scandal of modernity broke out over the nude, but in painting—in Manet's *Déjeuner sur l'Herbe* and *Olympia*. Exhibited at the Salon of 1865, *Olympia* did indeed renew the representation of the nude. It aroused the most violent reactions. It was not the picture of a naked woman lying on a bed that shocked people; there had been many such in the history of painting, and in more equivocal attitudes than this one. What shocked was the way it was seen and represented: Manet portrayed his nude model just as she was, with her qualities and defects, without idealizing her. More pointedly than any photographer had yet done, Manet recorded here what he saw, refusing to make any emotional or intellectual adjustment in what it was given him to see. He even reduced the possibilities of painting by narrowing it down to a telling record of observed effects.

In comparison, the photographers were less creative. Martin aimed at pictorial idealism. Durieu made his best pictures under the guidance of Delacroix's eye. Olivier and Vallou de Villeneuve chose their poses and settings from a realistic standpoint, and that was all to the good. Others exploited erotic themes already treated in painting and continued to situate them in the stock context of Antiquity or the East.

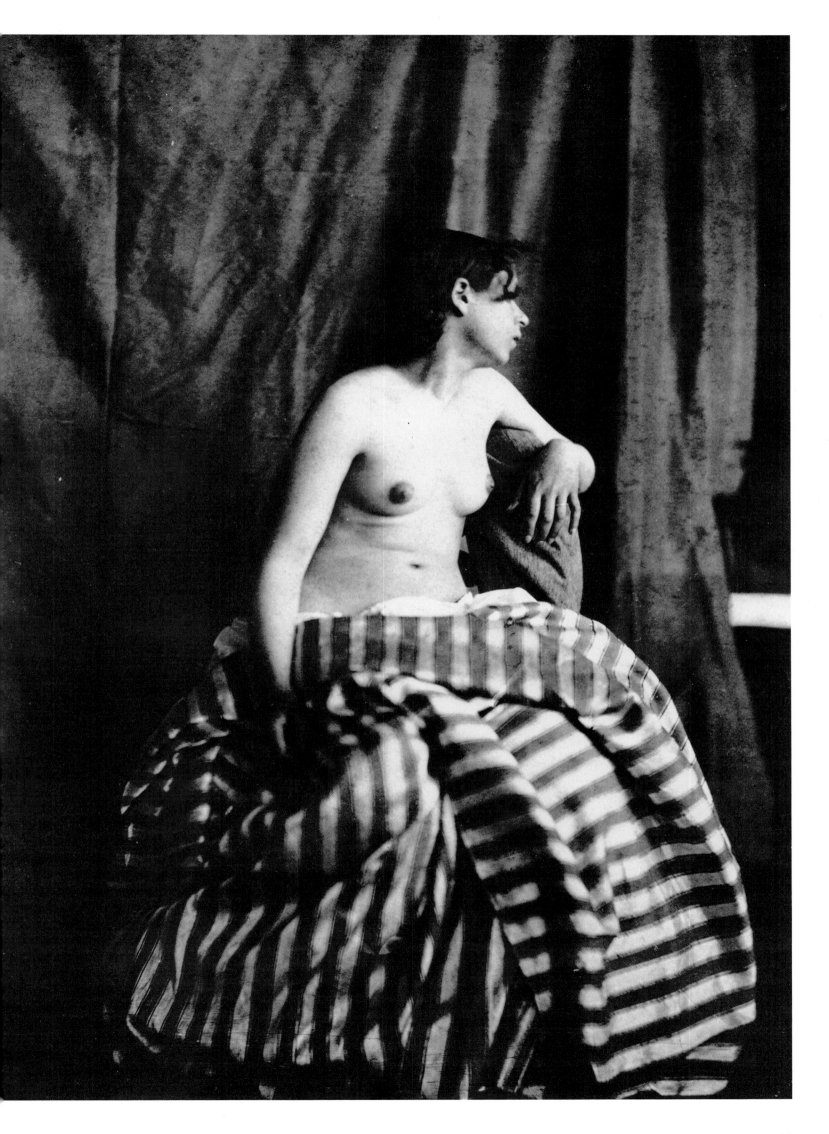

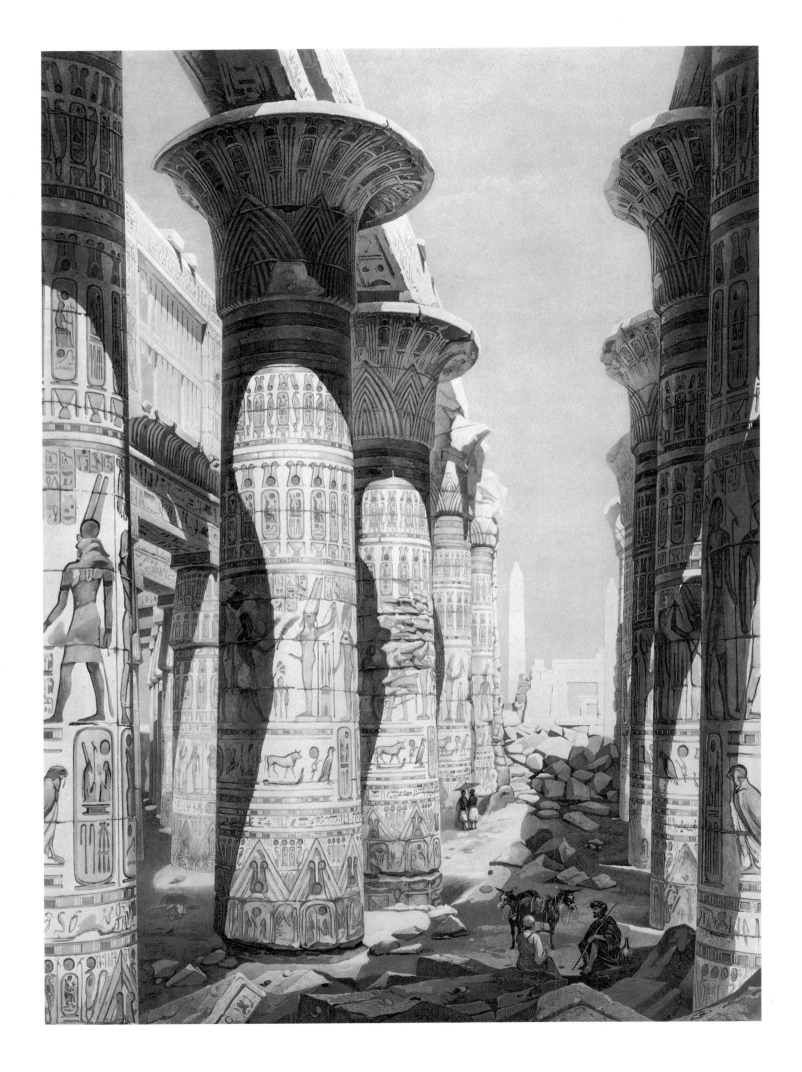

Hypostyle Hall at Karnak (Thebes), Egypt.
Aquatint after a daguerreotype illustrating
Hector Horeau, *Panorama d'Egypte et de Nubie*,
Paris, 1841.

▷ Eugène Viollet-le-Duc (1814-1879):
Details of the First Order of the Courtyard
of the Palazzo della Cancelleria, Rome, 1837.
Pen and watercolour.

40

INITIAL
SOCIAL
EFFECTS

From the moment in the 1840s when Talbot's calotype superseded the daguerreotype, photography began to exert a wider influence; for the calotype, as a negative-positive process, could be printed in any number of copies. The single, reversed print of Daguerre's process could satisfy curiosity and arouse wonder, but was limited to a few eyes. Only with the multiplication of prints from a negative did photography become a genuine means of diffusion and communication. As such it could not fail to have social consequences through its impact on ways of seeing and thinking. It is interesting to take stock of its effects around 1850.

Several attempts had been made to publish books of photographs, but only Hill and Adamson in Edinburgh produced prints of the requisite quality before Blanquart-Evrard improved on their calotype process and was able, from his printing works near Lille, to launch a bulk production of books illustrated with photographs. Before, it had taken hours to obtain a positive from a negative; now, from 1851, Blanquart-Evrard was able to print 300 pictures a day and the cost price was considerably reduced.

The photograph answered the fundamental need underlying the whole movement towards realism: the need for an accurate and detailed record of the visual world. Charles Nègre was well aware of this when he wrote in 1854: "Photography does not form a separate, barren field of art. It is only a means of execution, uniform, rapid and sure, which serves the artist by reproducing with mathematical precision the form and effect of objects and even that poetry which at once arises from any harmonious combination."[1] But it was by way of the publishing trade that photography was destined to impose a standard way of seeing.

Two of its characteristics were to have a direct effect on society: its power of revealing things which are invisible to the naked eye and which specialists alone had been able to perceive; and its power of confronting everyone with images of unknown people and places, of strange and thought-provoking situations, of exceptional events. By steadily enlarging the field of knowledge and awareness, photography directly modified the traditional value of human experience. Till now people had lived narrow lives, knowing nothing of the world beyond the bounds of local experience and personal relationships. The civilization of the image began with the multiplication of photographs, and it emphasized visual knowledge in contradistinction to physical experience. Henceforth people saw more and more of what they would never actually experience—with momentous consequences, inasmuch as photography is but one code among others, reducing everything to the same scale, and limited to the delineation of appearances.

The field of vision opened up by photographers rapidly widened. After illustrating the immediate life around them in Europe and the East Coast of the United States, they began ranging into distant countries, bringing back uncommon and exotic pictures. It was the heyday of colonial expansion and they followed the colonizers, recording what they saw in Africa, in the East, on the American frontier: not only the landscapes but also the people, the "natives," their homes, dress, way of life. The unexpected consequence was that, by their strangeness, these visual records of foreign places began undermining the assumptions by which Western man lived—undermining them, then showing them up.

The growing production of photographs modified seeing habits by imposing new standards of comparison; it made seeing more analytical. The emergence of the Museum—which removed works from their setting and function and brought them together for comparative purposes—had

shown that the difference between two portraits lay not so much in the sitter's individuality as in the painter's view of the sitter. Likewise with the photographer: what mattered was his view of the subject. But multiplication familiarized the public with the most unusual forms, so that they came to be taken for granted, speeding up the evolution of taste and subjecting consumers to the system of fashions. And as images became more numerous, more pervasive, they were looked at with less attention. The mind became more inquiring and the eye more superficial, so that the photographer was driven to heighten his effects in order to catch the eye and create surprise.

Photography could not but have a direct influence on the evolution of the other arts: as it took over the field of realistic delineation, it set both painters and writers moving away from that field.

As an instrument of observation and delineation, photography was welcomed by scientists, and in their hands it produced some striking effects. Coupled with scientific instruments like the microscope and telescope, it revealed to a wide public some unsuspected facets of this world and others. Pressing ever further in its revelation of the invisible, scientific photography came to throw doubt on things visible to the naked eye. That reality lies both within and beyond the grasp of the senses was demonstrated when photography proved capable of recording the radiations of X rays and infrared rays. The very

The unexpected side of reality

existence of X rays, discovered by Röntgen in 1895, was questioned at first, because what the radiographs revealed was something no eye had ever seen.

Already in 1839, Arago foresaw the services that photography would render to science by way of photometry and micrography. In 1841 Talbot succeeded in recording views taken through a microscope. In 1844 Foucault made daguerreotypes of blood globules enlarged four hundredfold. In astronomy the results were even more surprising. The first photograph of the moon was made in Venice by Malacarne in 1845. The eclipse of the sun of 28 July 1851 was noteworthy for the first attempts to photograph such a phenomenon. In 1874 Janssen recorded the transit of Venus across the sun's disc with a specially designed camera, the "astronomical revolver." Thus it was now possible to draw up a chart of the sky and take pictures of the phenomena observable in it, such as comets and meteors; photography also promoted the discovery of new galaxies. Parallel advances were made in microphotography, and Bertsch's albumen prints of lice, caterpillars, grains of wheat, etc., made from 1853 on, extended the range of scientific observation.

Under the name of photogrammetry, photography was brought into the service of modern geography and map-making. It was a Frenchman, Aimé Laussedat, who worked out a technique of photographic surveying whose use made maps more precise and visually telling.

A very real scientific interest also attached to the effort to record objects in motion. The first such experiment was made by Talbot in 1851. Using the bright light of an electric spark, he was able to "catch" a page of *The Times* as it spun round on a revolving wheel to which he had tied it. The discoveries soon to be made with moving figures were unexpectedly startling. The camera showed already its power of revealing nature's secrets.

OBSERVATORY, Cranford, Middlesex.

NORTH LATITUDE......... 51° 28′ 57.8″
Min. Sec.
WEST LONGITUDE......... 1 37.5

ENLARGED PHOTOGRAPHIC COPY

OF A PHOTOGRAPH OF

THE MOON

HOUR
SEPTEMBER 7, 1857, 14—15

The Original Collodion Positive was obtained in five seconds,
by means of a Newtonian Equatoreal of thirteen inches
aperture and ten feet focal length.

Sir John W Herschel Bart.
with Warren De La Rue's
Compliments
Sept 22 /57

William Henry Fox Talbot (1800-1877):
Wing of a Lantern Fly, 1841.
Microphotograph.

Anonymous:
Spider Enlarged Three Thousandfold, 1865.
Microphotograph, albumen print.

Warren De La Rue (1815-1889):
Enlarged Photograph of the Moon, 1857.
Collodion negative, paper print.

△ Paul Jeuffrain
(1808-1896):
The Temple of Ceres
at Paestum, 1852.
Calotype.

◁ Edouard Denis Baldus
(1815-1882):
Pediment of the Gate House
of the Library,
Paris, c. 1855.
Assemblage of five prints.

As soon as the daguerreotype appeared, it was used to reproduce works of art; and many painters, from Charles Nègre to Man Ray, who first took the camera in their hands for this purpose, thereby discovered their vocation as a photographer. From the first it was realized that photography could reproduce a painting, sculpture or building more faithfully and objectively than any of the printmaking media. Niepce, in inventing photography, had in fact been impelled by the desire to reproduce the masterpieces of art. When it became possible in the 1840s to multiply prints from a negative, the number of photographic reproductions grew fast. The desire to see and know, to catalogue and classify, was catered for, and never had that desire been so keen. In France, in particular, the mid-nineteenth century was intensely art-conscious. There was a deepening awareness of the country's historical and artistic heritage. Thanks to the initiative of cultured antiquarians like Mérimée and Viollet-le-Duc, the past acquired a value in its own right, became a reality by whose standards the innovations of the day were judged—and often condemned.

The needs of archaeology and recognition of the importance of earlier creations justified the idea of taking stock of the past, of inventorying its masterpieces one by one. As photography advanced in quality and practicability, the Historic Monuments Commission in Paris realized the use that could be made of it, and in 1851 it commissioned five photographers, Baldus, Bayard, Le Gray, Le Secq and Mestral, to carry out a photographic survey of historic buildings, each being assigned to a different region. They performed their work ably, for all of them were genuinely interested in such an architectural survey. Though not a member of this official group, Charles Nègre, on his own account, made a similar survey of Provence.

German by birth, trained as a painter and active as a portrait painter in New York in the 1840s, Edouard Denis Baldus settled in France about 1850 and became one of the greatest architectural photographers of the early period, with a keen sense of volume and composition. In addition to the photographs he made in 1852-1853 of the monuments of Arles, Nîmes and Avignon for the Historic Monuments Commission, he made a photographic survey in 1854-1855 of the new wing connecting the Louvre with the Palais des Tuileries.

When photographers left home and travelled abroad, it was generally the monuments and masterpieces of art that caught their attention. The first book published by Blanquart-Evrard, from his Lille printing works, in 1852, was illustrated with such views: *Egypte, Nubie, Palestine et Syrie*, by Maxime Du Camp, with 125 photographs printed from paper negatives made on the spot.

Accompanied by the young Gustave Flaubert, Du Camp, a journalist and writer, left Paris in the autumn of 1849 on a journey to the Near East—a fashionable tour at the time, already made by several French Romantics. Before leaving, Du Camp secured an unremunerated but official mission from the French Ministry of Public Instruction to photograph the antiquities of Egypt and had prepared himself for it by a thorough study of photographic techniques under Gustave Le Gray. The results, considering the travel and weather conditions he had to overcome, were something of a feat. Du Camp's photographs are admirable for their definition and clarity; he framed his subjects from an angle calculated to bring out the tension set up between light and shadow, thus enhancing the physical reality of the monuments he recorded. The fascination we feel before the work of these early photographers stems from the extraordinary precision they achieved, with the long exposures that were still necessary.

At home these photographers also documented the sweeping changes being brought about by urbanization and industrialization, notably in Paris, where Baron Haussmann in 1853 began changing the face of the city, rebuilding, modernizing, laying out new thoroughfares. The photographs of Charles Marville recorded the old streets and houses of medieval and Renaissance Paris just before they disappeared.

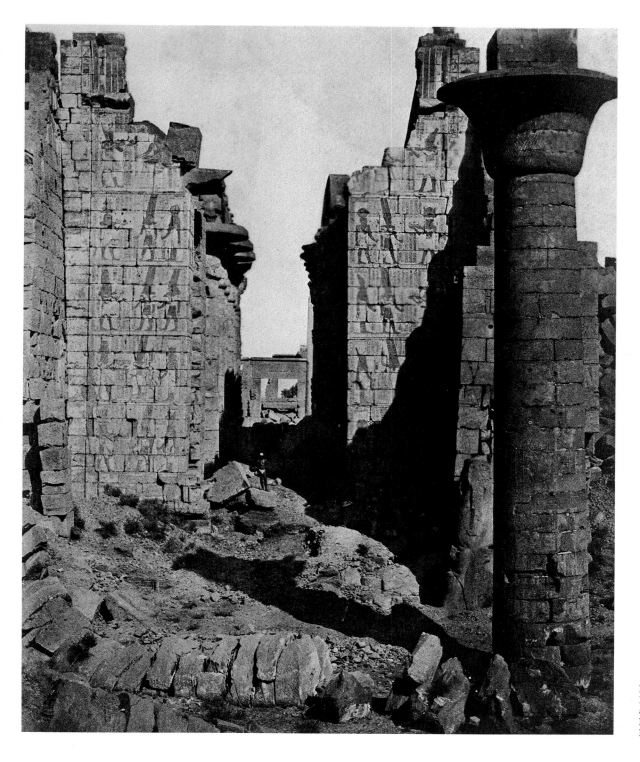

Maxime Du Camp (1822-1894):
Entrance of the Hypostyle Hall
at Karnak (Thebes), Egypt, 1850.
Paper negative, print by the
Blanquart-Evrard process.

45

Photography only found its full application when it became possible to reproduce its prints directly and mechanically and employ them to illustrate books, periodicals and newspapers. This involved long and laborious efforts.

Niepce had already had the idea of "over-etching" his heliograph prints on a metal plate, thus permitting the image to be righted and opening the way to multiplication. This idea was taken up again for the diffusion of the daguerreotype, with a printing on a metal plate; but this remained a slow operation and so was incompatible with bulk publishing. It was, however, the process used by N. P. M. Lerebours in publishing the famous *Excursions Daguerriennes* (Paris, 1840-1842), a series of views which he commissioned photographers to take in Europe, Africa and the United States.

Publishers and newspaper editors were eager to have pictures, and wood engravings still seemed the most economical system of illustration, since they could be printed on the same presses as the text. A successful attempt was made to sensitize the woodblock to the photographic print, but it yielded a photographic drawing which still had to be hand-cut by skilful block carvers. Then the lithographic stone was sensitized, good results being obtained in 1852 by Lemercier and Lerebours, and were further perfected by Poitevin. Lithography was already abundantly used by the press, and it was the medium chosen by Daumier for his caricatures; but while the sensitizing of the stone gave an immediate reaction no longer requiring human intervention, the results remained of poor quality. So it was that the first books of photographs were illustrated with actual photographs printed from original negatives. Such was the practice of Hill and Adamson.

The reproduction of photographs

◁ Sea-Front Church in Stockholm.
Aquatint and etching after a
daguerreotype by N. P. M. Lerebours,
for *Excursions Daguerriennes*, Paris, 1842.

The problem of reproducing photographs was so topical that in 1856 the Société Française de Photographie offered a cash prize for a photomechanical process of reproduction. It was awarded to Alphonse Poitevin in 1862 for his positive carbon-prints. The problem had not been solved, but his process of photolithography using gelatin later gave rise to the collotype.

Earlier, in 1851, the newly founded Société Héliographique (renamed in 1854 the Société Française de Photographie), the first professional association of photographers, appointed a group including Le Gray and Le Secq to consider the creation of a printing establishment in France to which all photographers could send their negatives. This was achieved independently, by Blanquart-Evrard who, that same year, opened his Imprimerie Photographique near Lille; his first publication, *Album photographique à l'usage de l'artiste et de l'amateur*, a portfolio of architectural and landscape subjects, appeared in December 1851. A similar establishment was soon opened by Fontenay in Paris. The photographic industry was born.

Actually, anticipating Blanquart-Evrard's *Album photographique* by a few weeks, Eugène Piot in 1851 had published *L'Italie monumentale*, a book illustrated with photographs. Such publications answered a demand. *La Lumière*, the journal of the Société Héliographique, reported regularly on the problems connected with photography, in particular the problem of reproduction. On the opening page of its

Pierre Trémaux: Turkish Stelae, c. 1860.
Photolithograph, Poitevin process.

◁ Charles Nègre (1820-1880): Left Side of the Main Portal
of Saint-Trophime, Arles, 1852. Salted paper print.

47

issue of 21 October 1852 appeared one of the first photogravures, made by Nègre. By means of etching and aquatint, the negative was engraved directly. A resourceful inventor, Nègre perfected his process and he was awarded a first-class medal at the Exposition Universelle held in Paris in 1855; tribute was paid in particular to his picture of the *Portal of Saint-Trophime at Arles*, of which the photogravure was scarcely inferior to the original photograph. But photomechanical printing works failed to flourish, costs proving higher than expected.

Already in the 1840s the press had seized on photographs, and they were given as models to the woodcutters who translated them into engravings published in the illustrated weeklies like *L'Illustration* in Paris, *The Illustrated London News, Die Illustrirte Zeitung* in Leipzig and *Gleason's Pictorial Drawing Room Companion* in Boston. Only the process of Poitevin and its further development by Woodbury in 1864 could as yet meet this need with any fidelity to the original. In 1873 the magazine *Paris Théâtre* illustrated its cover with a photoglyptic engraving, a method similar to the woodburytype. The same method was used by the specialist in reproduction, the Paris firm of Goupil, for its *Galerie Contemporaine.* (It was while working for Goupil that Van Gogh and his brother Theo formed their artistic taste a few years later.)

Retouching, montage and trick photography

△▷ Oscar G. Rejlander (1813-1875):
The Two Ways of Life, 1857.
Combination print from thirty negatives.

◁ Cover of *Paris-Portrait* with
a Nadar photograph of the actress
Jeanne Nadaud, Paris, 1879.
Photoglyptic engraving.

The first photographic society, the Société Héliographique, founded in Paris in 1851, did much for the development and diffusion of the new art. Its director, Ernest Lacan, can rightly be called the first historian of photography, on the strength of his books *De la photographie et de ses diverses applications aux Beaux-Arts* (1855) and *Esquisses photographiques* (1856). Its motto, suggested by B. de Monfort, was: *Rien n'est plus beau que le vrai, mais il faut le choisir*. The Société Héliographique probably inspired the first field missions of French photographers. Reorganized in November 1854 and renamed the Société Française de Photographie, it sponsored in 1855, in the context of the Exposition Universelle, the first exhibition of photographs to be held in France.

There, for the first time, the question of retouching was raised, when Franz Hanfstängl of Munich exhibited a retouched negative, together with prints made from it before and after retouching. From then on, the practice of retouching widened the scope of photography, setting it free from its mirror function, deflecting it from its initial purpose of recording appearances. Photographs thus came more and more under the spell of the painter's way of seeing, thanks to the effects permitted by retouching. Working with pencil or brush on the positive or negative, the skilful retoucher—who became a specialist in his own right—could remove the specific features of the photographic print and make it resemble a drawing.

Pierre Petit (1832-?):
Fragment of the panorama "History of the Century,"
representing the period 1815-1829.
Photographs by Pierre Petit (figures) combined
with painting by Stevens and Gervex (setting).

It was at the Paris Exposition of 1855, too, that Charles Nègre imposed the genre scene as a photographic subject. He had already practised retouching, but he made a new application of it in his photographs of the Panthéon, with the appearance of the sky in the second print—an effect obtained by overprinting two negatives (the sky usually being overexposed and therefore white). In 1852 Bayard had already shown the possibilities of overprinting, commented on enthusiastically by Lacan in the pages of *La Lumière*.

Trick photography pointed the way beyond appearances, to an exploration of the imaginary and subjective. Discovered accidentally rather than by design, it opened up an entirely new field. Henry Peach Robinson, from the 1850s, used it systematically in building up his composite images from several negatives. Its most characteristic exponent was Oscar Rejlander, a Swedish photographer working in England; he is best known for his allegory *Two Ways of Life* (1857), a combination print made from over thirty separate negatives. One of the first to exploit trick effects was Martin M. Lawrence, whose allegorical composition *Past, Present, and Future* was shown in London in 1851, at the Great Exhibition in the Crystal Palace.

Charles Nègre (1820-1880): The Pantheon, Paris, c. 1854. Salted paper print.

The Pantheon, Paris, 1855. Photogravure in black ink.

The development of photography as an art depended on exhibitions and the comparisons there made possible. In November 1856 Nadar wrote a letter to the Société Française de Photographie denouncing the absence of photography from the Paris Salon. Engravers were allowed to exhibit there: Nadar claimed the same right for photographers. The officials in charge refused it: photographers were not to be allowed to compete with painters, especially since they were now able to contrive genre scenes and historical subjects of their own. For officialdom photography was not an art. Some men, like Boissonnas, set out to contradict this view by practising "history photography," based on an elaborate reconstruction of some moment of the past, more accurate and detailed than a stage set, and calling, paradoxically enough, for even more thought and preparation than a history painting.

Finally, in 1859, Nadar and the Société Française de Photographie won their battle: the Fine Arts officials yielded and photography was admitted to the Salon. But it was relegated to an annex, symbolically separated from the Salon down to its last appearance there in 1876.

Fred Boissonnas (1858-1946):
The Cave-Dwellers, c. 1892.
Study on the banks of the Arve, near Geneva.
Carbon print from orthochromatic plate.

The photographic industry and studios

The spread and popularity of photography gave rise to a whole industry, echeloned on successive levels: the plate and camera makers; the picture-producing studios; the developers, printers and distributors. These three levels of the industry were closely connected but the first was the least important in the context of the evolution of vision: opticians, chemists and physicists were not long in manufacturing mass-produced cameras and plates ready for use, together with printing facilities. The industrialization of picture-making was more significant. All over Europe and the United States photographers opened portrait studios. Some of them, like Disdéri in Paris, who popularized the *carte-de-visite* photograph, had an elaborate establishment with a whole arsenal of sets and properties calculated to meet the desires of a wide range of customers. Backdrops were available corresponding to every conceivable situation, objects for evoking past and present, scenery for every taste; for the portrait photographer, like his counterpart the portrait painter, worked indoors, venturing occasionally only as far as the courtyard or garden of his studio when better lighting was required. These working habits lasted down to the First World War.

The photograph was a product; as such it required channels of distribution. Here industrialization had some of its most powerful effects. Publishers multiplied to cope with the demand; as production

increased they had to set or follow the public taste and find the right forms of presentation. The photographs were generally brought together in volumes or commercialized singly like prints. They kept to the standard subject-matter of the printmaker: portraits, still lifes, landscapes. Portraiture, for the most part, did not lend itself to multiplication, since it depended on a specific commission; the other themes did, and the most lucrative of them was the reproduction of works of art. To develop and expand their business, publishers tried to achieve a distinctive style, to set a fashion, to monopolize some particular field. Their growing production gradually extended the bounds of knowledge, of the public awareness of art, science, topical events; and until the introduction of the halftone process after 1880, enabling the press to use photographs directly, it was these publishers of illustrated books and journals who shaped the way of seeing of their time.

It was in the 1860s that photographs began to be produced on an industrial scale. One of the pioneers in France was Adolphe Braun. Born at Besançon in 1811, he became a designer of textile patterns and turned to photography about 1853 with the idea of "forming a collection of studies intended for artists who employ flowers as decorative elements." Seeing the success of his photographic pattern-book, he followed it up with a landscape album photographed in Alsace. Before long he had a team of photographers working all over Europe. Then he turned to the reproduction of works of art, photographing the drawings in the galleries and museums of Basel (1862-1864), then the Louvre and the major museums of Europe, and finally the frescoes in the Sistine Chapel. By 1868 Braun had a collection of 4,000 negatives; so brisk was his production that by 1870 he had 8,000. He published his photographs at Dornach-Mulhouse in Alsace, using the carbon process of Poitevin. Alinari in Florence, from the 1850s, built up a similar photo-collection of Italian works of art.

The reproduction of art masterpieces opened up a new field for publishers, some of whom even obtained exclusive rights to certain works. The wholesale distribution of such reproductions could not help but modify prevailing conceptions of art and the nature of art criticism as well. From descriptive, the study of art became more biographical and analytical. In Paris in 1853 the Bisson brothers

Adolphe Braun (1811-1877):
Still Life with Hare and Ducks, 1859.
Collodion negative.

published their photographic reproductions of Rembrandt's works, printed lithographically by Lemercier, with a text by the art historian Charles Blanc.

Painters, so long dependent on reproductive prints for a knowledge of the old masters, were fascinated by what the camera could do. Colour photography was not yet possible, but even in black and white it reproduced line, composition and tonal values with unprecedented accuracy. Painters had less and less need to make copies, till now an important part of their schooling. With its power of conjuring up the art masterpieces of all times and places, the photographic reproduction gradually took their place in the collective memory. Knowledge was widened to the detriment of experience. Already Corot and Delacroix had had some of their paintings photographed. Photography made possible the modern catalogue raisonné in its modern guise of completeness and accuracy. Knowledge through photography of a master's whole œuvre modified the appreciation of art, a fact that did not escape contemporary artists. Till now the artist had felt bound to put the best of himself into each work. The multiplication of both reproductions and exhibitions modified this commitment. Picasso and Matisse, for example, were well aware of being appreciated less for this or that work than for their achievement as a whole. And indeed what came to count even more than the achievement was the trend it set.

The success of the portrait photograph sprang from the desire of the bourgeoisie to see itself portrayed in the same way that the great ones of the world had been immortalized in painting. But as these pictures multiplied, other uses were soon found for them.

The making of portraits ensured good business for a large number of photographer's studios, and some of them became important establishments. Disdéri's studio in Paris employed ninety people by 1861 and could produce over 2,000 photographs a day. Born in Paris in 1819, Adolphe-Eugène Disdéri was trained as a painter and worked for the Paris theatres, before turning to photography about 1848. Thanks to his business acumen and artistic sense, he made a brilliant success of it. He first made his name with Paris street scenes in the spirit of those of Nègre, but also moved here in a direction of his own, with stylized subjects to which he often gave a caricatural turn; he singled out representative types of a social class and so much emphasized their characteristics that they look like made-up actors. In 1854 he patented a camera with several lenses. With this he could take eight or twelve poses of one sitter on a single negative, giving a series of *carte-de-visite* photographs—paper prints measuring 2½ × 3½ inches pasted on a mount the size of a visiting card.

This new format was criticized by other photographers, but it pleased the public, which was delighted to have a series of pictures from which to choose. Disdéri's invention inaugurated a type of portrait

Commemorating and identifying

Adolphe-Eugène Disdéri (1819-1890):
Dr Cabarrès, c. 1860.
Uncut print from carte-de-visite negative.

Heliotype illustrations for Charles Darwin,
The Expression of the Emotions in Man and Animals,
London, 1872. Nos. 6-7 possibly by O. G. Rejlander.

and set a trend which has continued to this day. And with it the requirements of industrialization and commercialization gave priority to the customer's desires over the ideas of the creative artist.

For one-fifth of the usual price Disdéri offered twelve portraits, and his innovation was successful because it made photography accessible to every class of society. His reputation reached its height in 1859 when the Emperor Napoleon III, leading his troops out of Paris on the way to Italy, stopped in front of Disdéri's studio to have his *carte-de-visite* photograph taken.

The craze for having one's picture taken led naturally to the group portrait, to commemorate an event or gathering. Until the appearance of the snapshot at the end of the 1850s, group portraits kept to a stereotyped composition, falling into line with the famous corporation portraits of seventeenth-century Dutch painting.

The study of facial expression developed along both scientific and political lines. Preceding the photographers here, Géricault around 1820 had painted his searching portraits of madmen and madwomen, tracing in their eyes and features the signs of their all-consuming inner fire. A similar intent shaped the development of ethnological photography. Following up his *Origin of Species*

Anonymous:
Infant School, Geneva, 1892.
Sepia toned bromide print.

(1859), Darwin used photographs, including some by Rejlander, to illustrate his *Expression of the Emotions in Man and Animals* (1872), offering thereby a natural explanation of phenomena which appeared to stand in the way of the acceptance of evolution. Photography furthered the study of physiognomy, the art of judging character from appearance, which had been popular since the work of Lavater in the eighteenth century.

The police form and the identity card were not far away. They were the inevitable consequence of this formidable multiplication of portraits. The camera offered the best possible way of identifying a man and keeping tabs on him. In the wave of repression that followed the Commune in 1871, the Paris police used the photographs taken during the insurrection as conclusive evidence to gain convictions. Portrait photography entered the political arena as a means of bringing the election candidate closer to his constituents. It was easier to vote for a man one knew at least by sight. Alexander Hesler's portrait of Lincoln counted for much in the success of his political career. The photograph of Major Robert Anderson, who defended Fort Sumter against Confederate besiegers in 1861, sold in untold thousands of copies.

Photo reporting

Pieter Oosterhuis:
Nadar's Balloon arriving in Amsterdam
on 14 September 1865.
Stereoscopic plate, collodion
negative, albumen print.

As public interest grew in events of the day, photographic journalism came into being; and its development in turn made people more curious about the greater world beyond the horizon, more eager for knowledge of it. Much had been done by painters like Géricault and Courbet to stimulate this movement away from purely artistic reference, towards the realities of modern life.

The problem for photographers at first had been to get away from the connection with painting. When some of them did, as in the first stereoscopic views of Paris around 1860, the public was disconcerted by their realism and took them for montages. The modernity of such snapshots was lost even on Baudelaire, who in his Salon review of 1859 referred scathingly to Daguerre and portrait photographers: "Our foul society has rushed forward, Narcissus-like, to gaze at its trite image on the metal plate." But in *Le Peintre de la vie moderne* (1859-1860) he calls attention to the quotidian: "Modernity is the transitory, the fleeting, the contingent; that is one half of art, whose other half is the eternal and the immutable."

▷ Anonymous:
The Emperor Nicholas II and Empress
Alexandra of Russia
in Paris, 8 October 1896.
Stereoscopic plate.

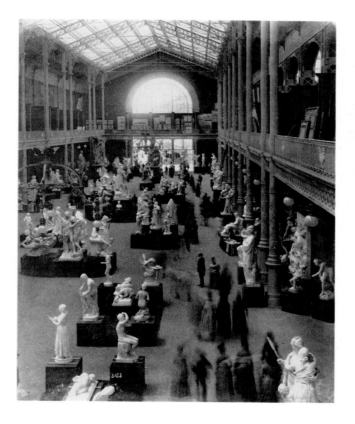

◁ Anonymous:
The Gallery of the Arts,
Exposition Universelle, Paris, 1889.
Bromide print.

The press gave more and more page space to illustration, whetting the curiosity of its readers, who were made more alive to international events, to overshadowing realities beyond the narrow round of daily life. To attract a wider readership, newsmen sought out the strange and unusual. Out of this trend arose the reportage, carried out with courage and resourcefulness. As soon as smaller, lighter cameras and the introduction of camera film made it possible, photo reporters were to be found wherever something was happening, building up the archives of modern history.

The camera reportage goes back to the 1850s, answering at first to a political purpose, when the British government felt the need to conciliate public opinion hostile to the Crimean War. To do so it sent out Roger Fenton, a barrister who took up photography in the 1840s and became the first secretary of the Photographic Society. His work in the Crimea was made difficult by the bulky material of that day (1855), the heat and the careful exposures then necessary (from three to twenty seconds). In 1856 he returned to London with 360 negatives—not scenes of action, but landscapes, views of the battle areas, pictures of the soldiers and camp life. A true Victorian, he tastefully avoided the horrors of war, as indeed he had been requested to do at the outset, to spare the feelings of the men's families at home.

△ Roger Fenton (1819-1869):
Camp of the 5th Dragoon Guards
in the Crimea, during the
Crimean War, 1855.
Collodion negative, salted paper print.

◁ Mathew B. Brady (1823-1896):
Remains of Confederate Artillery Wagons
at the Battle of Chancellorsville,
3 May 1863. Albumen print.

This changed with the American Civil War (1861-1865). Here for the first time, thanks to Mathew B. Brady, we have an unsparing photographic record of the carnage and futility of war. Well known since the 1840s as a portrait daguerreotypist, Brady left his Washington studio and went into the field, on the Union side, with a team of twenty assistants, including Timothy O'Sullivan and Alexander Gardner. As he had already photographed many prominent figures in politics, Brady easily obtained official permission to follow the campaigns and work freely in the theatre of operations, carrying his photographic equipment in a wagon. But work in the field proved difficult and dangerous, and camera technique was still ill-adapted to recording the decisive, heroic moments. Yet what Brady did was remarkable enough, taking pictures of the officers and men, the preparations for battle, and the ruined towns and dead soldiers left in the wake of battle. All this he recorded in 7,000 negatives, many so

harrowing that they could not be put into circulation at that time. The heroic myths of war were exploded by Brady, who showed it for the hell it is.

From now on the camera became the privileged witness of events. Governments stepped in and sought to use it for propaganda purposes. Thus photographers followed the Mexican campaign and execution of Maximilian (1867), and Manet used these photographs to paint his *Execution of Maximilian*. Political events attracted photographers, whose pictures in turn could set a fashion or satisfy the public curiosity. Thus it comes as no surprise to find that the famous photographs which the Bisson brothers made of their ascent of Mont-Blanc followed by one year the annexation of Savoy to France (1860), an event which brought forth a spate of publications on this region.

Henceforth men's doings, achievements, wars, were systematically recorded by the camera: the construction of railways, the opening of the American West, the building of the Suez Canal and so on. The world was brought before the eyes of all.

Alexander Gardner (1821-1882):
The Field Where General Reynolds Fell,
Gettysburg, July 1863. Albumen print from
*Gardner's Photographic Sketch Book
of the War*, Washington, 1866.

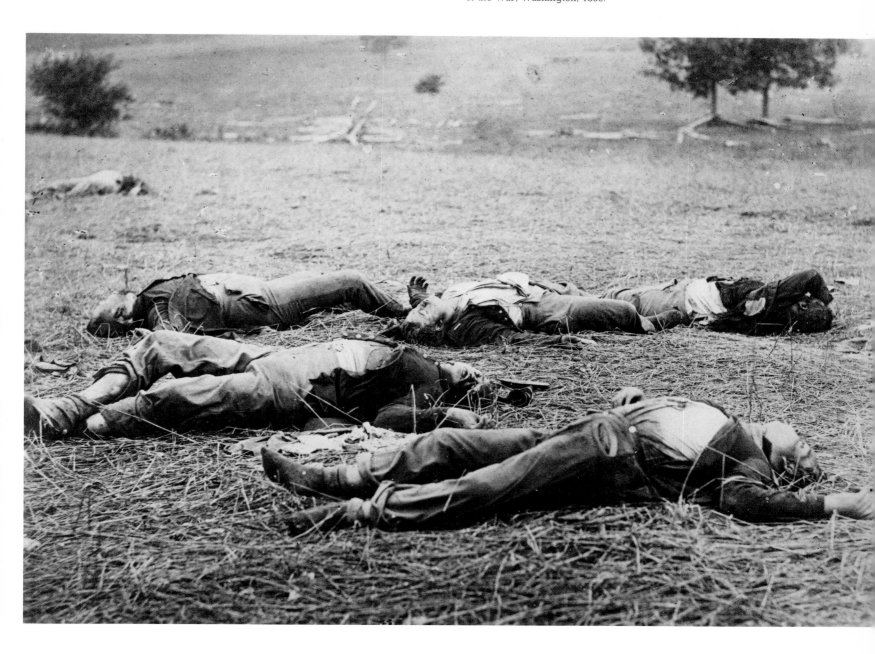

Etienne-Jules Marey (1830-1904):
Chronophotograph of a Seagull,
detail, 1886-1887.

▷ Giacomo Balla (1871-1958):
Pencil Study of Wheels
in Motion, 1912.

THE RECORDING
OF MOVEMENT
AND ITS
FASCINATION

To achieve its objectives photography had to be able to capture movement and this proved a difficult undertaking. The way towards the snapshot had been opened by the painters, by Courbet, then Manet, who showed the human figure off guard, unconscious of being seen.

In an increasingly production-conscious civilization in which time assumed a new value, the recording of movement became a primary aim. Stimulated by a steady succession of technical improvements, photography came forward as the first medium of expression to reveal the space-time dimension. The measurement of distance by speed became an essential notion by 1900, and from there to the fourth dimension was but a step.

This conquest of movement could only be launched on the strength of a keener awareness of modernity. Following the painters, photographers broke away from the aesthetic of the happy medium, neither realist nor idealist, which had prevailed in the 1850s and had required them to refrain from anything that might go counter to propriety and established values and habits. The observation of reality led them on to the possession of reality. While technically it was still impossible to go beyond the set pose, many photographers sought to capture real life without recomposing it in the studio, to achieve that modernity called for by Baudelaire[1] which was "based on the circumstantial, on period, fashion, morals, passion." Only a bold artist could throw off the weight of tradition, as Edmond Duranty[2] pointed out in 1856 with reference to Courbet: "It takes immense genius to reproduce simply and sincerely what one has before one's eyes," because "three hundred years of an artificial artistic schooling have made contemporary painters powerless. They are men who have recoiled from their own time and imagine that they better understand the past, which they have not seen, than the present in which they live and move. Such men cannot be absolved from lack of intelligence... In what way are we less interesting than the men before us?"

It was Manet, Degas and Monet who were to impose this taste for what was alive and modern. In 1861, with his *Concert at the Tuileries*, Manet offered the first example of an image deliberately left uncomposed. Refusing to arrange the scene before him within the frame of the picture, he caught it at a glance, in an unusual way, from close at hand, as if he were one of the crowd. This integration of the spectator into the subject implies that the scene depicted continues its life in all directions. The picture offers as it were a "slice" cut out of life, and this impression is enhanced by the unexpected attitudes. Even in the foreground are people turning their back to us; children are caught in all the abandon of their games; no one is conscious of the painter's eye upon them.

In his review of the 1866 Salon, Emile Zola[3] insisted on the need to go beyond "realism" by refocusing attention on actual life: "The word realist means nothing to me, because I would subordinate reality to temperament. Give me what is true and I applaud; but give me what is *individual and alive* and I applaud even more." Zola developed the same idea in *L'Evénement illustré* of 23 May 1868: "It is not for me to plead here the cause of modern subjects; that cause was won long ago. No one would venture to maintain that the present time is unworthy of the artist's brush." The conquest was complete as regards subject matter; it was still to come as regards the way of seeing, and it came with the impressionist generation—artists who, precisely, were fascinated by the implications of movement. In his book on the Impressionists, *La Nouvelle Peinture* (1876), the novelist and critic Edmond Duranty was explicit: "What we require is the special note of the modern individual in his clothes, in

Edouard Denis Baldus (1815-1882):
The Chantilly Viaduct, 1855.
Print from paper negative.

the midst of his social habits, at home or in the street... The pencil shall be dipped in the *stuff of life* and we will no longer see merely compass-drawn lines but *animated* forms." This taste for movement and the open air and the ever changing forms of nature which characterized Impressionism was shared by the most inventive photographers. Duranty had no doubt about the convergence between them: "Assuming, for example, that at a given moment one can get a colour photograph of an interior, the result will be a perfect accord, a true and typical expression, with all things attuned to one sentiment." But he showed that he had no inkling of the forthcoming developments in photography, for he went on: "Observation has to make up for those *instantaneous* means of execution which we do not possess, and memory has to supply the colours which we are unable to render." Colour photography was still some way off, but the instantaneous rendering of movement was achieved in 1878 by Muybridge, in his amazing sequence of locomotion pictures of a galloping horse.
Between 1860 and 1870 many technical improvements were made. To catch the drift of a cloud in the sky, the surge of the breakers by the sea, the movement of a man walking, was very difficult for the generation of Le Gray and Nègre; it could only be done by moving the lens as far away from the subject as possible. Many obstacles had to be overcome before the photographer acquired the freedom of the painter's eye: the time it took the hand to remove the lens cap and put it back on; the slow reaction of the negatives; the bulkiness of the camera equipment. Not until about 1880 did snapshot photographs become a reality. The city streets photographed before that time usually look deserted, the negatives being unable to record a moving figure otherwise than by a slight blur. But there had been some exceptions. As early as 1855 Auguste Bertsch had so much improved the speed of collodion plates that he had reduced exposure time to one-quarter of a second. He gave a demonstration in that year, photographing one of the Paris toll-gates: here for the first time moving figures were distinctly recorded.

The capturing of movement was not only a technical problem of fixing whatever might be moving before the camera lens; the discovery of the dynamism of the spectator was equally important. To convey the illusion of seeing while being in motion oneself: this idea arose from a new awareness of reality; it changed the traditional relation between seer and seen and renewed the space and composition of images. Here again painting showed the way, with the Impressionists. While the photographer was still burdened with a heavy camera standing on a tripod, the painter set up his easel freely in town and country, seeking to record his impression, looked at his motif from new angles and patterned it more boldly. A comparison between Monet and Baldus is enlightening. Trains were a prominent feature of modern life. Baldus photographed them to spectacular effect but in a stereotyped way. Monet conveyed their dynamism and suggested the oblique line of sight that we have of things when we are moving. Monet was the first to paint his pictures from start to finish in the open air. He thus perceived the change of appearances in varying conditions of light, whose shifting effects he captured, and so discovered that light is not tonal value but colour. To render it he used small touches of unmixed pigments—the so-called divisionism so characteristic of Impressionism, and so different from the traditional technique of smoothly blended brushstrokes. Captivated by changing light, running water, shifting skies, Monet sought to render not so much instantaneity as change itself. For life was in this multiplicity of movement. The Impressionists, wrote Duranty in *La Nouvelle Peinture*, ''have tried to render the walk, movement, bustle and crisscross of passing figures, just as they have tried to render the trembling of the leaves, the ripple of water, the vibration of air saturated with light.''

Claude Monet (1840-1926):
The Railway Bridge at Argenteuil,
c. 1873. Oil painting.

Emile Zola (1840-1902):
The Paris-Rouen Train, c. 1895.
Print from glass plate.

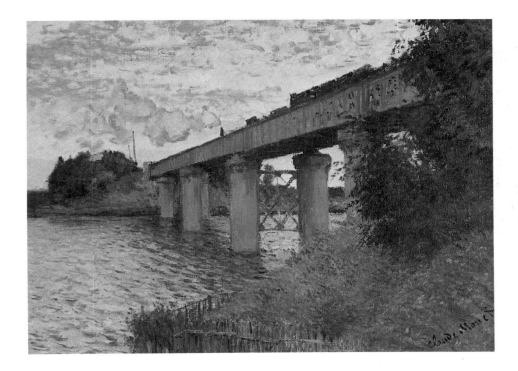

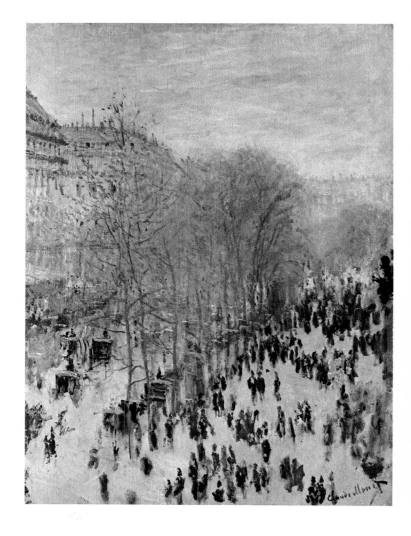

△ Claude Monet (1840-1926):
Boulevard des Capucines, Paris, 1873.
Oil painting.

◁ Auguste Bertsch (?-1871):
Paris Toll Gate, 1855.
Two snapshots, collodion negative.

In the 1860s cityscapes were popular. Such photographs were taken from an upper-storey window, thus removing the subject to a certain distance from the lens—a necessary condition for distinctness. The pictures obtained with the stereoscope were much superior to others. The subject seen from above, along a plunging line of sight, was not new; painters from Corot onwards had often adopted this viewpoint. But stereophotography became the fashion in the 1850s and '60s. And paradoxically it was this "solid" image, giving the illusion of relief, that introduced movement into photography.

Sir Charles Wheatstone defined the principle of stereoscopy about 1835: he showed that by making two drawings, one reproducing what the left eye sees, the other what the right eye sees, one obtains the illusion of relief, the space between the eyes giving two slightly different viewpoints of the subjects. The conclusive demonstration was given in 1844 when Sir David Brewster, already the inventor of the kaleidoscope, built an instrument with two lenses. This lenticular stereoscope was taken up and industrialized in France by the optician Jules Duboscq. He found that he obtained greater distinctness on glass than on paper; and because the images were small (making for easier handling, quicker preparation and shorter poses) and because the focal length was short, the stereoscope gave an instantaneous view, tantamount to a snapshot.

One of the first snapshots dates to 1855. This was a stereoscopic view by Charles Nègre, who by chance had trained his camera on a horse in front of his house in Paris, just as it slipped and fell on

The stereoscopic view,
forerunner of the snapshot

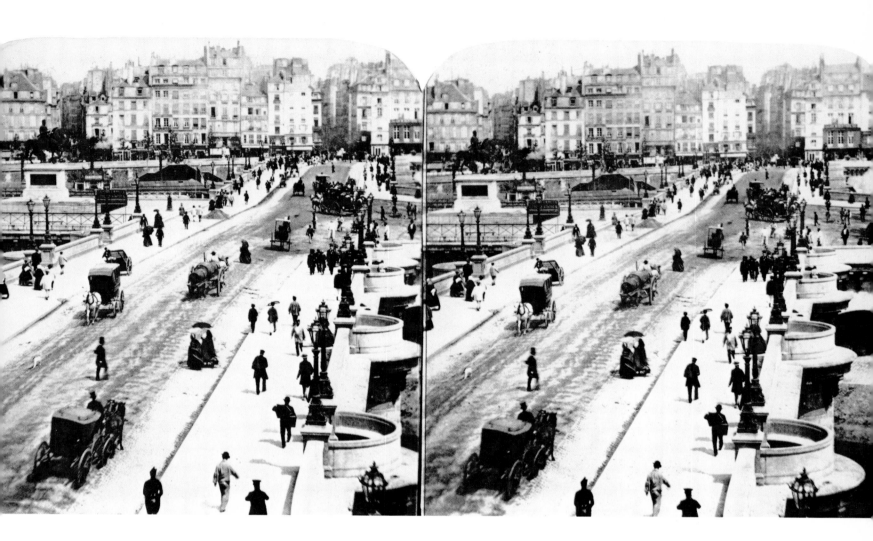

Hippolyte Jouvin:
The Pont Neuf, Paris, 1860-1865.
Stereoscopic plate.

the wet street. In 1860 appeared a series of Paris street scenes by Charles Soulier and C. and A. Ferrier which were remarkable for the sharpness of the image. The exposure time was a fraction of a second, so that the horse-drawn vehicles and hundreds of strollers in these panoramic views were fixed on glass with scarcely a blur. Also dating from the early 1860s is an album of 197 stereoscopic photographs by Hippolyte Jouvin, called *Vues instantanées de Paris*. Baudelaire[4] remained unconvinced, dismissing this fashion in a curt phrase: "Thousands of eager eyes peered into the holes of the stereoscope as into the skylights of infinity."

Stereoscopic views counted for much in the popularization of photography. They were published by the million, in series devoted to cities, countries, historic buildings, the Holy Land and a variety of other subjects; some series even made up imaginary stories. The illusion of relief is utterly convincing. In its popularity, the stereoscopic view heralded the great vogue of the postcard. It had the further advantage that its negatives could be and were developed on paper.

Here a significant comparison between photography and painting suggests itself. At the very time when photography was improving fast and was about to overcome the hitherto blurred image of moving subjects, the impressionist painters were reinventing the blurred image in an effort to convey a more accurate perception of movement. And visitors to the first impressionist exhibition (Paris, April-May 1874) were indignant with Monet for reducing the figures in his *Boulevard des Capucines* (1873), seen from above, from a distance, to a few blurred brushstrokes devoid of detail.[5]

Much has been written about Degas's connections with photography—too much, and all too often without verifying the actual facts. It is true that for years he collected photographs, but just as he collected all kinds of pictures of his time, such as Japanese prints, which in fact liberated his imagination and confirmed his intuition much more effectively than photography. It is also true that Degas himself practised photography, but only from the time, in the 1890s, when the camera had become accessible to all; and by then he had long since worked out his modern way of seeing in his paintings. It may also be asserted that his photographer's eye was much more conventional than his painter's eye.

Of all the artists of his time Degas was the one who had the keenest eye for modern life, the keenest sense of modernity which he developed to its ultimate consequences. Manet had already introduced contemporary subjects, and treated them with a new sobriety of representation. But it was Degas who

Clementina, Viscountess Hawarden (1822-1865):
Girl in Fancy Dress by a Mirror, c. 1864.
Albumen print from glass.

totally changed the relation between seer and seen, between subject and object, depicting contemporary man in his everyday life. He was the first painter to depict movement while being himself in movement. In perspectival vision, as it prevailed in painting and even more in early photography, the spectator kept his distance and brought the object forward into his field of observation, this permitting him to plot it out and arrange it to his convenience. An arbitrary and not really natural state of affairs, since reality associates the viewer with the object viewed and integrates him into the world: the object is approached by the movement of the subject. This is the reality that Degas discovered, and he translated his mobility as a viewer into a variety of compositions, remarkable for the unusual viewpoints, the unexpected cutting-off, the steep or plunging line of sight. We have been accustomed to this novel way of seeing by photography and cinema, which have taken it up and systematically exploited it, but when introduced by Degas it was disconcerting and bewildering.

Degas had the genius to renew the way we look at things, to multiply surprise effects, to find the angle that shows things in a new light, the distance that enlarges knowledge. Recording what he saw without arranging it, conscious of the actual distance separating him from his model, he made play with gaping or looming foregrounds, introduced the significant void into painting and so established a new relation between the figure and its milieu. Till then the milieu had been alien to the figure; now it became the field of its presence, the place of its action.

Even in his early pictures of the 1860s, one feels the interest Degas took in the movement of the spectator, but not till 1872 does one find a systematic use of off-centre effects. As his vision broadened he was led on to the high viewpoint, the steep line of sight—visual effects inevitable in the theatre or music hall, which he gradually extended to all subjects, to renew the viewer's grasp of them. No photograph of the period achieves the direct vision and eye-riveting effects that Degas achieved in his circus pictures and even in so simple a theme as his *Woman in the Tub*.

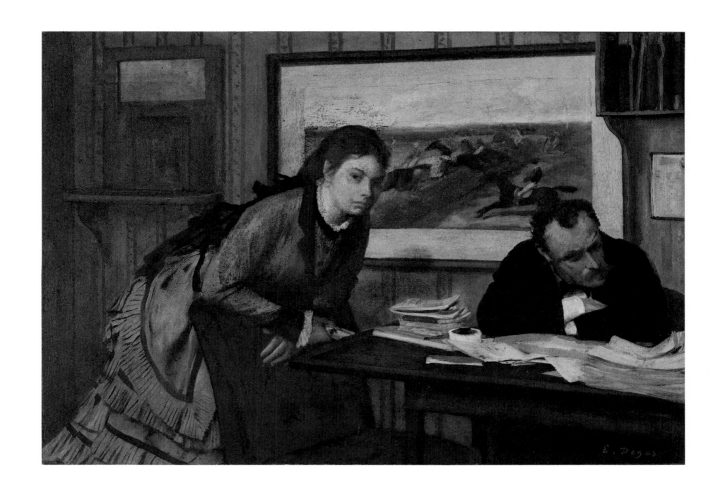

Degas invents the modern way of seeing

Edgar Degas (1834-1917):

Sulking, 1873-1875.
Oil painting.

Self-Portrait with Madame Halévy, c. 1895.
Gelatin silver print.

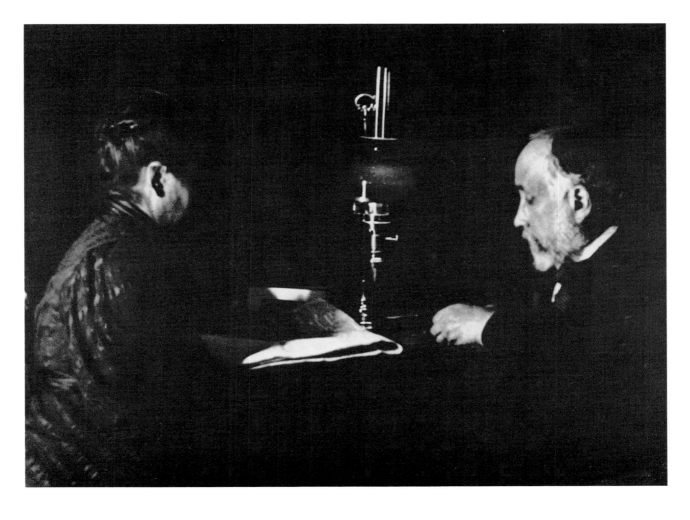

As achieved in painting or photography, the expression of movement soon took opposite forms. When the snapshot became photographically possible, it attracted many photographers, for the recording of gesture unawares may often yield surprising results. But did these instantaneous pictures really translate movement? They were scientifically accurate and went beyond the limits of optical perception, revealing what the human eye is incapable of grasping; but they produced a curiously static impression. Muybridge and Marey were conscious of this, so much so that they devised, independently, a systematic montage of snapshots in order to transcribe movement. For in the rapid sequence of moments which constitutes movement, the camera singles out one, arresting it and holding it fast. Lifted from the context of its before and after moments, the snapshot may be disconcerting. Thus in the case of a leaping figure, the puzzled viewer may wonder how the mass suspended in mid-air can escape the pull of gravity.

Did instantaneous pictures translate movement?

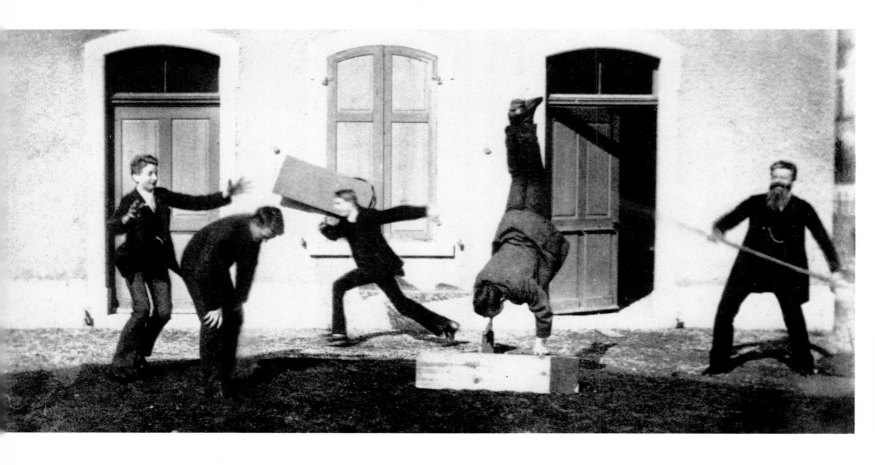

The painter, for his part, has to meet different requirements, both as regards perception and execution. To grasp the specific nature of a movement, he has to carry out precise and searching analysis, and he has to carry it out in a brief moment of time, as his eye takes in the figure. Because what he sees is its transformation and displacement, he restores its continuity on canvas, pieces together the sequence of moments which recreate movement in its continuity. "Movement by itself," wrote Matisse,[6] "is unstable and is not suited to something durable like a statue, unless the artist can convey his consciousness of the complete action of which he represents but one moment."

This is what Degas did, and Lautrec too. The attitudes they give their figures in movement may never have existed, but they are the more convincing because they translate an actual time-sequence; they do not demonstrate movement, they express it. Degas singles out the most significant moment, the extreme attitude. The choice of subjects is in itself significant. He focuses his eye on the ballet dancer, not only for the sake of her movement, but because she expresses it through a code of gestures which enhance that expression. Then, when he turns to subjects taken from everyday life, like the woman taking a sponge bath in a tub, he singles out the extreme attitude, the unexpected and even unperceived instant. "Till now," he wrote, "the nude has always been represented in poses which imply a public... Here is one of mine washing her feet, and it is as if you were looking at her through the keyhole."

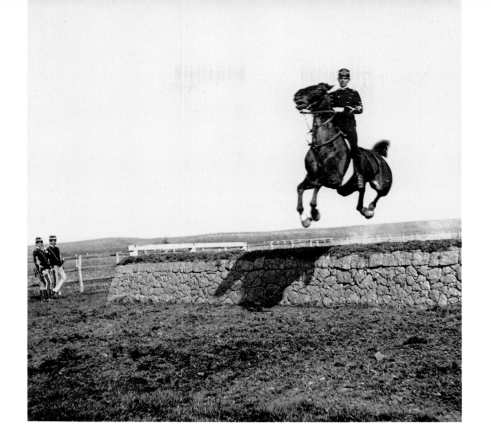

Count Giuseppe Primoli (1851-1927):
Horseman Jumping at Tor di Quinto.
Bromide print.

Alfred Ehrmann:
Skipping, c. 1892.
Bromide print.

◁ Johann Link (1819-1900):
Snapshot, 1890.
Bromide print.

Anonymous:
Bullfight, Nîmes, 1894.
Stereoscopic plate.

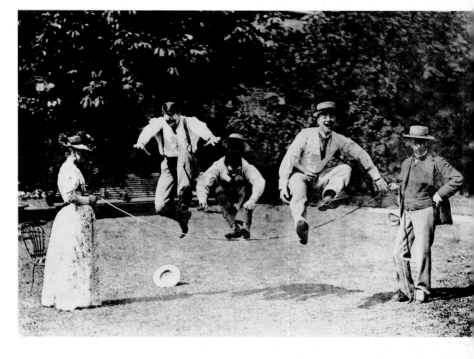

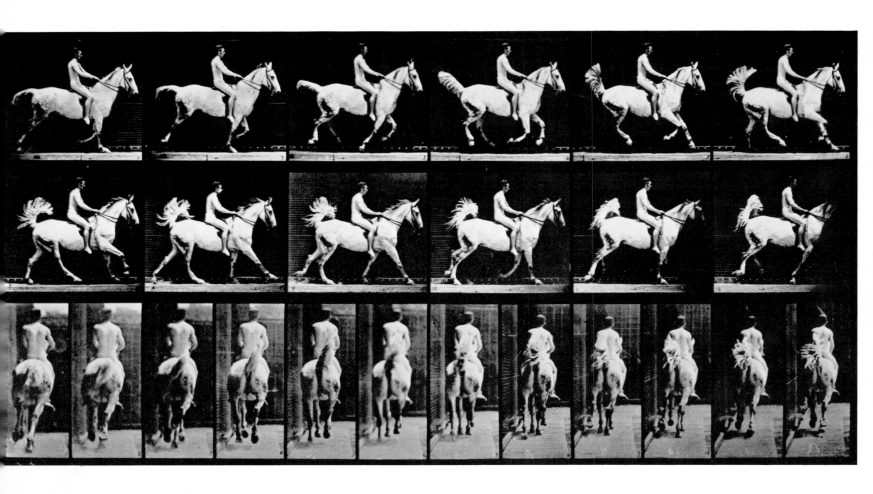

Muybridge,
the first photographer
of movement

Born in England, at Kingston-upon-Thames, in 1830 (his real name being Edward James Muggeridge), Muybridge went to the United States about 1852. There he made his name as a professional photographer, famous for his views of the Yosemite Valley taken in 1867. In 1868, just after the purchase of Alaska from Russia, he was commissioned by the U.S. government to photograph the Pacific Northwest. In 1872 Leland Stanford, the railroad builder and former governor of California, who had a horse-breeding farm at Palo Alto, called him in to demonstrate the actual position of a horse's legs during the trot, canter and gallop; and for this Muybridge devised a system of triggered shutters on a row of cameras. Stanford is said by some to have had a wager; by others, to have had a book in mind on the subject; by others, to have been intent on verifying certain statements by the French physiologist Etienne-Jules Marey. That Stanford drew Muybridge's attention to Marey's experiments with movement (to which Marey had not yet applied photography) is attested by a letter of 1879 from Muybridge to Marey. [7] It is a fact, too, that Marey only turned to photography after seeing Muybridge's early pictures of animal locomotion.

In 1872, while working with Stanford's thoroughbred *Occident*, Muybridge obtained the first instantaneous photographs of a trotting horse, showing all four legs off the ground. His experiments were broken off by a personal tragedy: Muybridge shot his wife's lover, stood trial and was acquitted by a California jury, but he left the country for a couple of years. Returning in 1877, he resumed his experiments the following year at Stanford's Palo Alto breeding farm, setting up a row of twelve cameras, a little over two feet apart from each other, alongside the racecourse, mechanically triggered by trip-wires, or rather strings, placed in the horse's path. By this means he obtained a complete sequence of images and a break-down of the horse's movements. The photographs were published

in several scientific periodicals in the United States, England and France. Muybridge went on to a whole series of experiments in animal and human locomotion, using a battery of as many as twenty-four cameras. His studies of consecutive movement in animals, birds and humans were published in a series of books, the most comprehensive being the eleven folio volumes of his *Animal Locomotion*, published in 1887 under the auspices of the University of Pennsylvania.

Through the publication of his 1878 photographs in the French scientific weekly *La Nature*, Muybridge got in touch with the physiologist Marey. As a result he paid a visit to Paris in 1881 and gave a demonstration of his methods and results in Marey's laboratory and also in the studio of the painter Ernest Meissonier. He projected his photographs with an instrument of his own invention, the zoopraxiscope, a kind of projection lantern. The rapid sequence of instantaneous photographs, as thus projected for the first time, produced the illusion of movement, to almost cinematic effect.

Muybridge's pictures, reducing the subject to a system of signs, created a sensation. Their sequential projection destroyed the traditional conception of space and pointed towards the new notion of space-time. Degas is known to have made some drawings after Muybridge's photographs, his purpose being not to take them as models but to measure the gap between this scientific revelation of a moving horse's actual movements and the limited human perception of them.

◁ Edgar Degas (1834-1917):
Dancers, 1899.
Pastel.

Eadweard Muybridge (1830-1904):

◁◁ Horse in Motion with Male Nude Rider.

▽ Draped Female in Motion.

Illustrations for *Animal Locomotion*,
Philadelphia, 1887.

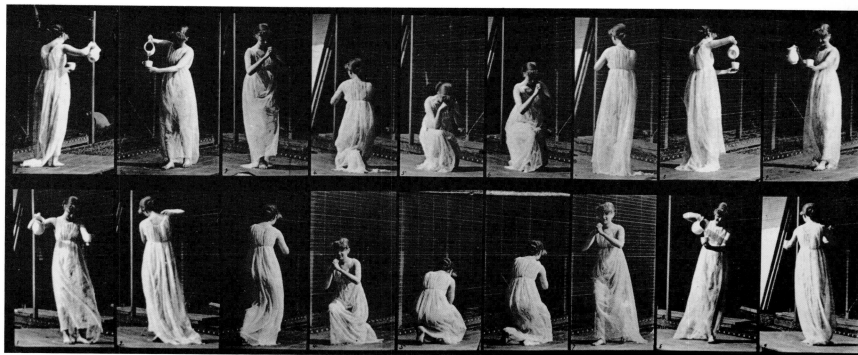

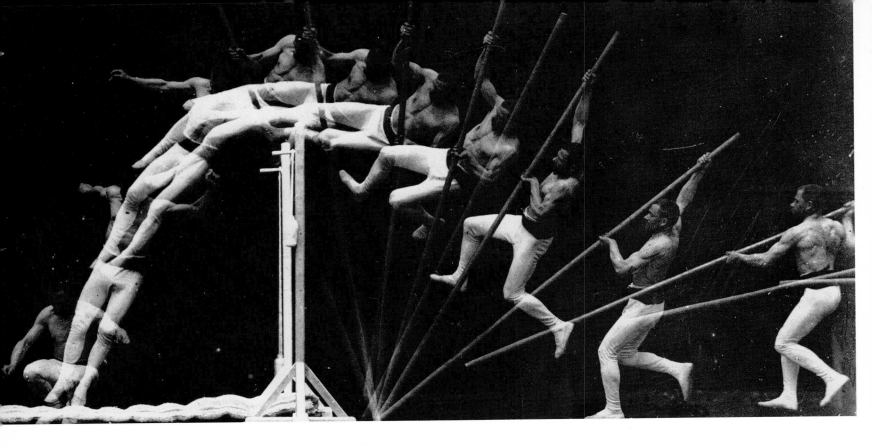

Chronophotography

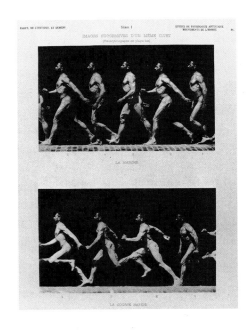

Chronophotography, the system invented by Etienne-Jules Marey, made the movement even more explicit by showing each position of a moving body in relation to all other positions on the same plate. Born at Beaune in 1830, Marey won a high reputation as a physiologist after publishing some studies on the circulation of the blood. Appointed professor at the Collège de France in 1868, he devoted himself to the study of heart movement, muscular contraction, bird flight and all forms of organic movement. The initial results were published in *La Machine animale* (1873). Having the mind of an engineer, he devised mechanical instruments of his own to record organic pulsations and physiological structures, publishing[8] his findings in *La Méthode graphique dans les sciences expérimentales, et particulièrement en physiologie et en médecine* (1878). After seeing the horse-in-motion photographs published by Muybridge in *La Nature* (14 December 1878), Marey turned his mind to photography as an instrument of demonstration and research. By 1882 he had invented a "photographic gun," the forerunner of his chronophotographic technique. Till 1890 he used glass plates, thereafter film.

A disciple of Claude Bernard, Marey developed the science of physiology by a series of mechanical experiments. For him "each bodily function can be associated with a special mechanical device"—and these devices he made himself, over the years, for the detecting and recording of organic movement. The camera for him was one more such device, in the service of experimental science. As he wrote in 1885: "I turned to photography for the solution of certain problems which had eluded

the processes of recording movement by mechanical means."[9] In fact he went much further than that, and his photographic work, because governed and shaped by an absolute respect for truth, became genuinely creative, genuinely artistic. In this he was not alone: at this period in the history of photography, several researchers devoid of any artistic bent or purpose, intent only on scientific truth, proved themselves to be camera artists. It is not too much to say that Marey's achievement confutes the forecast made by Baudelaire: "It is self-evident that industry, if it breaks in upon art, will become its deadliest enemy. If photography is allowed to substitute for art in some of its functions, it will soon have supplanted art or completely corrupted it."[10]

By inventing the photographic gun, Marey invented a veritable semiology of movement, reducing it to a sequence of signs which demonstrate the continuity of "that relation of space to time which is the essence of movement." At the same time, by giving "the senses an acuteness of perception which nature had denied them," he introduced a new concept of space which was destined to have many consequences in modern art. With Marey's photographic gun, we have the beginnings of the hand camera. He obtained his first results with it in February 1882: the break-down of a bird in flight, seen in a continuous sequence of images, taken at a shutter speed of 1/500th of a second. The advantage of this camera, as he pointed out, was to bring together "on a single plate a series of successive pictures, representing the different positions which a living creature moving at any speed has occupied in space, over a series of unknown moments."[11] Thus he obtained, for the first time on one plate, an overall view of the successive positions in the trajectory of a moving body in space. Marey's

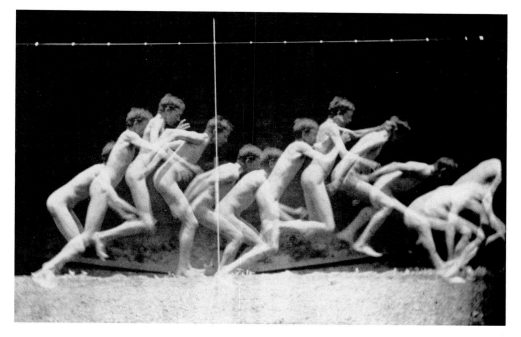

Thomas Eakins (1844-1916):
Chronophotograph of a
Distance Jumper, 1884.

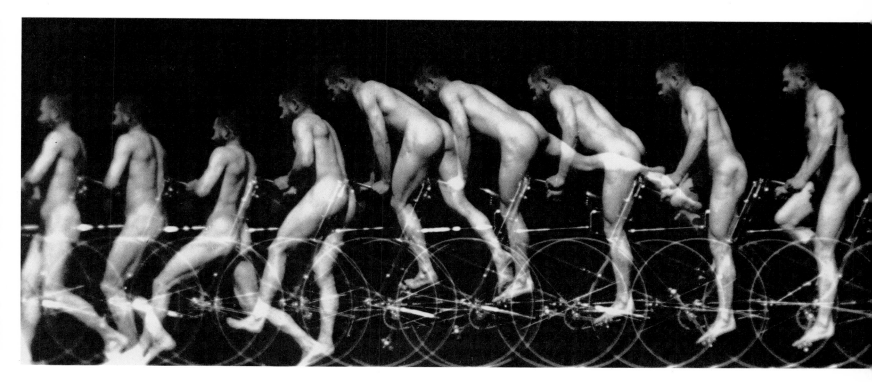

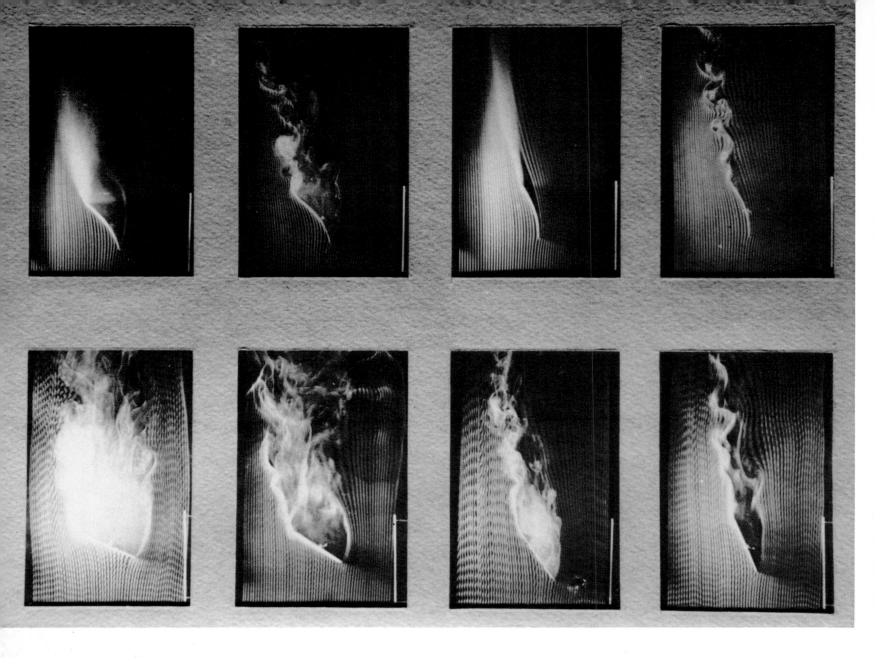

Etienne-Jules Marey (1830-1904):
Movement of Air against Bodies of Various
Shapes placed in a Field of Parallel
Streaks of Smoke, 1900-1901.
Chronophotographs.

Exploiting the space-time concept

photographs of 1885, of a man wearing a special costume and moving against a black background, entirely renewed the understanding of the mechanical functions performed by human muscles and bones. His invention of a chronophotographic projector in 1892 pointed the way to the modern cinema camera. Marey also used photography for the study of moving objects and the dynamism of fluids.

The experiments of Muybridge attracted the attention not only of Marey in Paris, but also of the American painter Thomas Eakins in Philadelphia. Keenly interested in human anatomy and locomotion, and himself a skilled photographer, Eakins invited Muybridge to lecture in Philadelphia and helped persuade the University of Pennsylvania to finance the publication of Muybridge's book *Animal Locomotion*. Eakins, a painter first and foremost, intent on scientific realism, took photographs for the express purpose of using them as the basis for his paintings of moving figures and horses. He was one of the first painters to do so.

The first public showing of a motion picture was given by the Lumière brothers in Paris on 28 December 1895, but its invention had been foreseen for a long time. In 1845 the French novelist Champfleury wrote: "What would be our enthusiasm if we could see the progress made by the daguerreotype a hundred years from now. Then, instead of merely recording a scrap of life, the camera will set the whole of life moving and unfolding before the wondering eyes of our descendants... A story

or novel set forth by improved daguerreotyping would show us a series of scenes from life in which everything would appear clear and sharp, everything would come alive. Here would be art at its greatest."[12]

Curiously enough, the problem of cinema projection was solved long before the problem of cinema photography. Devices for suggesting movement by a sequence of images were already known in the eighteenth century. In 1833 Joseph Plateau designed his phenakistoscope, in which figures on a disk seen successively through a slit gave the impression of motion. About the same time the Austrian Stampfer invented stroboscopic disks, producing similar effects. The figures used in these early devices were of course drawings. Following the discoveries of Muybridge and Marey, photographs were used instead and similar experiments were made with them. Between 1891 and 1893 Edison invented the kinetograph and kinetoscope, and with these he was able to take and project a film of 1500 photographs at a speed of forty images per second; but the kinetoscope could only be used by one person at a time. Emile Reynaud, inventor of the praxinoscope in 1877, gradually improved it and by 1880 was giving public showings with it in Paris at the Musée Grévin. He projected animated drawings consisting of as many as 700 images.

The Lumière brothers came to cinematic exploration after a long experience of photography. Their father Antoine Lumière had opened the first French studio for the processing of gelatino-bromide dry plates, and his two sons Auguste and Louis were indefatigable experimenters. To Louis Lumière must go the main credit for inventing the cinema. He used perforated film-strips about fifty feet long, each carrying 900 images, and he projected them at a speed of fifteen per second. The success of his cinema was immediate and irreversible. So was the competition it met with: by 1896, one year later, 126 patents relating to motion pictures had been taken out. Among the photographic experiments leading up to the cinema, one in particular may be mentioned: the sequence of exposures made by Paul Nadar in 1886, showing his father interviewing the chemist Eugène Chevreul on the eve of the latter's 100th birthday. (It was Chevreul who had worked out the laws of simultaneous colour contrasts, applied in painting by Seurat.)

Etienne-Jules Marey (1830-1904):
Chronophotograph of a White Horse
on a Black Ground, c. 1886.

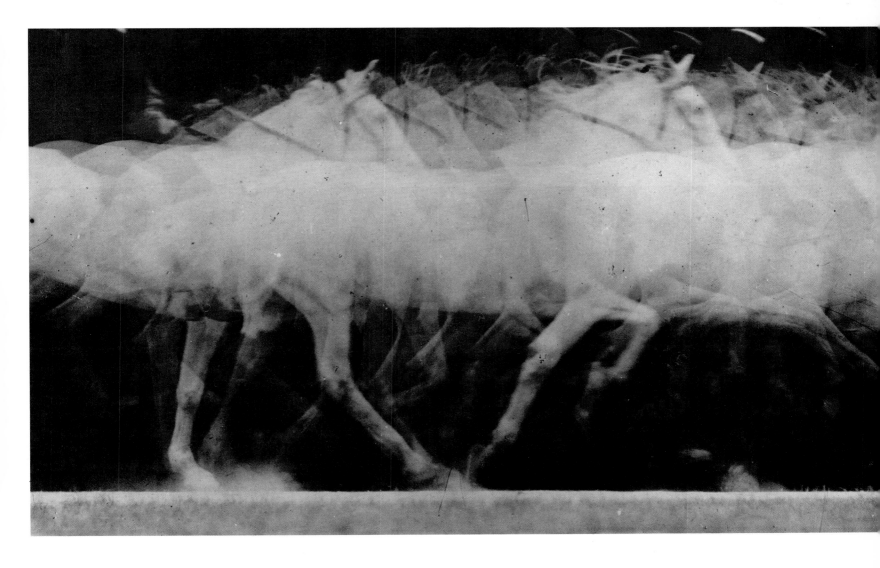

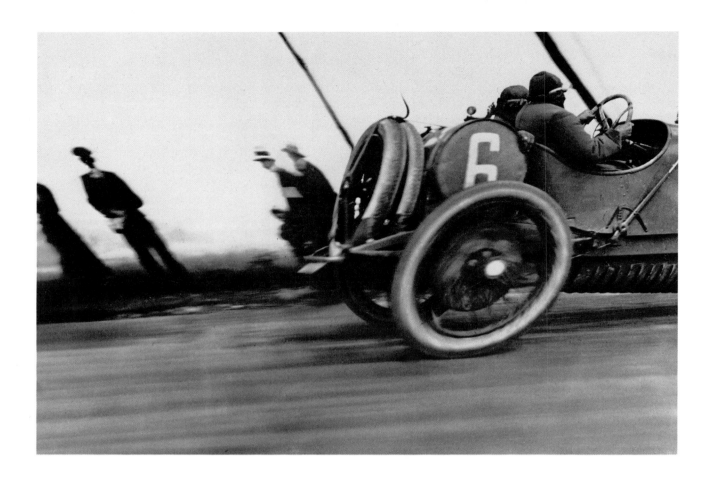

The snapshot and painters

The "time-span" of the cinema cannot be equated with the picture space of the painter, and Degas was well aware of this. He had by no means fallen under the spell of the snapshot, and now, in the 1890s, he was working on a series of pastels inspired by ballet dancers: with these he gave a different illustration of the movement corresponding analogically to that of the cinema. By focusing his eye on a group of ballerinas rather than the star dancer, Degas invented a sort of chronophotographic drawing. The development of a movement is illustrated by the progressive displacement of the different figures of his composition. The sense of dynamism is enhanced by the flawless integration of space and colour into the whole. Comparison between a Degas pastel and dancer photographs shows, significantly enough, that the greater expressive power still lay with the painter.

But from this point of evolution things changed and the rivalry between painting and photography became pointless. Photography went so far, so fast, that it soon contrived to show the invisible. But are things unseen by the naked eye still real? The answer was sometimes in the negative, for in going beyond the visible photography—which realism had justified—cast doubt on the very concept of reality. The reactions of Rodin are significant. As a sculptor preoccupied with moving figures, he defined movement in art as being "the transition from one attitude to another." He was thereby led to produce abstractions comparable to those arrived at by Degas. An example of Rodin's abstraction is his striding figure of John the Baptist—striding, but with both feet firmly planted on the ground. Here was an apparent contradiction with the artist's declared naturalism.

In conversations with Rodin,[13] Paul Gsell said to him: "When, in the interpretation of movement, the artist finds himself in complete disagreement with photography, which is an unimpeachable mechanical record, he is obviously distorting the truth."

"No," answered Rodin, "it is the artist who is truthful and it is photography that is deceptive. For in reality time never comes to a stop; and if the artist succeeds in conveying the impression of a movement carried out in several successive moments, his work is certainly much less conventional than the scientific image in which time is suddenly arrested."

So it was over the expression of movement that the first breach was made in the concept of realism. Where did the truth lie, in mechanical observation, in the visual perception, or in the impression? The debate proved unending as science and technics multiplied their demonstrations and proved that the very foundations of life lie beyond the scope of the human eye.

The photographic representation of movement failed to elicit the response from painters that might have been expected. Apart from a few advocates of illusionist or scientific realism like Eakins in the

United States or Meissonier in France, who both used photographic documentation and indeed copied photographs, the snapshot served above all to enable painters to measure the gap between the camera eye and the phenomenology of perception (such was the case with Degas and Lautrec) or to convince them that there was no further need of their brushes for the delineation of visual appearances. Only Seurat may have taken some account of chronophotography, in his final canvases like *Le Chahut*, where he developed the synthetic rhythm of a movement. But there is no proof that he did. Seurat's theory of a scientific aesthetic might have made him responsive to the demonstrations of Marey; but the latter had not yet visualized them photographically, and it seems more likely that Seurat took inspiration from the theories of dynamogenic representation put forward by his friend Charles Henry. It was not until later, when the consciousness of space-time had developed, that chronophotography made its influence felt in painting.

But meanwhile the snapshot was giving some surprising results—especially disconcerting in J. H. Lartigue's famous snap of 1912, showing the wheel deformation of a speeding car, or again in his 1929 picture of a racing car at Antibes. Put to the service of science, the photography of movement was developed to spectacular effect in the 1930s. Harold Edgerton, of the Massachusetts Institute of Technology, succeeded in recording the reactive movement produced by the impact of two heterogeneous bodies: the distortions of a tennis ball and the strings of a racket when they meet, or the splash of a drop of milk falling into a saucer of milk.

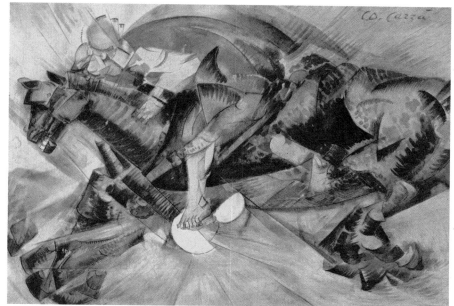

◁ Carlo Carrà (1881-1966):
The Red Rider, 1912.
Pen and watercolour.

Jacques-Henri Lartigue (1896):

◁◁ Grand Prix of the Automobile Club de France, with Delage Automobile, 26 June 1912.

▽ Circuit of Cap d'Antibes, with Type 37 Bugatti, 1929.

Prints from glass plates.

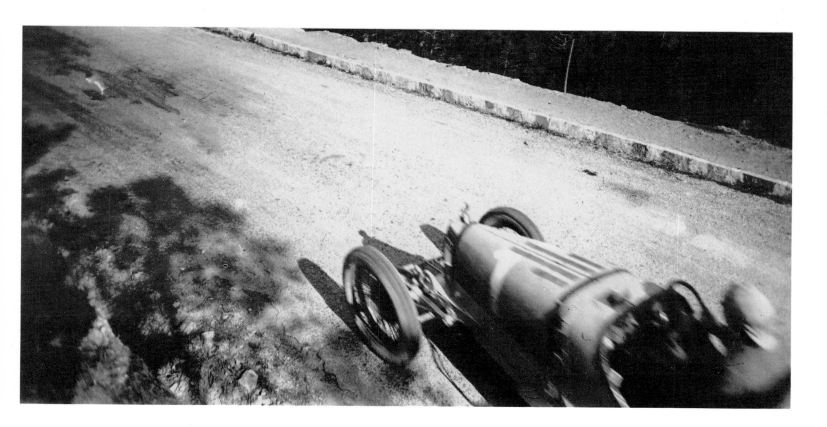

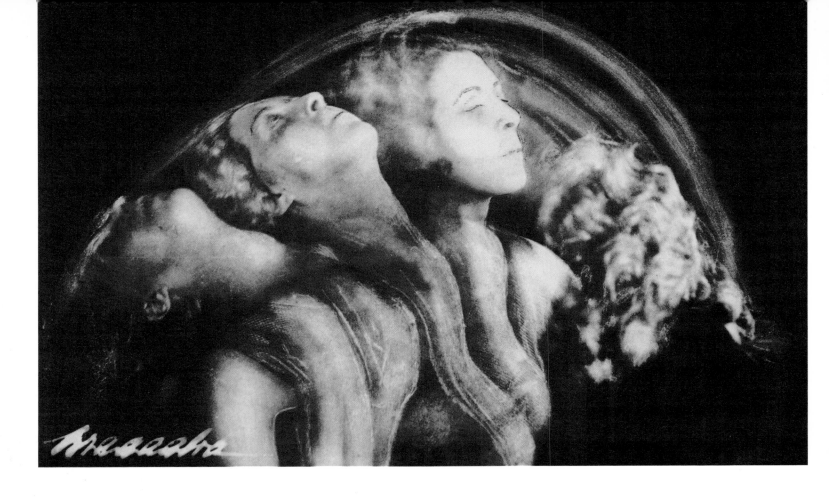

Arturo Bragaglia (1893-1962):
The Fan, 1928.
Bromide print.

Giacomo Balla (1871-1958):
Dynamism of a Dog on a Leash, 1912.
Oil painting.

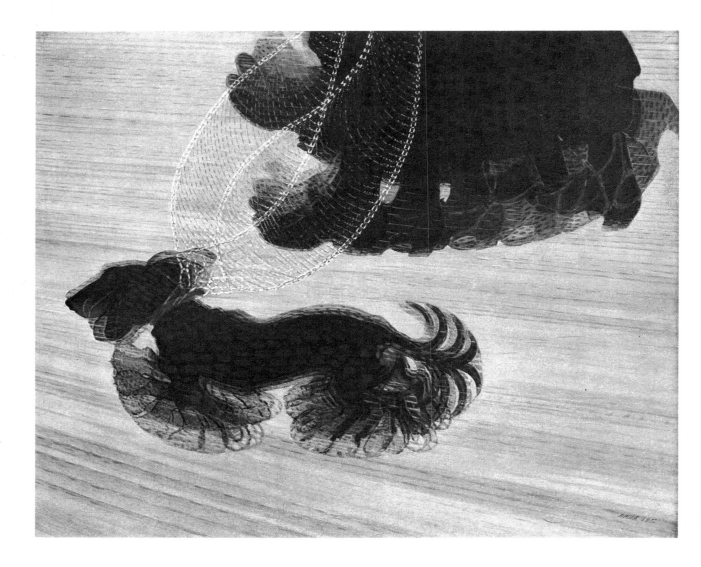

It was in the early 1900s that motion photography began to influence painters. When Frank Kupka, a Czech painter working in Paris, attempted to suggest movement, he was prompted by Marey's experiments. But he amplified the scientific data by a break-down of light, which he translated in terms of pure colours, whose patterns he carried to the point of abstraction.

The photographic analysis of movement naturally had an even stronger influence on the Futurists. A friend of theirs, the photographer Anton Giulio Bragaglia began in 1910 some photodynamic experiments akin to those of Marey. In 1913, developing a previous essay,[14] he published a book setting forth his ideas and researches: *Fotodinamismo Futurista*. Marinetti, the poet and spokesman of Futurism, tried to keep Bragaglia out of the movement, but his influence was strong and indeed determinant. The motion photographs of Bragaglia and his brother are distinguished from those of Marey by an emphasis on the continuity of movement obtained by a prevailing fuzziness which serves to link up each successive phase of the overall movement. In 1912 Balla used Bragaglia's photographs for his futurist paintings; and Balla made the most of colour in rendering movement. The reference to chronophotography was important for the Futurists, whose whole programme was centred on the representation of movement and speed.

Anton Giulio Bragaglia (1890-1960)
and Arturo Bragaglia (1893-1962):
The Cellist, 1913.
Bromide print.

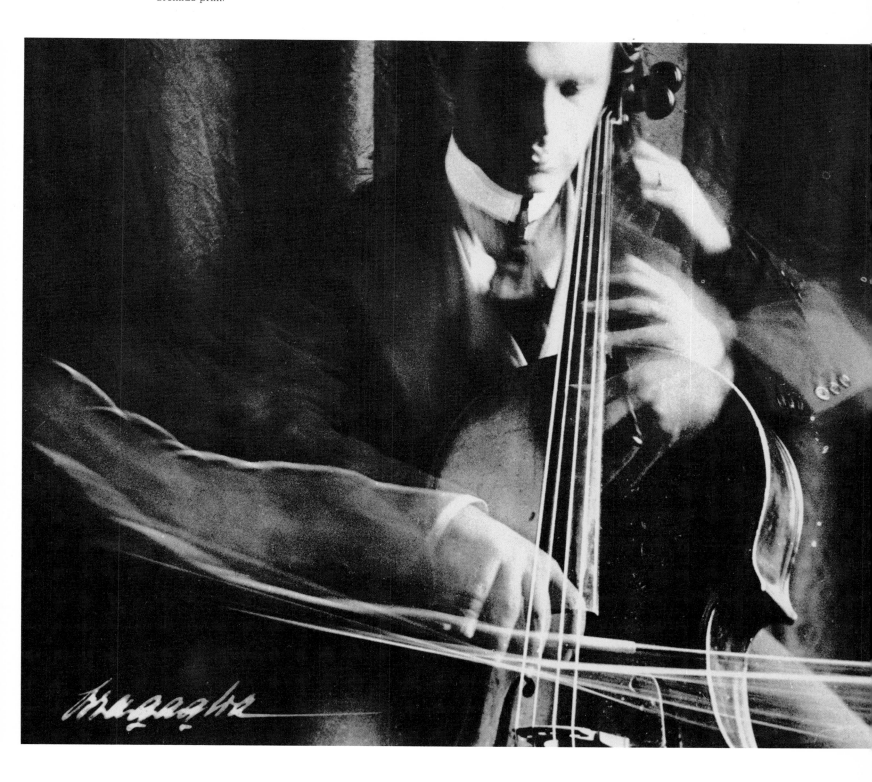

Marcel Duchamp (1887-1968):
Nude Descending a Staircase No. 2, 1912.
Oil painting.

The influence of chronophotography is evident, then, in the breakdown of movement as depicted by Boccioni, Balla, Carrà and Severini. The Cubists, and more particularly the Puteaux group, were also influenced by it. Braque and Picasso, taking over from Cézanne, had followed a line of their own: the movement of the viewer, multiplying his viewpoints on a given object and thereby modifying the relation between seer and seen. The Puteaux group,[15] headed by the three Duchamp brothers (Jacques Villon, Raymond Duchamp-Villon, Marcel Duchamp), put the emphasis on movement itself. Chronophotography having demonstrated the destruction of the unity of time, Marcel Duchamp drew the consequences and integrated time and space in his *Nude Descending the Staircase*, which created

a sensation at the Armory Show in New York in 1913. This painting testified to his search for a spatial organization based on kinetic elements and conveying an almost abstract representation of movement. Duchamp made no secret of the shock he experienced on seeing Marey's photographs, and the dotted curves setting off the hips of his *Nude* are a direct reference to Marey's movement diagrams. Jacques Villon and Francis Picabia were also keenly interested in chronophotography. The connection with Marey is pointed up by the fact that Picabia's grandfather, Alphonse Davanne, was an expert photographer; that Duchamp was Picabia's intimate friend; and that Davanne and Marey served together on the organizing committee of the Exposition Universelle in Paris in 1900. The systematic breakdown of movement practised by Duchamp and Picabia in their early pictures led on to their subsequent emphasis on machinery: mechanical elements implying an even more evident and symbolic sense of time liberated both painters from naturalism and sentimentalism.

Harold E. Edgerton (1903):
Swirls and Eddies of a Tennis Stroke, 1939.
Silver bromide print.

Anonymous:
Painter on the Banks of the Arve near Geneva, 1890.
Bromide print.

▷ Honoré Daumier (1808-1879):
Landscape Painters at Work, 1862.
Lithograph, second state.

PHOTOGRAPHY
AND
PAINTING

As soon as it appeared, photography was seen by some painters as a threat to their livelihood, destined, they feared, to provide those delineations of reality which they alone had provided hitherto; others, on the contrary, saw the specific features of the new medium, its usefulness as a supplier and multiplier of images, and took a keen interest in it. The underlying hostility to it steadily mounted and burst into the open with Baudelaire's review of the 1859 Salon, in which he refused to grant photography the status of an art. In this he made himself the spokesman of a widespread feeling and thereby provoked a rupture pregnant with consequences. In trying to prove him wrong, some photographers deliberately set out to vie with painters; and some artists felt impelled to react against photography, deliberately depriving themselves of the benefits or lessons which they might have drawn from the new medium.

What in fact had moved Baudelaire to denounce photography was his belief in the virtues of imagination, his conviction that it alone made the artist and that naturalism was bad art: "Imagination has taught man the moral sense of contour, of colour, of sound and fragrance. It created, at the beginning of the world, the analogy of metaphor... It creates a new world, it brings forth the sensation of the new." One may agree with him here, even while feeling that his conception of realism was too restrictive: "Of late we have heard it said over and over again: Copy nature and nature only. And this doctrine inimical to art is supposed to be applied not only to painting but to all the arts." Because he believed that even an "excellent copy of nature" could have nothing creative—but why could it not achieve the creation of a "new world" out of "accumulated materials"?—Baudelaire went on gloomily: "In these deplorable times a new industry has arisen which has contributed not a little to confirm the belief in this foolishness and to ruin whatever of divine may have remained in the French spirit... In painting and sculpture, the present credo of sophisticated people... is this: 'I believe in nature and I believe in nature alone (there are good reasons for this). I believe that art is and can only be the exact reproduction of nature... So that any industry which could achieve results identical to nature would be tantamount to absolute art.' An avenging God has granted the prayers of this multitude. Daguerre was its messiah. And then the multitude said: 'Since photography gives us all the wished-for guarantees of exactitude (they believe that, the fools!), art is photography!' "[1]

Baudelaire saw photography as a branch of industry, and that is why he indicted it. Industry "spilling over into art becomes its mortal enemy, and the confusion between the two prevents either from achieving its purpose. Poetry and progress each have their pretensions, and each hates the other with an instinctive hatred. When these two meet on the same path, one of them has to become a servant to the other." This assumption of incompatibility prevented Baudelaire from realizing that photography can be creative, over and above technique, by virtue of the photographer's eye, sensitivity and intelligence. He concluded: "If photography is allowed to substitute for art in any of its functions, it will soon have supplanted or corrupted art altogether... Let it rescue from oblivion the ruins, books, prints and manuscripts which time is devouring, precious things whose form is about to disappear and which demand a place in the archives of our memory—let it do that and it will be thanked and applauded. But if it is allowed to encroach on the domain of the impalpable and the imaginary, of all that owes its value only to the fact that man has put his soul into it, then God help us!"[1] In wishing to reduce photography to the level of a reproductive medium, Baudelaire went astray and the work of later generations has shown how wrong he was.

Painters and photographers aim at the same effects

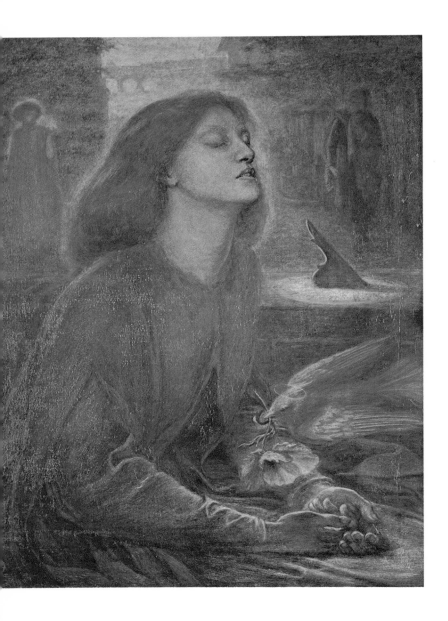

The relations and rivalries between painters and photographers proved fruitful; innovation thrived on them. As painters pressed on from naturalism to Impressionism, they grasped the importance of the constituent elements of the image and developed their expressive possibilities to the verge of abstraction. Photographers too explored and tested the specific features of their medium, bringing out the ways in which it differs from human perception. As the history of photography broadened and developed, they found their references not only in a certain idea of nature but also in the achievements of previous photographers, which led them to singularize their approach and vision. As it came to form a universal and collective memory-bank, photography modified the stock of knowledge and shifted the levels of experience, till it constituted an imaginary museum of images, unimaginable without the camera.

English art in the latter half of the nineteenth century reflects the new climate of the times, showing how that climate reshaped the aspirations of artists and consequently their forms of expression. From 1848 there came to the fore the Pre-Raphaelites, a group centring on William Holman Hunt, Dante Gabriel Rossetti and John Everett Millais. In revolt against academicism for both aesthetic and moral reasons, against what they saw as the degradation of taste, they wished to revive the moral and pictorial purity of the Quattrocento primitives, as exemplified in the Campo Santo frescoes at Pisa. They called for a fresh study of nature and the most careful delineation of it. Taking their subjects from Christian history and English literature, they charged them with symbolic meanings; but their concern for truth establishes a connection with the French realists of the same period, however different the latter's aims. Intent as they were on nature observation, the Pre-Raphaelites were led to paint out of doors, "directly and frankly" (in the words of Hunt), "not merely for the charm of minute finish, but as a means of studying more deeply Nature's principles of design, and to escape the conventional

◁ Lewis Carroll (1832-1898):
Beatrice Henley at Putney, 1862.
Albumen print.

▽ Sir John Everett Millais (1829-1896):
Autumn Leaves, detail, 1856.
Oil painting.

◁◁ Dante Gabriel Rossetti (1828-1882):
Beata Beatrix, c. 1863.
Oil painting.

◁ Anonymous:
Jane Morris Posing
for D.G. Rossetti, 1865.
Albumen print.

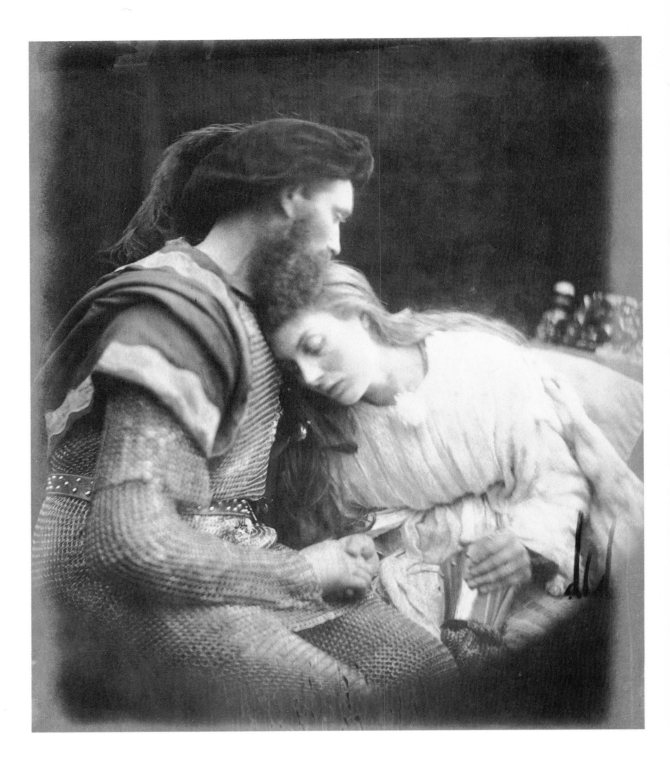

Julia Margaret Cameron (1815-1879):
''Lancelot and Elaine,'' William Warder
and May Prinsep, 1874. Illustration
for Tennyson's *Idylls of the King.*
Albumen print.

treatment of landscape backgrounds.''[2] Ruskin, coming to the defence of the group, explained to his readers that ''the principles on which its members are working are neither pre- nor post-Raphaelite, but everlasting. They are endeavouring to paint, with the highest possible degree of completion, what they see in nature, without reference to conventional or established rules.''[3] Their manner of seeing and working gradually commanded attention, and the way of ''precisionism'' was opened. But, in this direction, the painters were followed up and soon outstripped by the photographers.

A hundred years later, Pre-Raphaelitism strikes us less as a return to the sources, less as a renewal of the artist's relations with nature, than as the afterglow of Romanticism and a transition towards Symbolism. But the aesthetic bias of the Pre-Raphaelites shaped the Victorian way of seeing and thus acted powerfully not only on painters but also on photographers. Two of the greatest English photographers, however, were concerned not so much with probing into reality as with conveying their conception of it: Lewis Carroll and Julia Margaret Cameron. Like the Pre-Raphaelites, they organized for each picture a *mise en scène* which their technical ''awkwardness'' makes all the more moving.

Mrs Cameron, wife of a high official in the Indian Civil Service, was nearly fifty when she took up photography in 1863, after her return from Calcutta, and after settling at Freshwater in the Isle of Wight: "From the first moment I handled my lens with a tender ardour." She was influenced by the conceptions of the English painter and sculptor G. F. Watts, who was then best known for his large moralizing frescoes, imbued (as it seems to us now) with a cloying sentimentality. But while she took over certain subjects from Watts, she was able to transcend their literary content. She is best known for her portraits of her family and her friends, such as Browning, Tennyson (who lived near by at Farringford House), Darwin, Carlyle, Watts and Sir John Herschel, who in the 1860s sat for her in her Freshwater studio. "When I have had such men before my camera," she wrote,[4] "my whole soul has endeavoured to do its duty towards them in recording faithfully the greatness of the inner as well as the features of the outer man."

Her apparatus was rudimentary and even defective, she worked slowly and imposed hours-long sittings on her subjects; but the results are in their way unsurpassed. The Cameron portraits are often deliberately out of focus, and the resulting blur and strong chiaroscuro caused by the subdued lighting of her studio are characteristic of her style. In the opinion of Roger Fry, her portraits "bid fair to outlive most of the works of the artists who were her contemporaries."

Julia Margaret Cameron (1815-1879):
"Enid," Emily Peacock, 1874. Illustration
for Tennyson's *Idylls of the King*.
Albumen print.

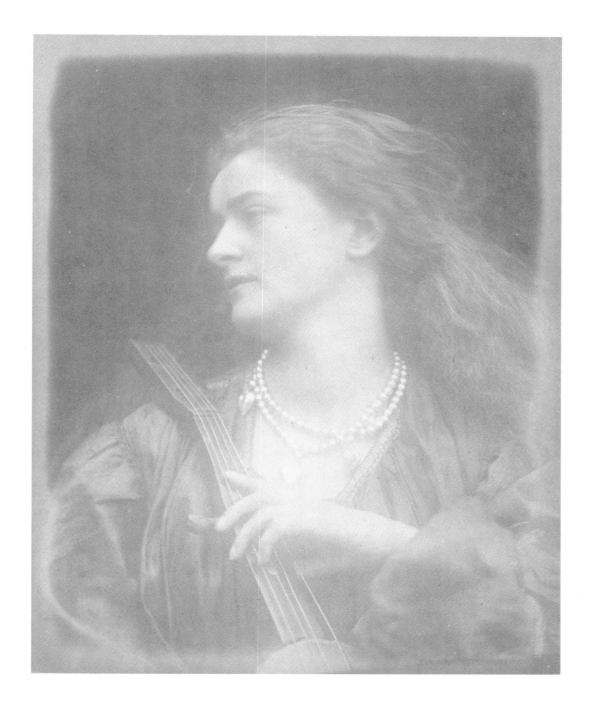

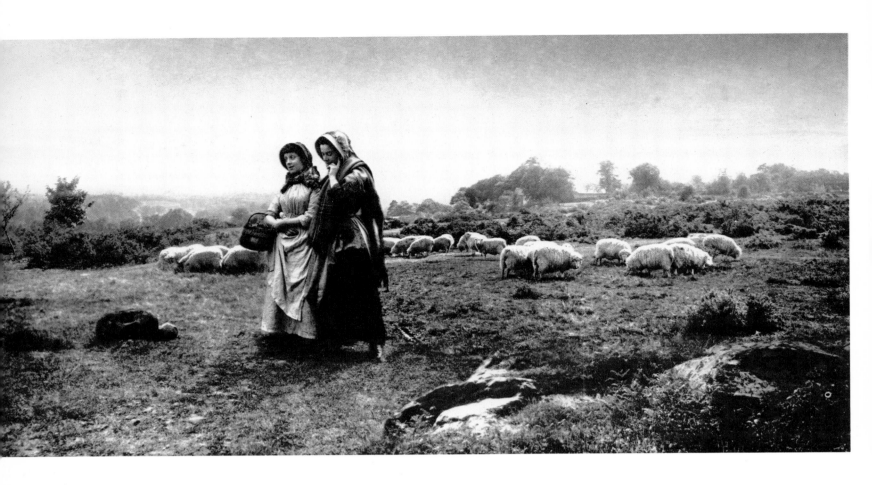

Photography as painting

The taste for allegory and literary effects so characteristic of the Pre-Raphaelites reappears, applied in different ways, in another English artist of the Victorian period: Henry Peach Robinson, who oriented photography away from the studied reproduction of reality which, for its inventors, had seemed its true purpose.

Robinson opened a studio at Leamington Spa in 1857 and made his name with the first of his composite photographs, *Fading Away* (1858). Made from five negatives, it represents a consumptive girl mournfully attended by her parents and sister. The public was struck by this deathbed scene and the realistic rendering of the languid girl, pillowed up beside a curtained window. Robinson deliberately aimed at art photography on a par with painting, which then meant academic painting, and he set out to reproduce the effects peculiar to painting. He was a prolific writer on his art, and his *Pictorial Effect in Photography* (1869) went through several editions in England and the United States and was translated into French and German; it is a handbook in which he sets forth the compositional rules governing his work—rules based on those of the nineteenth-century art schools. Robinson, preferring idealistic illusion to truth, oriented photography towards a dangerous aestheticism.

Robinson's composite photographs were the result of careful planning, based on a drawing of the overall composition in which he assigned every element to its place, worked out the setting in detail and tested the effect of various juxtapositions. Trained as a painter, he was well able to vie in his elaborate photographs with the academic painters of his time. But seen from the vantage point of today his photographs amount to little more than imitative and sentimental picture-making.

It was only long after the death of Thomas Eakins (1844-1916) that the quality and interest of his photographs came to be recognized: they seem to us a more creative achievement than his paintings. A thoroughgoing realist, and one of the foremost American painters of his generation, Eakins turned to photography fully conscious of its original and specific features, well understanding the enlargement of knowledge and acuteness of analysis which it afforded. Drawing was the painter's traditional means of recording his experience of nature and sketching out his pictures. Eakins took up photography as an extension of drawing, permitting a more accurate observation of reality and a sharper definition of it than painting could offer.

Eakins used photographs to begin with as a basis for his portraits, then for a more searching study of movement. He found that they revealed more than the naked eye can see, that they opened the way to the "verism" to which he aspired. American painting of the later nineteenth century aimed frequently at illusionism and *trompe-l'œil*, at depicting a "slice of nature" released from the thrall of time, visibly laden with a wealth of detail: a world seen as it were through a magnifying glass. For this purpose photography was the unsurpassable medium, as Eakins was the first to show.

Henry Peach Robinson (1830-1901):

◁ Carolling, 1887.
Platinum print.

▽◁ Pencil study for *Carolling*, 1887.

▽ Study of a Woman, exhibited in 1859.
Collodion negative.

In 1884, as head of the Pennsylvania Academy schools in Philadelphia, Eakins invited Muybridge to give a lecture and continue his experiments there. Familiar since 1879 with Muybridge's photographs of animal locomotion, Eakins wished to experiment on the same lines with human movement (since anatomy and life studies were the two main disciplines of traditional art schooling). Muybridge, in the 1870s, had shown the use that might be made by painters of his systematic breakdowns of movement, and though keenly interested in them Eakins was soon disappointed by the abstraction of Muybridge's shots which effaced the sense of time. To regain it, and in the interests of a greater accuracy, Eakins invented a camera similar to Marey's "photographic gun": a perforated disk permitting him to bring together on a single negative the successive phases of movement from different viewpoints, thus giving a continuous picture of the action.

Eakins never published his results. By his restrictive vision he limited photography to a merely preparatory element in the making of a painting. But he made lavish use of the documentation which he brought together, and photography enabled him to achieve a high degree of precision and made him aware of far more details in a moving body than his eye could ever have found in a "still life." Though Eakins failed to realize that photography can be an end in itself, a self-sufficing medium of expression, he printed his negatives with the utmost care on different kinds of paper chosen according to the effect he sought. As a result his photographs have the quality of fine prints. In this medium he was a bold innovator, bearing out the words of his friend Walt Whitman: "Tom Eakins is not a painter, he is a force." In his painting he kept to the aesthetic of his time; in his photographs and the use he made of them he showed his originality.

Eakins,
the aesthetic
of an artist

Thomas Eakins (1844-1916):
Boy Playing Pipes, c. 1900.
Study for his oil painting *Arcadia*.
Albumen print.

Thomas Eakins (1844-1916):

△ Amelia C. Van Buren, c. 1891.
Albumen print.

◁ Clara, c. 1900.
Oil painting.

The generation that followed the Impressionists had a different view of nature and art. Manet and Monet had focused on the visible world, intent on disclosing the mysteries of reality. The Symbolists turned away from it, intent on releasing the powers of the subjective self. For the artists who came to the fore between 1880 and 1900, painting was essentially a means of bodying forth ideas and feelings. They brought the subconscious into play by taking a different approach to forms and colours, by drawing on a fresh stock of themes. Avoiding the set formulas of academic art, and eager to transcend the limits of naturalism, these artists found a confirmation of their intuition in the reinterpretation they gave of the works of the past and above all in their discovery of non-European art forms. The Romantics and the Pre-Raphaelites reverted to the themes and style of early Renaissance or late medieval art. The Impressionists learnt much from Japanese prints. The Symbolists too looked to Japan, but other painters sought fresh inspiration in the art of India, of South America, of Africa. In these alien realms of expression they found stylistic abstractions and subject matter which facilitated their efforts to liberate art from naturalistic illusionism. Their access to those realms was through photographs, which provided an indispensable source of reference both to nature and to the art of the past. Photography acted as a working substitute for direct experience.

In the 1890s and the early 1900s a new mannerism prevailed in European art. Style and aestheticism reigned supreme, and some painters contrived to achieve them by way of photography. The use made of it by the Belgian artist Fernand Khnopff is particularly significant: he resorted to it for a distancing

The "distance" of the photograph

◁ Fernand Khnopff (1858-1921):
Arum Lily, 1895.
Tinted photograph.

▷ Alphonse Mucha (1860-1939):
Model in the Studio, 1899-1900,
posing for *The Spinner*, a Mucha
sculpture for the
Bosnia-Herzegovina pavilion
at the Exposition Universelle,
Paris, 1900.
Albumen print.

effect, as a basis from which he moved on to "disguise the rhetoric of reality and... to reinforce a system of signs."[5]

From the inertia inherent in the photograph Khnopff derives the inertia of his poetics, the pictorial arrangement which gives its true dimension to the mystery of being, to the enigma of existence. His photography was so important for him that he kept it secret all his life. When, after his death in 1921, his studio was opened, even his closest friends were surprised to find in it a Steinheil camera and a mass of photographs taken by himself. Yet, in a paper on Art Photography read before the Royal Academy of Belgium in 1916,[6] he had described it as merely "an agreeable pastime for an idler." For him, photography was a medium condemned to realism, while art should be idealistic, a "personal interpretation of one's deepest dreams." But a closer look at his statements shows that his animus was not against photography in general but "art photography" in particular—against the tricks and contrivances by which a photograph is deprived of its specificity and made to resemble a painting. "The artist (by which I mean the painter) creates," he wrote. "He is the master of his work in the fullest sense of the word: it is his creature; he can do what he likes with it, and modify any part of it as he pleases, to the very last moment." And this is precisely what Khnopff did as a photographer, arranging and modifying his subject to suit the idea he had in mind, setting a pose in such a way as to get the effect of distance and strangeness which he desired.

Khnopff illustrates the phenomenon described by Roland Barthes: "If the Photograph seems to me closer to the Theatre, it is by way of a singular point of junction: Death... Now it is this same relation that I find in the Photograph; however much alive one tries to see and conceive it (and this mania for 'aliveness' can only be the mythical denial of a deathly uneasiness), the Photograph is like a primitive stage, like a Tableau Vivant, the figuration of a motionless, made-up face behind which we see the dead." And Barthes says again: "The photograph of the deceased touches me like the deferred rays of a star."[7]

This concern to uproot reality from time also motivates the photographic work of Alphonse Mucha, a Czech artist who lived for many years in Paris. The camera gave him a means of seeing in silence, of standing over and above any contingency. He isolated his sitter in order to bring out the only aspect that interested him: the abstraction of a contour, the gleam of a surface, the elegance of a distortion. As a practised painter and designer Mucha was adept at re-echoing these features in the rhythms and harmonies of the setting and space. It is obvious that with him, as often as not, the idea preceded the photograph. Here, for example, the girl poses for a sculpture yet to be made, but beside the clay model that dictates her attitude.

Subjects from everyday life

Pierre Bonnard (1867-1947):
Little Girl with Cat, 1899.
Oil painting.

Edouard Vuillard (1868-1940):

△ Misia Natanson and Félix Vallotton, 1899.
Oil painting.

▷ Misia Natanson and her Sister-in-Law, c. 1900.
Albumen print.

More and more amateur photographers came forward as camera techniques were simplified and film development was industrialized. Following the example of Degas and Zola, the Nabi painters Bonnard and Vuillard took up photography as a useful and instructive side-line in the 1890s, recording the events of their family life and the places where they spent the summer holidays. By the time they acquired a camera they had already worked out the style of their paintings and so did not use this documentation as a source of inspiration. Their paintings are characterized by abstraction of depth, a soft but pervasive luminosity suggestive of intimacy, a sensuous handling of paints and rendering of texture. Their photographs show analogous effects, thus vouching for their highly personal way of seeing. And so a like vision informs the work of the painter and that of the photographer.

But in practice Bonnard and Vuillard did not paint what they photographed or vice versa. What we do find is that they often photograph a subject which they had previously painted. As photographers they remained, technically speaking, clumsy and ingenuous, but the pictures taken are always distinctive, informed by the same vision as their paintings. This likeness springs from the inherent originality of their way of seeing and feeling. Trained on the world by a great painter, the camera eye is not so much a mirror of reality as a piercing glance revealing its features in an unsuspected light.

Pierre Bonnard (1867-1947):

Grandmother Bonnard (Mother of Pierre Bonnard)
and Robert (?) Terrasse at Noisy-le-Grand, c. 1899.

Grandmother Mertzdorff with Robert Terrasse
at Noisy-le-Grand, c. 1898.

Albumen prints.

Light and colour

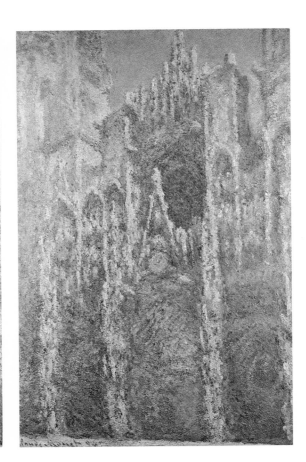

Claude Monet (1840-1926):

Rouen Cathedral, the Portal, 1894. Oil painting.
Rouen Cathedral, West Façade, Sunlight, 1894. Oil painting.
Rouen Cathedral, the Façade at Sunset, 1894. Oil painting.

The discoveries and innovations made by the Impressionists from the late 1860s on were to have momentous consequences not only in painting but also in photography. In his effort to penetrate more deeply into nature, Monet was led to paint in the open air, directly from the motif. He familiarized himself with the life and movement before him, with the changing appearances of a given subject according to the season, the time of day, the density of the atmosphere. Sometimes two of the Impressionists painted the same motif working side by side, and the results demonstrated the close relation that exists between observation and perception. A comparison between the *Sailing Boats at Argenteuil* (1873) as painted by Monet and Renoir would have disconcerted Baudelaire (who had died in 1867). It shows that two artists may differ more characteristically in their perception of the real world than in the exercise of their imagination. The latter is shaped by the knowledge and taste of the period in which they live, so that there may well be a narrower gap between two history painters working from imagination than between two painters trying to record what they actually see. Monet heightened the colour contrasts to the point of vying in intensity with the luminosity of the natural world; Renoir, while using a similar technique, was led by his sensibility to reduce the contrasts in the interests of an overall harmony. Such experiments opened the way to the researches of the twentieth century into the phenomenology of perception.[8]

Impressed by the importance of light, Monet made an ever more searching analysis of its visual nature and impact on objects. He found that light is colour, not tonal value, and thus singled out one of the constituent elements of painting. Hitherto, keeping to the system of values, artists had aimed at producing the illusion of a reality simply mirrored on the surface of the canvas. By means of the "comma brushstroke," applying small areas of unmixed pigments on the canvas, Monet recreated in the picture the principles he had observed in nature. By this method he gained a greater luminosity and brilliance of hue.

Here photographers were as yet unable to compete with painters. The best they could do was to tint their black and white prints or heighten them with watercolour, while Monet in his famous series illustrated the way in which colour-light constantly varies the appearance of the same motif: by

recapturing the poetry of the passing moment, by characterizing the singularity of that moment, he expressed the universality of life. Commenting on Monet's series of paintings of *Rouen Cathedral* (1892-1894), Clemenceau observed that "by contriving to express nature with ever finer precision this art teaches us to look, to perceive, to feel."[9]

Yet, as early as 1868, two French researchers had worked out a process of colour photography: Louis Ducos du Hauron and Charles Cros. By means of filters enabling them to bring out the primary colours, they arrived at a synthesis by the overprinting of negatives and by introducing into photography the system used for pulling colour engravings. (This process was subsequently taken up by printers and adapted to photogravure.)

Curiously enough, Louis Ducos du Hauron and Charles Cros were unacquainted and pursued their researches in Paris independently. As it happened, they achieved similar results about the same time and communicated them simultaneously to the Société Française de Photographie. In his pamphlet *Les Couleurs en photographie: solution du problème* (1869) Ducos du Hauron described his method. By an assemblage of filters he obtained three negatives (green, violet and orange) of the same subject, from which, by the law of complementary colours, he then obtained red, yellow and blue positives. Thus, by superposition, these positives printed by the carbon process produced the first colour photographs. Ducos du Hauron also described the possibility of making positive images on glass for projections, thus pointing the way to the subsequent printing process, by which plates covered with a network of lines served simultaneously as filters and printing grooves. But this process called for delicate adjustments and the emulsions were not sensitive enough. It was not until the early 1900s, with the introduction of the autochrome process, that colour photography became more generally feasible.

Louis Ducos du Hauron (1837-1920):
View, 1878.
Trichromatic photograph.

L. DUCOS DU HAURON 1877

97

△ Antonin Personnaz (1855-1937):
Woman in a Field Loading a Wheelbarrow.
Autochrome.

▷ Louis Lumière (1864-1948):
Girl and Lilac, c. 1906-1910.
Autochrome.

The colour photography processes of Charles Cros and Louis Ducos du Hauron were too complex to be exploited commercially. Despite the successful results which they achieved and promoted, colour failed to make its way in photography. To make up for its absence, photographers resorted to the use (and abuse) of the toning possibilities offered by gold or silver salts and the changes of hue permitted by carbon printing. Ranging from a bluish to a purplish-blue tone by way of dark brown or red, photography thus contrived to give the illusion of being in colour, but it remained monochrome.
Finally, in 1891, Gabriel Lippmann, professor of physics at the Sorbonne, devised a method by which the natural colours of objects were reproduced by means of interference on a single plate; but it was complicated and the results unpredictable. After experimenting with it the Lumière brothers reverted to the three-colour process (i.e. the combination of three negatives); but they were convinced that direct colour photography was possible and pursued their researches in this direction. In 1907 Louis Lumière brought out his autochrome process of colour photography—entirely new and of exceptional quality. The autochrome plate took the form of a transparency: it originated from Louis Lumière's discovery in 1904 of the properties of potato starch. The photographic plate was covered with minute grains of starch, dyed orange, green and violet in equal proportions. Washed with an emulsion of silver gelatino-bromide, the plate was exposed in the camera, the untouched side of the glass foremost. The coloured grains acted as selection filters. Development turned the negative into a positive reproducing the original colours by the phenomenon of complementarity. These autochrome plates yielded their maximum intensity when projected, but they could also be printed on paper, with excellent results.

Fernand Arloing (1875-1944):
Scenes of Family Life at Les Minguettes,
Saint-Fons, Lyons.
Autochromes.

On the strength of these results, and backed by the technical proficiency of their laboratories in Lyons, the Lumière brothers marketed their invention in 1907 and enjoyed a great success, since it was easy to use. The autochrome plate for the first time put colour photography within the reach of everyone. It held the field until 1932, when the glass plate was replaced by film; but the annual production had already reached the rate of one million plates by 1913. Edward Steichen, in New York, had the opportunity of experimenting with this technique before it was put on the market. He was delighted with it and exhibited some of his own autochrome plates in 1907 at Alfred Stieglitz's 291 Gallery in New York. Steichen gave it as his opinion that the colours as printed on photographic paper, however accurate in tone, could never equal in intensity and brilliance the colours of the autochrome plate. His opinion carried weight, and even today the autochrome plates of this period have a charm all their own, the colours having remained as fresh and bright as ever. The system devised by the Lumière brothers

corresponds aesthetically to Pointillism, the division of colours worked out by Seurat in painting, but owes nothing to it scientifically. What it does show is the soundness of the artistic intuition of Seurat and the Neo-Impressionists. The microscopic division of the colours on the photographic plate creates a poetry akin to that of the painters.

The Lumière factory and laboratories were located at Lyons, where the two brothers were well known and had many friends. Their invention aroused great interest locally and, taking it up, several amateur photographers of Lyons produced work of a quality vying with that of the Lumière brothers and their operators. It was only much later that photographers came to use colour for expressive and spatial effects. For the time being, they explored its descriptive and sentimental possibilities, choosing subjects of immediate appeal.

Jacques-Henri Lartigue (1896):
Landscape near Pau, 1912.
Autochrome.

Anonymous:
Emile Zola Photographing the Lac Supérieur
in the Bois de Boulogne, Paris, c. 1900.
Film negative print.

▷ B. Martin Justice:
Taken with the ''Quad,'' c. 1900.
Lithograph poster.

THE POPULARIZING
OF
PHOTOGRAPHY

In 1888 George Eastman invented the Kodak, the "smallest, lightest, and simplest" of all cameras, as he aptly described it. Launched with the slogan "You press the button, we do the rest," it was a great popular success, putting photography within the reach of everyone and profoundly modifying its use and practice. Till now it had largely remained in the hands of researchers and professionals; and while the former, impelled by their own particular interests and aims, had often produced some outstanding and significant pictures, industrialization gradually gained an impetus that made collaboration between them more and more difficult. As for the professionals—those who ran studios and laboratories in which they made pictures answering to the demand of an ever growing clientele— they saw an immediate threat in the appearance of the Kodak, whose express purpose was to popularize a technique which they considered a prerogative of their own. Years before, around 1840, many painters had seen a threat to their existence in the invention of photography, foreseeing that it would outdo them in descriptive realism. Likewise in the 1890s, professional photographers feared that the Kodak would check the growth of their business. They accordingly gave a "cultural" response to the popularization of their craft: the "art photograph," a retouched image resembling painting in its effects and testifying to a proficiency attainable only by specialists.

Paradoxically enough, in creative terms at least, the 1890s saw an abatement in the rivalry between painting and photography. The latter was capable now of acting in any circumstances, of documenting, recording and informing on an exhaustive scale, and painters, released from this function, were free to develop the specific powers of their art. Seurat singled out to abstract effect the basic constituents of the painter's medium; Gauguin explored the subjective content of images and the force of ideas; Van Gogh discovered the expressive power of colour; and Cézanne discredited the traditional view of reality by challenging the static, monocular vision inherited from Renaissance painting. In 1910, on the strength of this impetus, came abstraction—pictorial expression for its own sake, non-representational and non-naturalistic, referring to nothing outside itself. Later, after the First World War, some painters came back to photography, but for purposes very different from the mere reality-mirroring effect which it had once been expected to serve.

By the early 1900s, thanks to the Kodak hand camera and others, photography was very much a popular pastime. As its field of activity widened and the number of its practitioners increased, the consequences made themselves felt. Photographs were everywhere, and by creating the illusion that they alone recorded the truth about the natural world, they distorted its appearances. Susan Sontag,[1] in analysing what is in the last resort the significance of "pressing the button," writes: "There is something predatory in the act of taking a picture. To photograph people is to violate them, by seeing them as they never see themselves, by having knowledge of them they can never have; it turns people into objects that can be symbolically possessed. Just as the camera is a sublimation of the gun, to photograph someone is a sublimated murder—a soft murder, appropriate to a sad, frightened time." And pursuing this theme with the example of the photographic safari in Africa, she concludes: "Guns have metamorphosed into cameras in this earnest comedy, the ecology safari, because nature has ceased to be what it always had been—what people needed protection from. Now nature— tamed, endangered, mortal—needs to be protected from people. When we are afraid, we shoot. But when we are nostalgic, we take pictures."

As a reminder of absence, photographs become an extension of the memory, and an unlimited extension thanks to the multiplication of events and subjects which they store away when the camera is made accessible to all. By way of photography the past invades the present and the future.

△ George Walton (1867-1933):
Painted panel for a Kodak shop
in the Strand, London, c. 1900.

◁ Count Giuseppe Primoli
(1851-1927):
Photographers Photographed.
Bromide print.

▷ Paul Nadar (1856-1939):
Girl Crossing the Place
de l'Opéra, Paris, c. 1888.
Print from Kodak
circular negative.

George Eastman, a dry-plate manufacturer in Rochester, New York, coined the name Kodak himself, as being brief and easily pronounced in any language. His Kodak hand camera measured 6½ × 3½ × 3½ inches, weighed 2 lb. 3 oz. and cost 25 dollars. It took 100 circular pictures, 2½ inches in diameter.

Eastman not only invented the Kodak but launched the industrialization of photography at his Rochester plant—and this meant a standardization of vision pregnant with consequences. Once the customer had taken his hundred pictures, he sent the whole camera to the factory, where the negatives were developed and the camera reloaded and sent back to the owner. Taking pictures was so simple that no one could possibly feel it beyond his competence, and the number of amateur photographers multiplied astronomically. Most took it up for their own satisfaction, but some achieved remarkable results, so sincerely did they respond to their own desires. One of these was the French novelist Emile Zola.[2] Towards the close of his life, in the late 1890s, he bought a push-button camera and took hundreds of pictures, of family, friends, a passing train, views of the Seine near his country house at Médan, and much else, always with a sharp focus on details. To all such amateurs

photography appeared as a privileged and specific means of seeing; and like the inventors before them they were inclined to put the emphasis on their own activities. It was an outlet for curiosity and a lasting record of its findings.

Uneasy and self-defensive in the face of this great popular success, this mass movement towards photography, the professionals banded together in clubs and associations and held exhibitions of members' work. Thus in 1891 the Vienna Camera Club organized its first exhibition, with twenty-five participants. In London, in 1892, the Linked Ring Brotherhood was formed by a group of younger photographers who had seceded from the Photographic Society. In 1893 the Photo-Club de Paris organized "the first exhibition of photographic art." That same year the Hamburg Kunsthalle held an international exhibition of 700 photographs. In New York, in 1896, the Society for Amateur Photographers and the New York Camera Club merged as the Camera Club; and in 1902 Alfred Stieglitz founded the Photo-Secession.

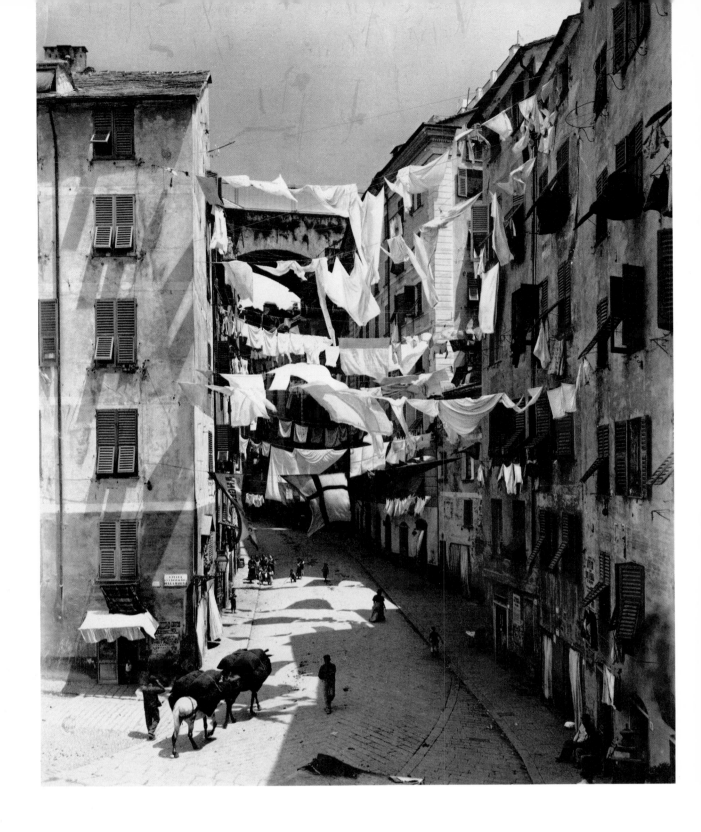

Having been brought within the reach of all, photography soon gained a new dimension, that of a universal memory-bank. The eye was progressively schooled by the habit of taking pictures, so much so that things came to be seen not so much for their own sake as for the pictures that could be made out of them. And the reality that Courbet and Manet had been so eager to record because they felt that it had never been recorded for its own sake—that reality was now to be misrepresented owing to the pictorial bias of photographers who, forgetting or ignoring the ordinary, straightforward view of things, were determined to seize on the particular, the singular, the accidental.

The habit was thus acquired of going about with the camera case slung over one's shoulder and the eye on the look-out for the accidental effect likely to give a fresh insight into things and mark them with the seal of the temporal, the ephemeral. The tourist photographer appeared on the scene in growing numbers, denaturing with his camera what he only wished to record. For the subjects of observation remained conventional, light effects being relied on to add the emotional overtone or the touch of unexpectedness which passed for originality. And if the accidental was not at hand, the pose could be fallen back upon. Drawing the inference from this substitution of reality by a reproduction of it, Walter Benjamin wrote: "The need to bring things spatially and humanly 'nearer' is almost an obsession today, as is the tendency to negate the unique or ephemeral quality of a given event by reproducing it photographically. There is an ever-growing compulsion to reproduce the object photographically, in close-up." [3]

Not for Atget the pictorial, the ''good subject'' so much sought after by others. He is a classic instance of the straight photographer. Paris and the surrounding country, the Ile-de-France, he recorded in generally unpeopled pictures, void of incident or accessories, and all the more compelling for his knack of stamping each of them with the peculiar sign and mark of a modernity which justifies them even today.

''The city in these pictures is empty in the manner of a flat which has not yet found a new occupant. They are the achievements of Surrealist photography which presages a salutary estrangement between man and his environment, thus clearing the ground for the politically trained eye before which all intimacies' serve the illumination of detail'': so wrote Walter Benjamin of Atget's art.[4] But because of this very lack of incident he was regarded in his lifetime as a mere postcard photographer documenting the small trades of Paris.

From the picturesque
to the poetry of a solitary stroller

Eugène Atget (1856-1927):
Cour Damoye, 12 Place de la Bastille, Paris.
Bromide print.

◁ Alinari Studios, Florence:
Street Scene in Genoa, Windy Day, 1885.
Bromide print.

Eugène Atget (1856-1927):

△ Door of the Inn "A la Biche,"
35 Rue Geoffroy Saint-Hilaire, Paris.

▷ Rampant Arch, Church of Saint-Séverin, Paris.

Bromide prints.

Born in Bordeaux in 1856, Eugène Atget was over forty when he took up photography and his work was only discovered after his death (in 1927) by the American photographer Berenice Abbott. André Breton saw in him one of the ancestors of Surrealism and paid tribute to the originality of his vision. And yet the hand-lettered sign on Atget's studio door in Montparnasse was simply "Documents for Artists"—prophetic words, for artists (Man Ray, for example) were the first to recognize his consummate mastery of the medium in which he worked. The very banality of his subjects gave them the same impression of mystery as the paintings of Chirico. And indeed Chirico himself might have been speaking for Atget when he defined his own aims: "The main thing is to divest art of everything familiar which it has contained up to now: all subjects, ideas and symbols must be set aside."[5]

The few facts known about him were communicated to Berenice Abbott by Atget's friend André Calmettes: "Born in a port, he was expected to become a sailor and sent to sea as a cabin boy... I only got to know Atget later in Paris... he was an actor. After appearing on the stage in provincial towns, he played in the suburban theatres of Paris... his rather unappealing physique had kept him in thankless roles... He and I both had a keen appreciation of painting and we associated a great deal with painters. It looked as if Atget was to become one himself. But no, after some tentative efforts, he decided to be a photographer. It was already his ambition to create a collection of everything artistic and picturesque in and around Paris." [6]

Using already outmoded equipment, Atget worked as a photographer from 1898 until his death in 1927. He had the knack of choosing the right moment, in the right lighting, the moment that seemingly prompts him to ask: "What makes reality and where is illusion?" His approach was straightforward, he sought no effects and went on tirelessly recording what he alone was capable of seeing.

The invention and marketing of the Kodak brought the camera out of the studio; it ended the reign of the inevitably artificial studio portrait. Of course the family album had come into existence with photography; but by about 1900 it was becoming a different thing altogether. Before, the key moments of a man's life had been recorded by professional photographers: birth, conscription, marriage, children, anniversaries and so on. Now the amateur took over, seeking out his own subjects, taking his own pictures of family and friends, and taking them at any time or place, without their even knowing, perhaps, that the camera was trained upon them. Photography became a personal or family matter, and the snaps so numerous that they had to be sorted out and arranged in some order. It was open to anyone to record the people, places and times of his life which he wished to recall and remember. The family album was there to refresh the memory of them. Roland Barthes, thinking over the significance of this perpetual visualization of what time had swallowed up, wrote: "Earlier societies

The family album

Fred Boissonnas (1858-1946):
Picking Wild Flowers, 1905.
Telephotograph.

▷ Anonymous:
Villa Elvira, Messina, 1897.
Sepia toned bromide print.

saw to it that remembrance, as a surrogate of life, was everlasting and that at least the thing meaning Death was itself immortal: such was the Monument. But by taking Photography, which is mortal, as the general and so to speak natural witness of 'what has been', modern society has done away with the Monument. Paradoxically, the same century has invented the History of Photography. But this History is a recollection made up in accordance with positive recipes, a pure intellectual discourse which abolishes mythical Time; and Photography is a reliable but fleeting record. So that today everything is conspiring to put our species in the helpless position of soon being unable to conceive of the *sequence of time*, either emotionally or symbolically."[7]
The rise of the family album had the foreseeable effect of promoting the sentimental interpretation of photography. Just as painting moved away from descriptive realism, so photography too became more subjective and the amateur snapshot more closely identified with the subject and its emotional overtones.

△ Fred Boissonnas (1858-1946):
Summer Afternoon, 1899.
Bromide print.

△◁ Josef Dahinden (1863-1931):
On the Upper Slopes of Mount Rigi,
above the Lake of Lucerne, 1904.
Bromide print.

◁ L. L. Pricam Studios, Geneva:
Portrait of Adélaïde S.
Sepia toned bromide print.

Messine Villa Elvira

Recognized and firmly established as the most reliable means of recording reality, photography thus became a political weapon and its documentary powers were being made use of by the later 1880s, when its testimony was accepted as legal evidence.

Ethnological curiosity, which had prompted some of the earliest photographers, steadily grew and the search for exotic peoples and places was no longer the sole motive behind it. American photographers, for example, were soon taking a keen interest in the Indians who had been driven ever further westward, and memories of the frontier wars lingered in some of these pictures. It became clear too that photography had its part to play, a key part, in the surveying and safeguarding of the environment. In Paris and elsewhere it recorded the old face of the city before the sweeping changes wrought by modern urbanization. Similarly, it recorded some of the old ways of life before they were swept away by industrialization.

In 1889 the *British Journal of Photography* broached the idea of creating photographic archives for the purpose of providing "a record as complete as it can be made... of the present state of the world" and constituting "valuable documents" for the future.[8] In 1897 a wealthy English businessman, Sir Benjamin Stone, M. P. for Birmingham, was instrumental in founding the National Photographic Record Association, which aimed at a social documentation of village manners and customs which even then were dying out; this collection of some 6,000 photographs is preserved in the British Museum. A similar intention lay behind the founding of the Archives de la Planète in Paris, by Albert Kahn in 1910.[9] A banker and friend of the philosopher Henri Bergson, Kahn hired a group of photographers who, working under the direction of Jean Brunhes, one of the promoters of anthropogeography, set out "to record once and for all certain aspects, practices and modes of human activity whose inevitable disappearance is now only a question of time." By the time of Kahn's bankruptcy in 1931, the Archives de la Planète had brought together 72,000 colour photographs and 140,000 metres of film.

▷ John Millington Synge (1871-1909): Islanders of Inisheer, Aran Islands, Galway, 1898.

From ethnography to sociology

Arnold Genthe (1869-1942): Street of the Gamblers, Chinatown, San Francisco, 1896 or later. Silver print.

The first piece of photo-reporting of genuine sociological value was that of John Thomson, a Fellow of the Royal Geographical Society, who after ten years as a roving photographer and explorer in China and the Far East, trained his camera on London with even more remarkable results. In collaboration with Adolphe Smith (who wrote part of the text), Thomson published his *Street Life in London* (1877) illustrated with thirty-six Woodburytype plates showing street musicians, an Italian ice-cream seller, a shoe-black, a chair-mender and so on. In it Thomson wrote: "The precision and accuracy of photography enables us to present true types of the London poor and shield us from the accusation of either underrating or exaggerating individual peculiarities of appearance." This was one of the first landmarks in the history of sociological photography. Others soon followed, notably in the United States, where Riis and Hine documented the underside of American society.

Less sociological in its implications is the attitude of Genthe. His work stands on the borderline between reportage and investigation. His ambition lay rather in the direction of art photography, and the effects he achieved in portraiture earned him a certain renown. What strikes us most today is the vividness of his documentary photographs. Born in Germany in 1869, Arnold Genthe took a doctorate in philology at the University of Jena before leaving Europe and setting up as a portrait photographer in San Francisco in 1894. There he fell under the spell of Chinatown and began documenting the exotic life and customs he found there. The people he stalked were unaware of a photographer's presence, for he used a very small hand camera and so obtained pictures straight from life. Inquisitive and fascinated, he overlooked no detail of the architectural setting, no gesture of workmen and shopkeepers, no characteristic attitude. Genthe lived through the San Francisco earthquake and fire of 18-21 April 1906, and though his studio was destroyed he borrowed a camera and recorded the dramatic scenes he witnessed in a fine series of photographs of great historical importance.

Jacob A. Riis (1849-1914):
Slept in That Cellar Four Years, c. 1890.
Lantern slide.

Heinrich Zille (1858-1929):
Peasant Women Collecting Fire-Wood, 1900.
Photograph.

Jacob A. Riis took up photography with no thought of art: his initial purpose was to illustrate his work as a newspaper reporter. Born in Denmark in 1849, he emigrated to the United States in 1870, living from odd jobs and tasting slum life in New York. In 1877 he became a police-court reporter for *The New York Tribune*, later for *The Evening Sun*. Armed with a camera he set out to expose the living conditions he saw around him, embarking on a crusade that did in time lead to social reforms. His pictures of immigrant families in the tenements, of prostitutes and petty criminals in Mulberry Street, of sweat-shops in the garment district, of derelict children, were the irrefutable evidence for his indictment of places like the Lower East Side where more than a million people then lived in hopeless squalor. In his sometimes perilous expeditions into back alleys and dives and cheap lodging houses, Riis used (and was one of the first to use) flash powder invented in Germany in 1887, thanks to which his camera recorded faces and places in stark detail.

In the course of his crusade Riis published many articles and gave lectures illustrated with lantern slides. His efforts culminated in a famous book, *How the Other Half Lives* (1890). It was read by Theodore Roosevelt, who wrote to Riis promising him his support; and Roosevelt carried out his promise when in 1895 he was appointed President of the Board of Police Commissioners for the City of New York, launching a strenuous programme of reforms and rehousing. The work of this master of the documentary photograph is commemorated in New York today by the Jacob A. Riis Neighborhood Settlement.

Equally important as an investigative photographer was Lewis W. Hine, whose work also impressed itself on the American conscience and led to social reforms. Born in Wisconsin in 1874, Hine studied sociology at the University of Chicago, then at Columbia University and New York University. As a teacher from 1901 on, at the Ethical Culture School in New York City, he began taking photographs to illustrate his courses. Between 1904 and 1909 he made a series of about 200 photographs of immigrants landing at Ellis Island and coping with life in the New York slums—a signal example of photo-reportage. With his camera he pursued this new line of sociological inquiry, exposing human misery and injustice wherever he found it. Hine first published his photographs in 1908 and they proved so effective that he was given assignments to cover and document particular issues, such as the conditions of Pittsburgh steel workers. Most important of all was his work for the National Child Labor Committee in its crusade against the plight of the two million children in the United States between the age of ten and fifteen who at that time had to work for a living. Through the photographs in Hine's books[10] the American public discovered these exploited children toiling in the mines and glass works of West Virginia, in the canneries of Indianapolis, in the cotton mills of North Carolina. All his life, up to his death in 1940, Hine put his camera in the service of social reform, the fight against injustice and exploitation. He also focused it on the achievements that do credit to man's "courage, skill, daring and imagination." Such was his photo-reportage of the construction of the Empire State Building in central Manhattan in 1930-1931, published in his book *Men at Work: Photographic Studies of Modern Men and Machines* (1932). Like Riis, Hine grasped the subjective value of photography. He published his pictures as "human documents," described them as "photo-interpretations" and made them all the more telling by presenting them in sequences. In Europe, Sander and Zille worked in the same spirit.

Lewis W. Hine (1874-1940):
Fresh Air for the Baby,
East Side, New York, 1910.
Silver gelatin print.

Many professional photographers saw in the idea of "art photography" the justification of their work: their ambition was to achieve the effects of painting and drawing by manipulating their photographs in the course of developing and printing.

In a paper read before the Camera Club in London in March 1886, Peter Henry Emerson criticized the work of Robinson and his followers for subordinating photography to the set formulas of academic painting. Emerson saw photography as fulfilling its natural task when it drew equally on art and science by providing a direct transcription of visual sensations. He insisted on the superiority of photography, in both accuracy and illusionism, to all the engraved media of reproduction. To illustrate his true-to-nature theories, he published a book of forty platinotype prints: *Life and Landscape on the Norfolk Broads* (1886). It admirably captures the quiet beauty of this low-lying area of East Anglia, with its shallow meres, their low banks massed with luxuriant reeds and water plants. Developing his ideas of natural, straightforward picture-taking as opposed to the contrived picture-making of photographers like Robinson and Rejlander, Emerson set forth his credo in his book *Naturalistic Photography* (1889). He called for honest photographs taken on the spot and developed the same day. He objected to retouching, which he pointedly described as "the process by which a good, bad or indifferent photograph is converted into a bad drawing or painting... The technique of photography is perfect; no such botchy aids are necessary."[11]

Then, in 1891, Emerson had a revulsion against the views he had previously held and publicly renounced them in a booklet entitled *The Death of Naturalistic Photography*. With a certain bitterness he wrote: "The limitations of photography are so great that, though the results may and sometimes do give a certain aesthetic pleasure, the medium must always rank the lowest of all arts..., for the individuality of the artist is cramped... In short, I throw my lot in with those who say that photography is a very limited art. I regret deeply that I have to come to this conclusion."[12] But "talent is more important than good ideas" (John Szarkowski) and Emerson remains an outstanding figure in the "naturalistic school" of nineteenth-century photography.

Emerson and the invention of art photography

Peter Henry Emerson (1856-1936): The Lea, near Hoddesdon. Photogravure, plate XII for Izaak Walton's *Compleat Angler*, London, 1888.

Peter Henry Emerson (1856-1936):

Haymaking in the Norfolk Broads, c. 1890.
Platinum print.

Rowsley Bridge, on the Derwent.
Photogravure, plate XXXVI for
Izaak Walton's *Compleat Angler*,
London, 1888.

"Is photography an art?" The question arises again and again, at each stage of its history. There were professional photographers who put their faith in the thesis of Art for Art's Sake, who handled the medium in a way that effaced its technical specificity. Organized as clubs and societies, they held their own exhibitions and showed pictures which departed more and more from the specific possibilities of the medium. Art photography enjoyed its first triumph at the opening exhibition of the Vienna Camera Club in 1891. In London, from 1893, the Linked Ring group held annual exhibitions in a similar spirit, their idea being "the establishment of a distinct pictorial movement through the severance of... photography from the purely scientific and technical."[13]

And so after the emphasis on honest photography came the emphasis on style and "artistic character" —in other words, on effects. But disregarding the exigencies of the eye and neglecting the native, inherent possibilities of their medium, the art photographers merely lapsed again into the effects already produced by painters, while the latter were now engaged in a more searching exploration of reality and unending experiment with the expressive powers of their art.

Stieglitz
and the
Camera Work
group...

Alfred Stieglitz (1864-1946):
From My Window, New York, 1900-1902.
Photogravure in *Camera Work*,
No. 20, October 1907.

Alfred Stieglitz is one of the most influential figures in the history of photography, the first to demonstrate that it ranks as a fine art in its own right, one not to be opposed to or confused with the other arts, because it has its own specific and authentic character. His influence made itself felt not only through his pictures but also through his tireless activity as a publisher, gallery owner, and organizer of exhibitions.

By about 1890 the status of the photographer was threatened by the commerical and industrial expansion of photography. Stieglitz had the same misgivings as Emerson, but keeping steadfastly to his early aspirations he surmounted the crisis of art photography, surmounted it triumphantly, carrying with him some of the men and women who were to give a new dimension to photography. As it happened, it was Emerson who awarded a prize to Stieglitz for one of the latter's first photographs, *A Good Joke*, in a contest organized by *The Amateur Photographer* in London in 1887.

Born in Hoboken in 1864, Stieglitz went to Berlin in 1882 to study engineering. There he discovered photography and studied the technique under Dr H. W. Vogel, a photo-chemist who had made some important improvements in the use of emulsions. Abandoning engineering, Stieglitz travelled and photographed in Europe, following with keenest interest the debates then taking place in camera circles. When he returned to New York in 1890, he joined the Society for Amateur Photographers and became editor of its journal, *The American Amateur Photographer*. His practical competence added to his critical and theoretical intelligence soon established him as an authority. By his writings and lectures he opened the United States to the aesthetic debates attending the development of photography and, by the severity of his judgments, made his colleagues more critical.

Stieglitz called for straight photography without artifice. With his hand-held detective camera he made in the 1890s a series of unretouched pictures of New York which show him expert enough to foresee and obtain the effects he wanted, without after-manipulation. His creative powers and imagination, indeed his genius, were quickly recognized both in the United States and Europe.

In 1896 the Society for Amateur Photographers and the New York Camera Club merged to form the Camera Club. Stieglitz became its vice-president and editor of *Camera Notes*. Then, in 1902, he broke away and founded the Photo-Secession whose aim was: "To advance photography as applied to pictorial expression; to draw together those Americans practicing or otherwise interested in art; to hold from time to time, at varying places, exhibitions not necessarily limited to the productions of the Photo-Secession or to American work."[14] The name re-echoed that of the modernist movements in German and Austrian art circles. Stieglitz was its moving spirit and launched its quarterly journal, *Camera Work*, "the mouthpiece of the Photo-Secession," which he edited and published with open-minded acceptance of good work, from wherever it came and whatever the procedures used.

From 1903 to 1917 he published fifty numbers of *Camera Work*, the most prestigious survey of photography of that period. The editor's clairvoyance is shown by the variety and importance of the artists represented and the interest and quality of the articles. Stieglitz extended the scope of his

Alfred Stieglitz (1864-1946):

Cover of *Camera Work*.

Spring Showers, New York, 1900.
Photogravure in *Camera Work*,
No. 36, October 1911.

Gossip, Katwyk, 1894.
Photogravure in *Camera Work*,
No. 12, October 1905.

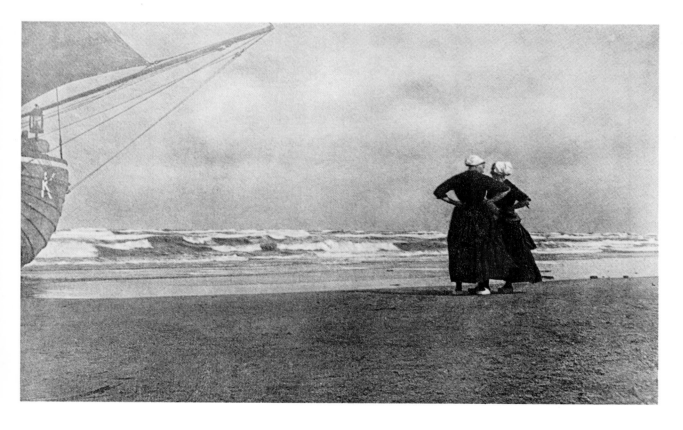

activities, and his influence, by founding in 1905 The Little Galleries of the Photo-Secession at 291 Fifth Avenue, New York—better known as the 291 Gallery. It became the American rallying point for all those interested in or practising contemporary art, for Stieglitz was bold and intelligent enough to make no distinction between the different art forms and media, always insisting on their close interaction. So that in addition to the photographers represented in *Camera Work* he exhibited in his gallery such artists as Rodin, Cézanne, Matisse, Picasso, Brancusi, Braque and Picabia; and Americans like Georgia O'Keeffe, John Marin and Marsden Hartley.

Equally demanding as a photographer and a promoter, Stieglitz sought out quality and novelty and promise where he could find them. In 1913 he declared that "photographers will learn to stop blushing if their photographs are considered simply as photographs," thus testifying to his abiding conviction that when the photographer is strong enough to develop his vision and recognize the specificity of his medium he becomes a creative artist. Thus, while he published and exhibited art photographs, he stands out as one of the makers of photographic art.

It was thanks to Stieglitz and the Photo-Secession that photography first achieved official recognition as a fine art on an equal footing with the other arts. In 1910 the Photo-Secession was asked to organize

... Gertrude Käsebier

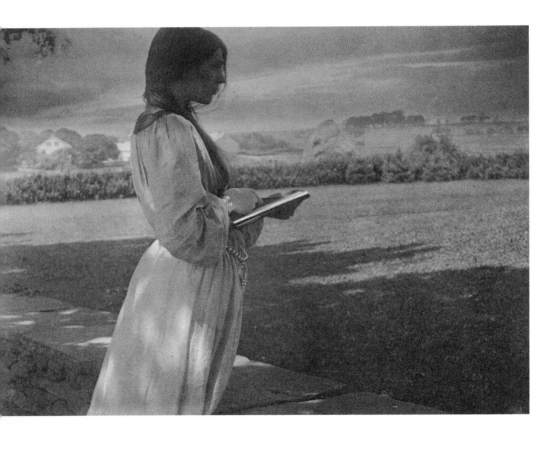

Gertrude Käsebier (1852-1934):

◁ The Sketch (Beatrice Baxter), 1899. Platinum print.

△ Portrait of Alfred Stieglitz, 1906. Gum bichromate print.

an international exhibition of art photographs at the Albright Art Gallery in Buffalo, New York. With the help of his friends Paul Haviland, Clarence H. White and the painter Max Weber, Stieglitz made a selection of some six hundred photographs. This marked the culmination of his battle for the public acceptance of photography as an art. After the show, the Albright Art Gallery purchased fifty of the prints exhibited: this constituted the first public collection of photographs in the United States.

In 1913, at the 291 Gallery, he presented a showing of his own photographs, for the first time since 1899. It was a significant gesture. He had there exhibited contemporary painting and sculpture, now both on the threshold of abstraction; and in an outspoken article he had urged the American public to visit the Armory Show in New York in 1913, the first big exhibition of contemporary art to be seen in the United States; and so he felt bound to show, in his own work, what photography could do and be at a time when painting had moved away from descriptive realism. Stieglitz's one-man show of 1913 was all the more necessary because the public misunderstood, or was unprepared for, the advanced exhibitions of painting he mounted at his gallery, interpreting them as a recognition of the limits of photography.

Gertrude Käsebier (1852-1934):
Woman and Boy Looking at a Book.
Silver print.

In all his activities Stieglitz was ably seconded by his friend and collaborator Edward Steichen, a man of ideas as well as a creative photographer. Born in Luxembourg in 1879 and brought up in Milwaukee, Steichen studied painting and lithography to begin with, then turned to photography. The photographs he sent in to the Chicago Photographic Salon in 1900 caught the attention of two jury members, Alfred Stieglitz and Clarence H. White. His style was so personal, his use of light so steeped in poetry and mystery, that he soon made a name for himself. Working in London, then in Paris, in the early 1900s, Steichen gained an international reputation: by 1910 he was recognized as one of the foremost art photographers. With his camera he achieved the same effects as painting and drawing. He assumed in practice an artist's right to take any liberty with reality and the processes of his medium in order to obtain effective results. His elaborate compositions are founded on an intricate play of tonal values powerfully supporting the emotional expression and symbolic implications. *Camera Work* regularly reproduced his pictures, and his portraits of Rodin, Bernard Shaw and Anatole France are both historic and artistic documents.

... Coburn and Steichen

▷ Alvin Langdon Coburn (1882-1966):
The Bubble, 1909.
Silver gelatin print.

▷▷ Edward Steichen (1879-1973):
The Little Round Mirror, Paris, 1902.
Silver bromide print.

Clarence H. White, born in Ohio in 1871, practised art photography with equal subtlety. While his subjects are simpler than those of Steichen, White's keen sense of detail and his intimist conception of space imbue reality with a mysterious and refined aura of poetry, sustained by a masterly control of printing techniques. His pictures have a richness of modulation hitherto unknown in photography. Similar sentiments and similar effects characterize the work of Gertrude Käsebier, born in Iowa in 1852. Trained as a portrait painter, she gave up painting for photography. By delicate manipulation she contrives to give reality a universal dimension, and by an alchemy all her own she seems to turn light into the very subject of her picture which, progressively distanced from its starting point, becomes an invitation to the dream. Conveying an experience of emotion rather than one of vision, she dominates her medium so effectively as, at times, to break the link with reality.

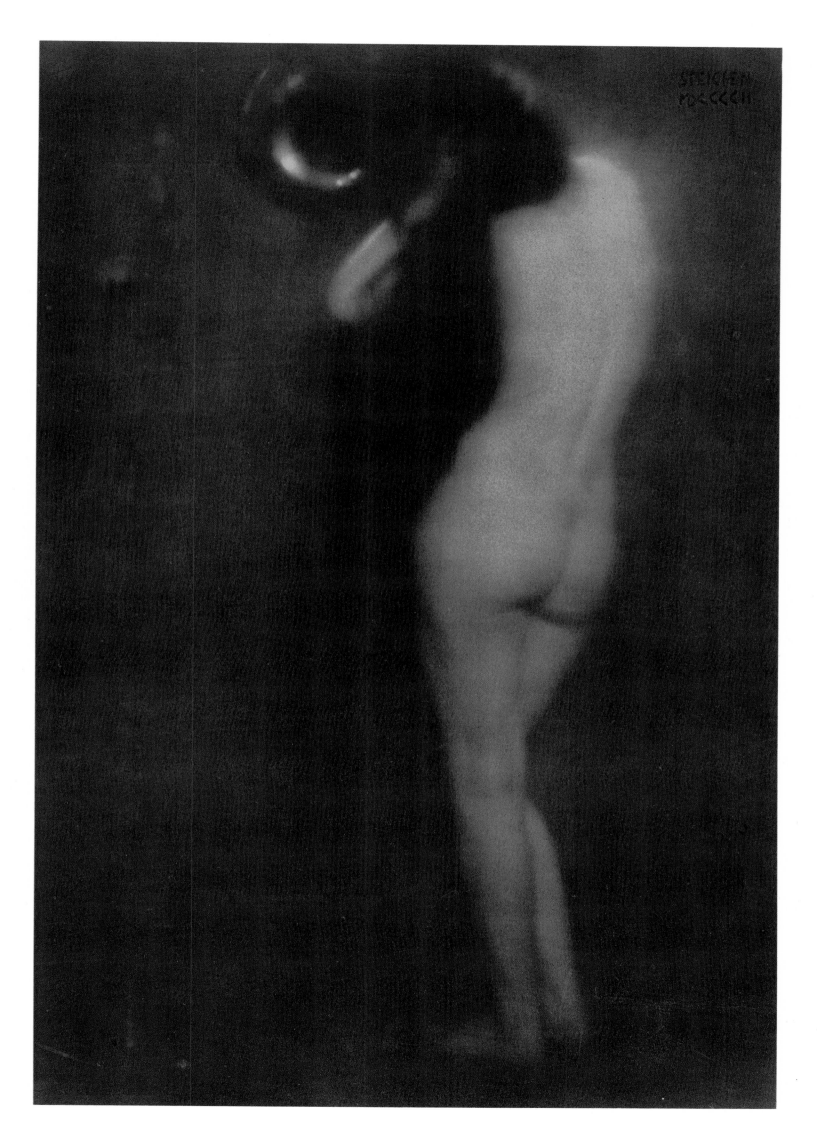

Title pages of
La Photographie est-elle un art?,
Paris, 1899, and
Esthétique de la Photographie,
Paris, 1900.

Robert Demachy (1859-1938):
Costumed Model in the Studio, 1898.
Gum bichromate print.

The popularization of photography in the 1890s incited many professionals to stand apart from the growing mass of amateurs by consciously vying with the effects and aims of painting. This reaction towards artistic photography coincided with the flowering of Symbolism in the arts, and it brought with it a studied manipulation of photographic processes; it required other subjects and careful preparation on the level of representation. The photographers who pursued these experiments were the "pictorialists," and most of them, in gratifying this taste, preferred to use the older, bulkier cameras which, requiring skilful handling, enabled them to get away from the purely mechanical simplicity of the latest, more perfected cameras. The pictorialists framed the subject carefully, cut their negatives to improve the composition, and adjusted tonal values by a process of dimming and brightening; and their prints were made on de luxe paper with a carefully studied grain.

Pictorialism triumphed in the period between 1900 and 1914. By multiplying the possibilities of intervention and transformation, it enhanced the standing of professional photographers. But all too often they lost touch with reality and truth, merely reproducing the effects peculiar to the other arts. P. H. Emerson, the disillusioned inventor of pure photography, put his colleagues on their guard against any systematic search for effect; as early as 1889, in his book *Naturalistic Photography*, he warned them against the temptation to indulge in "fuzziness," with its consequent loss of structure if carried too far. But after 1900 soft-focus photography again gained the day, and photographers

seemed never so pleased as when their pictures gave the impression of not being precisely what they were—photographs. The fashion was all for woolly outlines, for rough-textured papers, for light effects effacing the reality of forms and substance.

Arising first in England, then in the United States, pictorial photography soon spread to the continent and there became the prevailing trend. In France it was associated in particular with the Photo-Club de Paris, founded in 1894, and the *Revue Photographique*; its most successful advocates were Robert Demachy and Commandant Constant Puyo, a French army officer who after 1902 devoted himself to photography.

A rich amateur, coming of a well-known banking family, Demachy was a pictorialist noted for the wide range of distinct and characteristic images which he obtained from a single negative, by using different papers as the support and modifying lights and shadows. He wrote extensively on the aesthetics and techniques of the manipulated print: "There is nothing now to stand in the way and prevent a photograph from becoming a work of art... To treat a print with gum bichromate may or may not give it the spark of life, but without that treatment there can never be any spark at all."

Anonymous:
Female Nude, 1911.
Collotype postcard.

Constant Puyo (1857-1933):
The Happy Isle, illustration for
Esthétique de la Photographie,
Paris, 1900.

This elitist view of photography was part of the movement away from reality led by the Decadent writers of the nineties; it shared the subjects and aloofness of Symbolist art, the mannerisms and extravagance of the *fin-de-siècle* spirit. But pictorialism also gave a glimpse, for the first time, into those subjective depths of the individual which Freud was just then bringing to light with the new science of psychoanalysis. Practised and admired in cultivated circles, pictorial photography catalysed and released those hidden, intimate impulses which a sophisticated presentation made readily communicable even while travestying them. The poetry of light served as alibi to a self-confession either spiritual or erotic. This art form became a popular success, so much so that publishers brought out handbooks to teach the amateur how to distort his vision. Photography seemed to be repudiating its distinctive accuracy and sharpness of definition.

The reaction came in the United States, and Stieglitz was the power behind it. His express purpose in opening his 291 Gallery in 1905 was to exhibit the best photographers of the day alongside the avant-garde painters and sculptors, in order to point up the distinctive features of each art form to the exclusion or neglect of none. But in 1913 he was blamed by many for lending his support to the Armory Show, a mammoth exhibition which brought the American public face to face for the first time with modern art, chiefly French, in all its most daring and controversial aspects. The sight of it must have been deeply disturbing to pictorial photographers, must have made them realize that painting, which for them had been a reference and an alibi, was now exploring realms from which the objectivity of the camera was excluded. The New York critic Charles H. Caffin had written a few years before: "As long as painting was satisfied... to represent the appearances of things, photography could emulate it. Now, however, that it is seeking to render a vision of things not as they are palpable to the eye, but as they impress the imagination, Mr Stieglitz proves what he has known all along, that photography is powerless to continue its rivalry with painting."[15]

One outstanding photographer, Alvin Langdon Coburn, a friend of Stieglitz and member of the Photo-Secession, did nevertheless continue the rivalry with painting, especially with the abstract forms of modern art. In 1913, at the Goupil Gallery in London, Coburn showed some bird's-eye views of "New York from its Pinnacles," with distortions and patternings akin to those of the Cubist and Futurist painters. "Why," he wrote, "should not the camera artist break away from the outworn conventions, that even in its comparatively short existence have begun to cramp and restrict his medium, and claim the freedom of expression which any art must have to be alive?"[16] A rather different point of view was expressed by another member of the Stieglitz circle, Marius de Zayas: "Photography is not Art. It is not even an art. Art is the expression of the conception of an idea. Photography is the plastic verification of a fact. The difference between Art and Photography is the essential difference which exists between the Idea and Nature. Nature inspires in us the Idea. Art, through the imagination, represents that idea in order to produce emotions."[17]

At that very time, Stieglitz and his friends had come to see the limits of an art of "reproduction," and they reverted to the concept of pure photography—that is to say, an art of "production." From about 1912 on, they moved away from pictorialism and the manipulative techniques which it implied. That move was signalized, that same year, by a major exhibition of work by Käsebier, Coburn and White in the Montross Galleries in New York, which established all three as masters of pure photography.

◁ Carl Frederiksen:
Morning Mist, c. 1905.
Platinum print.

Frederick H. Evans (1852-1943):
An Open Door (Ely Cathedral).
Platinum print.

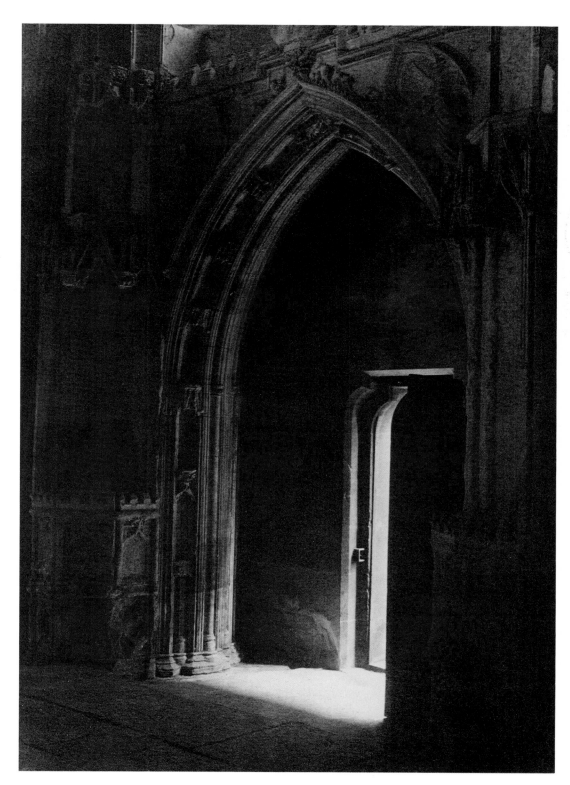

II

PRODUCING

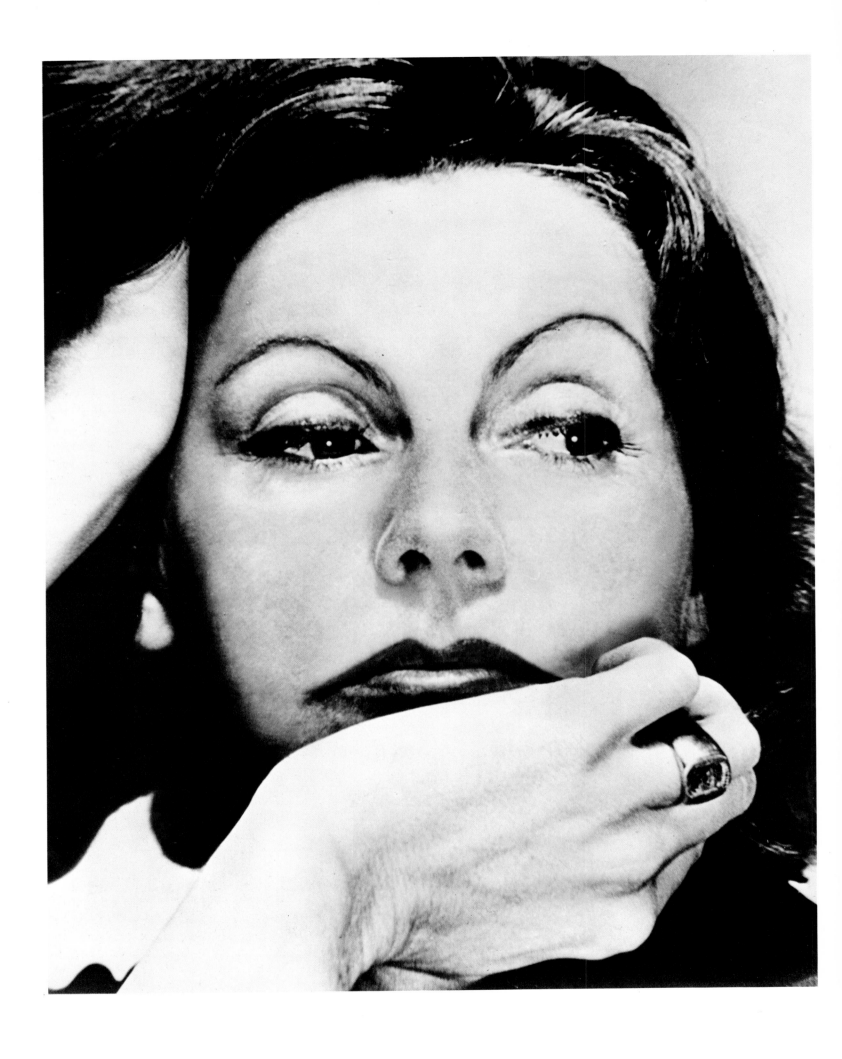

George Hoyningen-Huene (1900-1968):
Greta Garbo, 1951.
Silver print.

▷ Poster for ''Film and Photo,''
International Exhibition of
the Deutscher Werkbund,
Stuttgart, 1929.

130

ARRESTING TIME

"Subtle distinctions have been pointlessly made in the effort to decide whether or not photography is an art. What was not asked first of all is whether this very invention has not transformed the general character of art." In making this observation in 1936, Walter Benjamin[1] stated with refreshing clarity the problem raised by the fact that, between 1913 and 1950, photography moved in new directions and thereby modified the meaning and scope of creative art. The change, between those two dates, was one of content rather than form, of usage rather than function. For the point was no longer to reproduce but to produce, as the historical context required.

As the image assumed its new and privileged place in the field of information and communication, the issue was no longer whether to photograph or not, but what, how and for whom to photograph. Descriptive storytelling and sentimental appeal meant less and less at a time when science was being overtaken by economics and ideology ousted by politics. This is what Bertolt Brecht expressed when he said: "Now less than ever does the simple fact of *portraying reality* tell us anything about that reality. A photograph of the Krupp factories or the AEG doesn't reveal very much about those institutions. Reality, strictly speaking, has slipped into the functional... Thus it is necessary in fact to *construct something*, something artificial, manufactured."[2] This "something manufactured," bringing a new idea of man and the world, implied another way of looking at things. It was this new vision that the artists of the inter-war years experimented with, outside established aesthetic criteria—those artists anyhow who realized that "their vision does not depend only on their individual personality, but also on the knowledge of things possessed by them *and their time*."[3] They rejected the "beautiful" in favour of the "true." The world was changing and artists could not remain in an ivory tower while the media renewed the systems of communication and relation, while the visual gained an unprecedented predominance. They saw themselves rather as educators. And this is how Brecht saw them: "The work of the artist is not just a beautiful testimony about the beauty of the object; actually, and before all else, it is an account of what the object is, an explanation of the object. The work of art explains the reality to which it gives form; it renders an account of and transposes the experiences which the artist has had in life."[4] To make art is to put meaning into the communications dimensions and not just to convey an experience in terms of an image.

Photography found a creative élan and a broader scope in the multiplication of its possibilities of reproduction and diffusion (newspapers, books, magazines, exhibitions) and also in the new relation being worked out between art and life. Till now photographers had considered as "real" only what stood in front of their camera. Those of the 1920s enlarged this concept by detecting a reality in their medium itself. They reconsidered and retested the specifics of photography, with special reference to its basic quality: light. Its importance was stated by László Moholy-Nagy in 1925: "This century belongs to light. Photography is the first manifestation of light, even though it is in a transposed (and perhaps even because of that) abstract form."[5] Photography became a means of production and creation just when it ceased to have any surprises as a medium of reproduction, and just as films were beginning to afford a more convincing means of illustrating life since they could render movement and the time-span of the story.

The photograph came forward now as a distanced image aptly summing up or condensing a situation. Those who discerned this particularity sought to make the most of the distinctive features of their medium: the fixity of the image, the role of light, the significance of the cutting-off, the expressiveness of distance. Re-envisaging the relation between seer and seen, they discovered the importance of the

An art of light
on the frontiers of abstraction

Paul Strand (1890-1976):
Abstraction, Bowls,
Twin Lakes, Connecticut, 1915.
Platinum print.

operator's decisions and choices, to the point of making the photograph the staging-point of a *mise en scène* of the seeing subject. Henceforth the camera eye was exploited for its power of suggestive digression and insight, its knack of revealing other ways of seeing. This is what prompted Raoul Hausmann to say: "To be a photographer is to become aware of visible appearances and at the same time to acquire from them an education in individual and common optical aperception. Why? Because every individual sees in his own way but sees little more than images shaped by the cultural standards of a given period. Each period has its optical problem and reflects another awareness of visible things."[6] And it is the mission of the creative artist to express the awareness peculiar to his own time. The twentieth-century photographer has long known this. He has used his camera as a self-contained medium of expression, owing nothing to the vision of painters or the hand of draughtsmen. He has not hesitated to combine it with other techniques. Since the 1890s photography has ceased to be a competing medium for artists; indeed the latter have often taken it up along with their traditional techniques. It has come to occupy an important place in creative art, and coupled with collage it is a favourite medium of expression with the avant-garde. Reality is no longer solely in what is perceived, but also in how it is perceived.

Imogen Cunningham (1883-1976):
Nude, 1932.

"Pure photography" brings out the tension between the external world of appearances and the personality behind the eye focused upon it. From the early 1900s on, realism assumed a different meaning. It could no longer be limited to a record of appearances, but embodied the relation between subject and object. The general history of vision and in particular the trajectory of modern art led inevitably to this broadened concept. In moving towards a renewal of perception, the new photography showed on the way all the unsuspected multiplicity and disparity of appearances; and it emphasized the reaction of the subject in process of experimenting with the object.

As photography entered the museums, as exhibitions and books devoted to it multiplied, one result was that both the creative artist and the public came to look at things with a more analytical eye. While one photograph refers to the object taken, when several photographs bear testimony of the same object, a comparison between them points up the intelligence and sensibility of each photographer. Because the distance, the cutting-off, the angle of focus and the treatment of light are different, the photograph can no longer be considered as a mirror of reality. The determining factor is the eye and mind behind the camera.

This new awareness stems necessarily from the "climate of the times," the rootedness of artists in this moment of history. In an essay of 1939,[7] Bertolt Brecht discusses the meaning assumed by the term "realism" in the period between the wars: "Our time demands that we consider things in their process of development, as things in transformation which are influenced by other things and other processes. This way of seeing things we find in our science as well as in our art. The aesthetic reproductions of things express... the growing knowledge we have of the complexity, the transformable and contradictory character, of things around us and of ourselves."

"Pure photography" goes to define an aesthetic directly opposed to that of art photography. The concept arose in the United States in the Stieglitz circle on the eve of the First World War. It had lost none of its provocative force in 1921 when Stieglitz, who had not shown any of his photography since before the war, exhibited again, at the Anderson Galleries in New York. Commenting on his work, John Tennant, the editor of *Photo-Miniature*, wrote: "No effort at interpretation or artificiality of effect; there were no tricks of lens or lighting. I cannot describe them better or more completely than as plain straightforward photographs... They made me want to forget all the photographs I had seen before, and I have been impatient in the face of all the photographs I have seen since, so perfect were these prints in their technique, so satisfying in those subtler qualities which constitute what we commonly call 'works of art'." [8]

Emerson and Stieglitz had already shown in their early work the intensity inherent in a straightforward photograph, one without effects or retouching; but both were subsequently caught up in the wave of pictorialism. When that wave subsided, Stieglitz and his circle stood firm and unscathed. The sudden conversion of his friend Marius de Zayas was significant. While in *Camera Work* (No. 41, 1913) Zayas had written "Photography is not Art," in the next issue (No. 42-43) he wrote: "Photography is not Art, but photographs can be made to be Art... The difference between

◁ Paul Strand (1890-1976):
Abstraction, Porch Shadows,
Twin Lakes, Connecticut, 1916.

▷ Edward Weston (1886-1958):
Nude, 1936.
Silver print.

Photography and Artistic-Photography is that, in the former, man tries to get at that objectivity of Form which generates the different conceptions that Man has of Form, while the second uses the objectivity of Form to express a preconceived idea in order to convey an emotion... The first is a process of indigitation, the second a means of expression." What Zayas meant here by artistic photography had nothing in common with the work that had been referred to by that name a few years before. On the contrary, the American photographers of the early twentieth century had a sense of workmanship similar to that of Matisse when he said: "An artist must realize when he reasons that his picture is factitious; but when he paints he must have the feeling that he has copied nature. And even when he has departed from it he must still have the conviction that he has only done so in order to render nature more completely." [9]

For the photographer, this meant making appropriate use of the possibilities afforded by the camera (lens adjustment, cutting-off of the subject, length of exposure), but it also meant taking into account the effect produced by the print. Creative photographers no longer sought to sum up on the plate an impression or experience of the outside world, but aimed at the fullest possible rendering of the action

before them, while also gauging the effects which their handling of it might have on the spectator and following up those effects in further shots. Thus the camera was no longer a recording or documenting instrument but a means of discovering new and unknown forms, thanks to its intrinsic properties. It was only gradually that "pure photography" revealed the depth of its subjective dimension. The surprising thing about it initially was its "purism," indeed its abstraction. For being intent on revealing the specificity of their medium American photographers sought out the immediate, virtually automatic image in which the desire to represent merges with the explicit working out of the representation. What is distinctive about this photography is its knack of uprooting the image from actual space and time and demonstrating that it is a drawing obtained directly by the action of light. Photographing became the act of materializing an appearance whose reality is renewed by a particular modulation of light, by the *mise en scène* of the outlines and textures, by the cutting-off and the focus. "Every print I make," wrote Stieglitz in 1921,[10] "even from one negative, is a new experience, a new problem... Photography is my passion. The search for Truth my obsession." This search for truth was, for Stieglitz, the affirmation of his own way of seeing as conditioned by the specific capabilities of the camera. Pure photography, for him and his circle, was the affirmation of the reality of the photographic representation. What it made possible, as Moholy-Nagy later recognized, was "an intensive vision."

◁ Werner Mantz (1901):
Well of a Staircase,
Ursuline High School,
Cologne, 1928.
Silver print.

▷ Carl Mydans (1907):
Houses, Manville, New Jersey,
1936.

The photographer did of course remain very closely connected with the object of his observation; but because he presented it in a new way his pictures were charged with that abstraction which was then pervading the arts of painting and sculpture. Paul Strand, for example, has an attitude towards light which is similar to that of Brancusi in sculpture: the first, as a spectator, discovered its power to renew appearances; the second, as a maker, polished his forms in order that light might better assert its predominance. Strand summed up his view in an article he published in the last issue of *Camera Work* (No. 45-50, June 1917): "The objects may be organized to express the causes of which they are the effects, or they may be used as abstract forms, to create an emotion unrelated to the objectivity as such... but here, as in everything, the expression is simply the measure of a vision, shallow or profound as the case may be. Photography is only a new road from a different direction but moving toward the common goal, which is Life." And again, writing in *Seven Arts* (1917), Strand said: "The photographer's problem is to see clearly the limitations and at the same time the potential qualities of his medium... This means a real respect for the thing in front of him expressed in terms of chiaroscuro... through a range of almost infinite tonal values which lie beyond the skill of human hand. The fullest realization of this is accomplished without tricks of process or manipulation, through the use of straight photographic methods."[11] This American school also revealed the expressive power of concentrated focus and close-up. It trained the lens on the object, approaching it until the camera could catch the subtlest modifications of light and texture with unprecedented precision.

Edward Steichen arrived at pure photography during the First World War. As an aerial reconnaissance officer photographing enemy trenches during the war, he discovered some of the ways in which a photograph, by bringing out details and contrasts, reveals more than the eye can see. This revelation led him to abandon pictorial effects and concentrate on contrasts of light. Following up this line in

136

the 1920s, he worked for Condé Nast and made some outstanding fashion photographs. After the Second World War (in which, as a naval officer, he documented the role of aviation in the war at sea), Steichen was curator of the Department of Photography at the Museum of Modern Art, New York. Edward Weston, born in Chicago in 1886, continued this investigation of the object and the expressive close-up. He bought his first camera in 1902, after seeing an exhibition of photographs at the Art Institute of Chicago. By 1905, at the age of nineteen, he was already a professional portrait photographer and quickly made a name in the field of art photography. Then, in 1915 in San Francisco, he discovered in modern art the fascination of abstraction. Turning his efforts in this direction, he broke with his earlier work, highly successful though it had been, and trained his camera on nature with a fresh intensity. In his pictures of clouds, rocks, timber and people, Weston seemed to grasp the very essence of the materiality of the world, and the camera in his hands revealed unexpected correspondences between a veined leaf and a draped figure, a woman's flesh-tint and the pulp of a sliced fruit.

But Weston's eye was also intent on the investigation of form. His sense of shape and pattern, his grasp of the revealing and metaphorical power of distortion and cutting-off, afforded fresh insight into things and landscape and gave a breath of life to inanimate subjects. A similar power to surprise, even in straight photographs, is also characteristic of Imogen Cunningham. Both photography and cinema were then accustoming the eye—as Fernand Léger put it in 1925—to "the *personification of the enlarged detail*, the individualization of the fragment, in which a drama is implied and played out... The object on its own account is capable of becoming something absolute, moving, tragic."[12]

The pure patterning of these American photographs, their forthright contrasts of light, their emphasis on tactile sensations, all this has a parallel and counterpart in the prominence given to rhythm and texture in the painting of Braque and Picasso, from 1912 on, with the introduction of collage.

The effects of this visual revolution were equally remarkable when the photographer turned to the rendering of space: here the photographic vision of the Americans was so compelling that no one escaped their ascendancy. The renewal of the twentieth-century conception of space was achieved through the choice of the viewpoint, the control of distance, and the tilt of the camera. Thus the American Carl Mydans emphasized recession and perspective by means of a precision lens; the German Werner Mantz revealed the unexpected purity and abstract patterns of architecture; and the Russian Alexander Rodchenko heightened the expressiveness of the image by bringing out the dominant lines. With these photographers and others of the 1920s and '30s, the image spoke for itself, through the tension of its values and the power of its forms.

The American photographers developed vision as an end in itself permitting them to body forth their subjectivity; Weston saw in photography an instrument of self-knowledge and a means of identifying oneself with nature. The Russian approach was different, though equally revolutionary. Coming to photography later than the Americans and the Western Europeans, the Russians practised it with a lucidity and boldness that soon put them among the foremost achievers in the medium.

Outstanding among them was Alexander Rodchenko, a tireless innovator and one of the most active members of the Russian avant-garde. Born in St Petersburg in 1891, he welcomed the revolution of 1917 and saw his art as an instrument for the betterment of society. His stated aim was the "optimum functionality of the object, in forms corresponding to the requirements of the new social order." His ideas were in line with those already expressed in 1916 by the Russian art theorist Nikolai Tarabukhin: "Art is 'fabrication' and action, not a function of knowledge but before all else a voluntary function, for it establishes the primacy of creation over knowledge. Painting is not called upon to 'represent' the things of the outside world, but to fashion, make and create objects."[13] Rodchenko was an artist who had come to photography after reaching the limits of painting; his "last pictures," painted in 1921, were monochromes. Referring to them, Tarabukhin had written: "The death of painting, the death of easel art, does not necessarily mean the death of art in general. Art continues to live not as a definite form, but as *creative* substance."[14] It was while working as a propaganda artist and publicity designer that Rodchenko, in the 1920s, realized the power of the image and reverted to representational art. While on the editorial staff of the Moscow periodical *Novy Lef* he took up photography by way of the photomontage (which the Russians called factography): "Art can no longer be merely a mirror, it must act as the organizer of the people's consciousness... No form of representation is so readily comprehensible to the masses as photography" (El Lissitzky).

Making sense of reality: Rodchenko

Alexander Rodchenko (1891-1956):
△ Chauffeur, Karelia, 1933.
◁ Steps, 1930.

Alexander Rodchenko (1891-1956):
Pioneer, 1930.

For the Russian revolutionaries, and in particular for Rodchenko and Mayakovsky (who worked in close collaboration), factography was an art of agitation and the camera eye could point up reality better than the human eye by compelling the spectator to analyse it from a new point of view. When the Soviet government dissolved all the institutes of artistic research, Rodchenko was left with nothing but his camera to carry out his programme. In 1927 he accordingly set up as a professional photographer and proceeded to make some unforgettable pictures, using the camera with an artist's sense of effective composition and telling recession. His photomontages owed their peculiar power to the unexpected, often violent combination of heterogeneous elements; and in his reportages he achieved a thoroughly operational expressiveness, cunningly contrived while seemingly due to chance.

Rodchenko's photographs, centred on reality and reflecting it as an ever-renewed presence, possess a formalist sense which he himself defined in 1934: "Contradictions of perspective. Contrasts of light. Contrasts of form. Points of view impossible to achieve in drawing and painting. Foreshortenings with a strong distortion of the objects, with a crude handling of matter. Moments altogether new, never seen before... compositions whose boldness outstrips the imagination of painters... Then the creation of those instants which do not exist, contrived by means of photomontage. The negative transmits altogether new stimuli to the sentient mind and eye." And he concluded: "Photography has all the rights, and all the merits, necessary for us to turn towards it as the art of our time."[15]

So just at the time when there was much talk of the "decline of art," photography proved itself a medium admirably suited to delineating the industrial world, while lending itself at the same time to the expression of subjectivity and even of political ideas. For Rodchenko, photography was the only medium capable of *over-taking* reality.

139

The beauty of modernity

This new photography, "straight" for the Americans and "constructive" for the Russians, proved creative by revealing plastic forms and effects inconceivable outside this medium and promoting a new relation between the spectator and the world. Its forms and effects inevitably reacted on painting, after having influenced the contemporary sensibility, now more receptive to surprise, cutting-off, disruption and syncopated effects. As they developed the native potentialities of the camera, photographers moved away from the realistic models of an earlier period and showed the close relation existing between the new vision and abstraction.

With these photographers, prompted as they were by a new awareness of reality, the object assumed an importance and role similar to those assigned to it in painting first by the Cubists, who placed it at the very centre of the image, then by the Dadaists, who made play with what they called "found objects." Much of the credit for reintroducing the object into painting goes to Fernand Léger, who in an essay of 1930 pointed out the importance of film and photography in shaping the modernist view of the world: "A fragment enlarged a hundredfold forces upon us a *new realism*, and this realism must be the starting point of a modern evolution of painting... Modern life is so very different from the life of a hundred years ago that present-day art has to be the total expression of it." This point of view was shared by Robert Delaunay, who made no secret of his debt to photography: he was directly inspired by it in the orchestration of his pure colour rhythms.

For the American artist Charles Sheeler, the relations between art and photography were different. A member of the Stieglitz circle in New York, Sheeler as a painter never hesitated to use photographs,

his own photographs, as his point of departure. "My interest in photography," he wrote in the catalogue of his 1939 exhibition at the Museum of Modern Art, "paralleling that in painting, has been based on admiration for its possibility of accounting for the visual world with an exactitude not equaled by any other medium. The difference in the manner of arrival at their destination—the painting being the result of a composite image and the photograph being the result of a single image —prevents these media from being competitive." In practice however, if they did not compete, the two media certainly overlapped, for Sheeler's oil paintings make the most of photographic effects; they are a kind of hyperrealism before its time. In retrospect, Sheeler's photographs seem more revolutionary than his paintings: his views of industrial America, notably of the Ford plant in Detroit, bear in their precise geometric shapes the stamp that only he could give them.

In Russia, too, the two media were fruitfully combined, and Malevich—who never practised photography—wrote in 1927 to Moholy-Nagy: "I regard photography and film simply as new technical means which painters must absolutely make use of, just as from time out of mind they have made use of brush, charcoal and colour. It is certain, however, that photography and film must become as evocative for the sensibility as pencil, charcoal and brush."[16]

Charles Sheeler (1883-1965):

◁ American City Interior, 1936.
Oil on composition board.

▷ Ford Plant, Detroit, 1927.
Photograph.

Berenice Abbott (1898):
Canyon, Broadway and Exchange Place,
New York, 16 July 1936.
Silver gelatin print.

▷ Albert Renger-Patzsch (1897-1966):
Blast Furnace Air-Heaters.
Herrenwyk Plant near Lübeck, 1927.
Silver print.

If in the 1920s and '30s realism made a comeback in the arts, it was thanks to photography. The descriptive power of the photographic image exalted and illumined the modern world; it also prompted a reconsideration of certain features of that world. The straight photograph showed things up so forcefully, so memorably, that nothing could now be seen as it had been before. Speaking of the Neue Sachlichkeit (new objectivity), in the German painting of the 1920s, Wilhelm Kästner wrote: ''In photography this objectivity is expressed in the strict reproduction of the object, in its exact development, in virtual isolation from the environment and background, in a many-sided, searching illumination that eliminates shadows to the greatest possible degree or uses them merely as outlines of pictorial elements; and above all in the preference for clearly perceptible solid objects with a formal structure easier to apprehend than that of the painting.''[17]

This vision was built up by an arbitrary series of choices, involving the depth and angle of focus and the play of light, for the idea here was to get away from lifelikeness. This is what Brecht had in mind when he wrote: ''Artists have as a rule discouraged those who would take as a standard of judgment resemblance between their images of reality and reality itself.''[18] The latter was uppermost in the mind of Gisèle Freund, a French photographer of German birth, trained in the context of these years, when she wrote: ''Photography is the typical means of expression of a society founded on a civilization of technicians, conscious of the aims it has set for itself... Its power of exactly reproducing external reality, a power inherent in its technique, lends it a documentary character and makes it appear as the most

faithful and impartial process of reproduction of social life." But she also warned against the artificialness of that impartiality: "For photography, though strictly bound to nature, has only a factitious objectivity. The lens, that allegedly impartial eye, permits all possible distortions of reality... The importance of photography therefore lies not only in the fact that it is a creation, but above all in the fact that it is one of the most effective means of shaping our ideas and influencing our behaviour."[19]

The photographic image, from at least the 1920s on, owed its impact and effectiveness to the ease with which it could be reproduced and disseminated in the daily newspapers. It remained indissolubly connected with the moment of its making but continued to haunt the memory. The city, nature, plant life, objects, all and more besides were brought into focus as a source of surprise and wonder. And this new vision of reality became so enthralling that it readily replaced the direct experience of things. This point was taken up by Walter Benjamin: "As anyone can see, an image, and even more a work of art, and most of all a piece of architecture, can be better grasped in a photograph than in reality. There is a temptation to attribute this fact to a simple decline of the artistic sense, to a capitulation by our contemporaries. But we cannot help observing that at about the same time as the techniques of reproduction were being born, a change occurred in the way great works were apprehended. No longer could they be considered as the productions of individuals; they became collective products, so powerful that, in order to be assimilated, they had at first to be reduced. In the last analysis, the methods of reproduction are a technique of reduction and afford man a degree of control over works of art without which he would no longer be master of them."[20]

▷ Ansel Adams (1902):
White House Ruins,
Canyon De Chelly, Arizona, 1942.

▽ Edward Weston (1886-1958):
Dunes, Oceano, California, 1936.

Imogen Cunningham (1883-1976):
False Hellebore, 1926.

Photography became above all a form of abstraction for those who asked themselves whether reality lay in the technical specificity or in the subject which the image continued to convey.

The importance of the new photography was brought home in 1929 by two major exhibitions, both held in Germany: *Fotografie der Gegenwart* (Photography of the Present) at the Folkwang Museum, Essen; and *Film und Foto*, organized in Stuttgart by the Deutscher Werkbund (German Arts and Crafts Society). They displayed the best work of photographers from all over the world. Outstanding among the Germans was Albert Renger-Patzsch, who had been one of the first to recognize the effectiveness of pure photography in its application to newspapers, publishing and advertising. In 1928 he had published his book *Die Welt ist schön* (The World is Beautiful), reproducing a hundred of his photographs, their powerful realism marked by the close-up, the precision of detail, the surprising angle of focus. Nature here was arrested and seen as if beneath a microscope. Even though Renger-Patzsch was chiefly attracted by the commonest things and doings of everyday life, he illustrated what had already been advocated by Moholy-Nagy at the Bauhaus, the first school to consider the products of the camera as an integral part of contemporary speech promoting the creation of images particularly well adapted to contemporary communication. In 1925 Moholy-Nagy had written: "The camera can

improve, and even complement, the optical instrument which our eye is for us. This principle has already been applied in certain scientific experiments such as the study of movements (walking, jumping, galloping) and of mineralogical, zoological and botanical forms (enlargements, microscopic shots) as well as other studies in the natural sciences: but these experiments had remained isolated and the relations between them were not observed."[21]

It was precisely this connected relation between the fragments of a new reality that was shown and emphasized by the new photographers. Optical improvements in lens-making, together with improved sensitizing of film strips and the miniaturization of cameras, worked in favour of this new realism. As it came into fashion, it soon gave rise to the exaggerations which the German critic Carl Linfert denounced at the photography exhibition *Das Lichtbild* (Essen, 1931): "Since Renger-Patzsch, photographs have in fact taken on a frightening quality... The mania for watching things and photographing them has grown to such proportions that everything is collected but in the end nothing is perceived... The object itself, however rigorously the camera fixes and records it, has become more mute than ever before."

Fragments of a new reality

Karl Blossfeldt (1865-1932):
△ Fern (Aspidium spec.), between 1900 and 1928.
◁ Fern (Adiantum pedatum), between 1900 and 1928.

Aenne Biermann (1898-1933):
Composition: Eggs in String Bag,
c. 1932.

Objects of experiment

This was certainly not the case with the American photographers, among whom Weston now stood out as the leading figure. In the new pictures they gave of nature they sought out what Stieglitz called "equivalences," visual echoes of their intuition. And Ansel Adams—one of the most original of the newcomers, for whom the discovery of Paul Strand's work was decisive—went even further. Through scientific verification of all technical data he reached a level of skill enabling him to catch the subtlest variations of substance and light. A nature-lover, he extolled in his work the most beautiful landscapes of the United States in a language of his own which found its poetry in its rigour and integrity.

For Weston the camera was a revelatory medium: "The camera sees more than the eye, so why not make use of it" (*Daybook*, 1926).[22] His view was that the photographer must picture the final image completely in his mind even before snapping the shutter. By the sharpness of his prints, he led the eye to remember all the details, as if each negative had been the sum total of a long optical promenade. The collective name chosen in 1932 by the young photographers who admired him is significant: Group f. 64, the technical designation for the smallest lens opening, the one that produces the greatest sharpness of definition.

The world was an open field for these photographers: there could be no hierarchy of subjects. Everything, anything, was worth looking at and recording, from the sky and landscape to the geology of the earth, the fleeting instant of a particular light effect, the moist stems of plant life and the rhythm of their growth. They looked at everything with fresh eyes, as if they had never noticed it before. Even the most insignificant aspects of reality were searched out again and again; the simplest things seemed in their eyes to deserve a privileged place, because overlooked and unnoticed for too long. That they repaid scrutiny is proved by the lasting fascination of the photographs made of them.

And so often the most commonplace things proved the most stimulating for the photographer, bringing out best the singularity of his own vision—regardless of the ambiguities lurking behind that word "vision," which serves to express both what the artist sees and what he dreams of seeing. A way around it was suggested by artists like Wols, a German painter who in Paris in the 1930s made his living as a photographer, and Florence Henri, a French painter and advertising photographer formed in the Paris circle of Purist painters; also by the German photographer Aenne Biermann. By their peculiar choice of subjects, by their composition and *mise en scène*, they suggested the possibility of a third way in which the object no longer acted as a subject but rather as a polarizer of subjective or symbolic associations. Going beyond themselves, they found something of that transcendental power of the camera which their American contemporary Clarence J. Laughlin described as "the third world of photography"—the realm of spiritual insight or supernatural phenomena, which exists whether we realize it or not. Some of Laughlin's photographs actually show ghosts, and his "poems of the inner world" give us disturbing intimations of the strange and marvellous, of the Unknown whose mysteries are all too often veiled or overshadowed today by science and technology.

Florence Henri (1893):
Abstract Composition with Plate, 1931.

Man Ray (1890-1976):

◁ Face, 1920.

▷ Still from
 L'Etoile de mer,
 film after a poem by
 Robert Desnos, 1928.

IMAGES OF THE INVISIBLE

The Hungarian artist László Moholy-Nagy saw two lines of development for photography: the documentary record, focusing on visual reality, and "the luminous image answering to a deeper sense of the inner life." This latter approach was resolutely taken by the Dadaists, then by the Surrealists, who used photography with the same uninhibited resourcefulness with which they used other art forms.

It was in New York during the First World War, in the circle of Marcel Duchamp, that "imaginary" photography made its first appearance. Duchamp took it up because he was more interested in processes and their meaning than in aesthetic results.

Friends and accomplices, and precursors of the Dada movement, Picabia and Duchamp made a name for themselves in the United States in 1913, with the paintings they exhibited at the Armory Show. Paying his first visit to New York in 1913, Picabia was one of the few European artists to be present in person at the Armory Show; he met Stieglitz and began exhibiting at the 291 Gallery. Duchamp and Picabia had been close friends since 1910, when both began developing their talents in the direction of the absurd and ironical, adopting a radical anti-aesthetic stance in reaction against traditional artistic ideals which they considered obsolete.

In their campaign against naturalistic representation, they took the machine-object as their ally: the latter served them as a psychological or symbolic reality roughly equivalent to *trompe-l'œil*. For them art was not delineation but an object to be singled out and featured. This is what Picabia had in mind when in 1916 he wrote in Stieglitz's magazine *291*: "We create, to begin with, an objectivity in which we then place our subjective will. Our work then becomes the mental and metaphysical expression of the outside world; that is to say, it becomes a living object in itself, having its own expression." Duchamp's objects diverted from their function were in fact eye-fooling objects, presented no longer as replicas of nature but as statements of nature itself. Such was the case with his Readymades— found objects imitating nothing but themselves and presented as works of art. Duchamp thus arrived at the limits of painting and sculpture, as André Breton recognized in 1935: "It is unacceptable that drawing and painting should still be today at the point where writing was before Gutenberg. The only way out, in these circumstances, in to unlearn how to paint and draw."[1] Which is precisely what Duchamp was doing.

Since for Duchamp the idea counted for more than the object and alone justified the presence of the object, then why not use photography, a mechanical art offering an ideal opening for this dedicated breaker of illusions? Here better than anywhere else he could shatter the appearances of a society solidly set in its ways and ironize over its conventions and fictions. So Duchamp turned to photography in order to record his objects, his Readymades, and to commemorate the "happenings" in which he was already engaged. And here his meeting with Man Ray was decisive. The latter, a native of Philadelphia brought up in New York, had been introduced to avant-garde circles by Stieglitz in 1913. In his paintings Man Ray was already using mechanical means, having invented his Aerograph or "pistol painting," made by spraying the colour with an air gun; for he, too, was more interested in the creative act than in the aesthetic result. Poetry for him, as for Duchamp, was in the play of free fancy; both preferred life to art.

Man Ray came to photography in all innocence, using it at first merely to reproduce his paintings. By also reproducing the paintings of others he found he could earn a living with his camera. In doing so he discovered that photography could be as valid a creative medium as painting. It gave him a different

avenue of approach to the visible world. His invention of the Rayograph, or cameraless photograph, was the result of his intuitive aptitude for automatic, mechanical production. The Rayograph drained the image of any naturalistic references, presenting reality in terms of its unsuspected abstract content. But photography also offered a means of recording random effects and flukes. This was demonstrated by *Dust Breeding*, a work of Duchamp's photographed by Man Ray but "executed" by passing time. Such an approach opened up new possibilities for photography, and sensing this André Breton wrote in *Les Pas perdus* (1924): "The invention of photography has dealt a death blow to the old means of expression, both in painting and in poetry. As regards the latter, the automatic writing which appeared at the end of the nineteenth century is nothing less than a photography of the mind."

From this point on, photography provided artists with a whole new medium of expression, an open field of applications permitting them to bring light and movement into action and to record effects of chance more tellingly than ever before. In *Precision Optics* we have an experiment in stereoscopic cinema carried out by Duchamp and Man Ray Movement combined with the phenomenon of optical permanence conjured up a vision of circles and spheres which were never actually materialized.

The uprush of subjectivity

Raoul Hausmann (1886-1971):
Collage Head of the Poet Paul Gurk,
1918-1919.

With photomontage, the photograph was no longer made but put together out of the débris and industrialized fragments of a machine civilization. As the constituent element of a work of art, the photograph provided pieces of reality whose combination, whose montage, overflowed ordinary meanings and functions, while remaining closely connected with the everyday world—but a world so refocused as to show up the telltale gaps between reality and its images.

An automatic technique, in the surrealist sense of the term, photomontage also favoured the discovery of "what is visible only within myself" (Max Ernst). An offspring of the cubist collage, photomontage came to the fore in the context of Berlin Dada—one of the marching columns of the revolution. The cubist collage had offered a new manner of representing, one better attuned to the contemporary sensibility because based on discontinuity and discrepancy; but photomontage enlarged its meaning by putting this new method of image-making directly into the service of the masses and mass political activity. The need for a well-defined, well-motivated contemporary art was stressed by Richard Huelsenbeck in 1918: "Art depends in its execution and direction on the time in which it lives... The best artists, the most remarkable, will be those who, at every passing hour, pull the tatters of their bodies together in the hubbub of life's cataracts and, coming furiously to grips with the intellect of the times, bleed from their hands and their bodies... The word Dada symbolizes the most primitive relation with surrounding reality; with Dada a new reality takes possession of its rights."[2]

Hannah Höch (1889-1979):
Da-Dandy, 1919.
Collage.

Not only did the Dadaists put their works together out of materials taken straight from life, but they had no intention of being "artistic." For one of them, the Berliner John Heartfield, the artist's work was only "one way of fighting for liberty and revolution." This breakaway from "the accepted idea of art," by means of the collage and the tract, was carried out in the simplest, most direct terms, comprehensible to all. It depended on representation as opposed to aesthetic research, its purpose being immediate communication. Of all the means invented by Dada, photomontage was the most useful and most used, for by its very reality it questioned the objectivity of appearances. All the Dadaists seized on the extraordinary expressive possibilities of this medium, whose paternity they would later dispute. Probably it was invented by Raoul Hausmann in 1917, and his companion Hannah Höch used it too, most effectively, to denounce the prevailing absurdities. For Hausmann himself, who stands out as one of the most important photographers of this generation, photomontage also opened the way for a salutary return to the object: "With the discovery of photomontage, I adopted a super-realist attitude, which permitted me to use a perspective with several centres and to superimpose objects and surfaces."

In a lecture given in 1931 at the opening of the First International Exhibition of Photomontage in Berlin, Hausmann said something about the conditions and scope of his invention: "While the content, the actual idea of photomontage, was revolutionary, its form was equally subversive. The use of

△ Willi Baumeister (1889-1955):
Head, c. 1923. Pen and pencil over collage.

△△ Kurt Schwitters (1887-1948): Film, 1926. Collage.

◁ Max Ernst (1891-1976):
Health Through Sports, c. 1920.
Photographic enlargement of a collage
of photographs worked over with ink.

photography, in close connection with the texts, constituted a synthesis transforming the whole of the static film. The Dadaists... were the first to use photographic material which, on the basis of structures not only incongruous but often conflicting because of their properties as objects and their different spatial positions, went to create a new unity, one that from the chaos of that period of war and revolution brought forth a vision-reflection which was optically and conceptually new. The Dadaists realized that their method contained a propaganda potential which the life of their time did not have the courage to develop or integrate."[3] But Hausmann was also aware that the new medium had within it the power to renew aesthetic standards: "In this conception of photomontage, the optical element represents an extremely varied and variable element because of its structural and spatial discrepancies; because of these discrepancies between the rough and the smooth, between the aerial view and the close-up, between perspective and plane surface, the photomontage offers the widest technical variety; that is, the most elaborate working out of the dialectic of forms."

In Cologne Max Ernst gave his own personal interpretation of photomontage, which he discovered after his experiments with collage. And between the two he made little distinction. In both he saw "the *chance meeting of two remote realities on an unsuitable plane* (to paraphrase and generalize the famous remark by Lautréamont: *Beautiful as the chance meeting on a dissection table of a sewing machine and an umbrella*); or, to put it in briefer terms, it is a matter of cultivating the effects of a *systematic bewilderment*, according to the view of André Breton."[4]

This art of montage originated with the cut-out, the object being removed from its usual setting, then put into an unexpected relation by one or more chance encounters which reveal to the artist his own subjectivity. In these random combinations Max Ernst discovered "the elements of a figuration so remote that its very absurdity provokes in me a sudden intensification of my visionary faculties, a hallucinatory succession of contradictory images, double, triple, multiple, superimposed upon each other with the persistence and rapidity characteristic of amorous memories and visions of somnolescence."[5] Ernst made the most of this, one of the most fruitful and self-revealing of the automatic techniques of Surrealism.

In his account of the invention of photomontage towards the end of the First World War, Raoul Hausmann dwells on the fact that this technique gave him and others the exhilarating sense of acting as "art engineers," contrivers of unknown realities. Something of the same exhilaration lay behind Constructivism, the abstract geometry soon to be known as Concrete Art. Baumeister, Schwitters and El Lissitzky created images whose sole reference to reality lies in the actual materials of which they were made—materials often picked up from the rubbish heap, the detritus of our consumer society. But their work was not merely a new aesthetic based on discrepant components: it set out to express modern life and its contradictions, to embody a way of seeing based on discrepancy and difference. By emphasizing contrasts it disrupted the usual order of things, the optical harmony of appearances, and gave free rein to the artist's power of decision: from his choices sprang the new ideas. Here photomontage no longer referred back to an external reality, it acted directly on the

El Lissitzky (1890-1941):
The Builder (Self-Portrait), 1924.
Zincography.

Laszlo Moholy-Nagy (1895-1946):
◁ How I keep young and handsome?
1925. Photomontage.
▷ The Shooting Gallery, 1925.
Photomontage.

spectator and was keyed to a context of significant human attitudes: "This fragmentation has concretely released a whole aggressive drive, evidenced in the very snip of the scissors. The Great War was a mammoth process of smashing to pieces, in this unique of its kind... The soldiers and their officers were therefore haunted by unfathomable anxieties, by phantasmal visions of being cut to pieces... Collage and photomontage offered an artistic medium in which these anxieties, these phantasms of slashing and cutting, were subjected to a process of cultural sublimation and found release in pictorial representation," writes Eberhard Roters.[6] Hausmann, for his part, stated: "It is safe to say that photomontage, like photography and the silent film, still has much to contribute in unforeseeable ways to the education of our eye, to our knowledge of optical, psychological and social structures. And it will do so thanks to the clarity and accuracy of its means, in which content and form, meaning and statement, overlap and are inseparable."[7]

The Russian conception of montage was diffused in the West by El Lissitzky and Moholy-Nagy. They "mounted" images for the purpose of educating, but they did so with modern materials. Significantly enough, as Moholy-Nagy observed, the starting point was a mechanical process: "In most cases the possibilities of creating something new are worked out slowly, by way of previous forms, instruments and structures which the appearance of the new has in actual fact already exhausted, and which nevertheless, under pressure of the new in the making, experience an exuberant flowering... It may be supposed, with due caution, that some of the painters working today with realistic (neoclassical or veristic) means are preparing a new form-structure of visual representation, which will soon be using no more than technically mechanical means."[8]

One of the most important of the new men, as an innovative designer, maker and creative influence, was László Moholy-Nagy. A Hungarian, born in 1895, he was attracted by the possibilities of light, with which he experimented in sculpture, painting and photography. Schooled in the MA (Today) group in Budapest, he shared the views of the Russian productivists. Convinced of the key role of art

in the making of twentieth-century man, he took up photography in 1922. For him, modern technics had broadened the field of sensory experience and opened up a range of possible applications which the creative artist had to explore and test. Appointed to the teaching staff of the Bauhaus in 1923, he exerted a strong influence, for his pragmatic approach enabled him to see and follow up the subtle connections between artistic creation, political life and the scientific, intellectual and social aspirations of the contemporary world. Photography obviously gave him an ideal medium for his experiments with light, and in his book *Malerei Fotographie Film* (1925) Moholy-Nagy revealed himself as one of the best analysts of its potentialities: ''It must be borne in mind that reproduction (repetition of already existing relations), being devoid of any enriching aspects, is in the best of cases no more than a matter of virtuosity. Since production (productive creation) serves above all man and his development, it is for us now to adapt to productive purposes the facilities (means) hitherto employed for purposes of reproduction.'' With this in mind he also tried his hand at film-making.

For Moholy-Nagy art is ''the most intense and most inward language of the senses, and no individual in our society can do without it.'' But he saw in photography and film the most effective means of communication available today, and he himself put new life into them by experimenting not only with their constituents but also with their effects. In his experiments with the technical data of reproduction, he sought to enlarge the fields of human perception, to renew the receptive capacities of the spectator, to expand his awareness while liberating his fantasy, sensibility and intelligence. He introduced a new dynamic of vision by acting on the principle that ''seeing, feeling and thinking are co-ordinates and not a sequence of isolated phenomena.'' In this he succeeded so well that publicists have taken over his ideas and put them into practice. For Moholy-Nagy, creative art could no longer be a matter of single works: he saw the art of his time in terms of a series or sequence of works directly connected with the use of industrial techniques. Repetition did away with originality and made the image a component part of a whole from which it was inseparable.

Heartfield and the political dimension of seeing

John Heartfield (1891-1968):
"Never again!", 1932.
Photomontage.

Born in Berlin in 1891 as Helmut Herzfelde, John Heartfield anglicized his name as a protest against German nationalism. Closely associated with the satiric painter George Grosz, he militated from 1916 in the Berlin circles of the revolutionary avant-garde, before becoming one of the most active members of Berlin Dada. It was Heartfield who gave the art of photomontage its political dimension. What prompted him to take up photography was explained by his brother Wieland Herzfelde and his friend Grosz: "This thirst for images now to be found in the masses is stronger than ever before and it cannot be satisfied by what we are accustomed to think of as art, with our traditional show-case concepts. Illustrational photography and film-making are the only ways to satisfy this need... With the discovery of photography begins the twilight of art."[9]

Throwing in his lot with the communists in the 1920s, John Heartfield regarded the work of the artist as "a means of fighting for liberty and revolution." With his first collages he realized how effective an instrument this art of cutting out and recombining might be in the simultaneous struggle against the existing social order and the art and culture of an entrenched bourgeoisie opposed to the aspirations of the proletariat. Such were Heartfield's views—not uncommon in the aftermath of the First World War and the Russian Revolution. From then on he evaluated his work according to its practical effectiveness, its contribution to the struggle first against capitalism, then against the Nazis, and the collusion between the two. His art was not designed for contemplation; it was an incitement to action, and in photomontage he found the most telling form for his analysis and critique of political and social

realities which he was bent on changing. Using shock effects and visual and spatial contrasts, he also challenged the homogeneity of classical illusionist art and exposed its underlying contradictions. In a talk given in Moscow in 1931, Heartfield set forth his ideas: "Photography is a mechanical device; photomontage is a piece of work done with the products of photography. This entire process forms one whole. The expression 'shoot a film' is reactionary; we must say 'mount a film', that is, construct it, create it... If I assemble documents and juxtapose them with intelligence and skill, the effect of agitation and propaganda on the masses will be enormous. And this is what is most important for us. This is the very basis of our work. There lies our task."[10]

Heartfield entirely renewed the concept of realism by bringing it to bear simultaneously on the language of his art and its content. To convey new ideas, he invented new forms. His collages are often so subtle in their make-up that one is unable at first to detect where the discrepancy lies between the realities which he sets up against each other in order to denounce them. He generally extends the collage effect with a statement or slogan by which he pinpoints the deeper connection between facts and ideas. The whole point of this "breakdown" of reality was to prepare the way for political and social change.

Working from 1929 on for the Berlin weekly *Die Arbeiter Illustrierte Zeitung (AIZ)*, which had a circulation of one and a half million, Heartfield reached a wide audience and stood in the forefront of the anti-Nazi opposition in Germany. In 1933 he emigrated to Prague, and in 1935 he held an important exhibition in Paris at the Maison de la Culture. In a lecture there (2 May 1935) Louis Aragon summed up the artist's achievement to date: "John Heartfield *now knows how to salute beauty*. He knows how to create these images which are the very beauty of our time, because they are the very cry of the masses... because he speaks for the enormous host of the oppressed all over the world... Master of a technique which he has invented himself, unfettered in the expression of his mind, using as his palette all the aspects of the real world and shaking up appearances to suit his purpose, he has no other guide but dialectical materialism, no guide but the reality of the historical movement, which he translates into black and white with the frenzy of a fighter."[11]

John Heartfield (1891-1968): "As in the Middle Ages, so in the Third Reich," 1934. Photomontage.

The photogram

△ Laszlo Moholy-Nagy (1895-1946):
Photogram.

◁ Christian Schad (1894-1982):
Schadograph, 1918.

The photogram, an imprint of an actual object on light-sensitive paper, came to the fore in the experimental period of modern art in the 1920s. The procedure had already been discovered and used by both Talbot and Baldus in the earliest days of photography. The Dadaists now reverted to it with very different motives. The random element in this technique gave them just the chance they wanted to gamble with the "laws of chance"; it offered a loophole into the mysteries of self, into areas of fascinating bewilderment. And by dispensing with the camera, with the direct approach to nature, they found a roundabout way of connecting with reality, one that suppressed distance and appearance and depended solely on the direct intervention of light. Looking back over the history of this process in 1957, one of its inventors, Raoul Hausmann, said: "It must not be forgotten that the photogram is a free shape, and as such is governed only by the laws of correspondence between light and shadow on a two-dimensional surface. Instead of the normal marking-off of time in objective photography, here you get the immediate interpretation of a limited span of time. These new 'psychomorphic processes' being inseparable from a more or less lengthy movement, one may invoke here the concept of 'the individual instant'. The personal notion of time, which nowadays prevails in the photogram, depends on the sense of form peculiar to each creative artist."[12]
Even more than photomontage, the photogram releases that "marvellous faculty which enables us, while remaining within the field of our experience, to reach out to two remote realities and throw a spark across the gap between them; to bring within the scope of our senses certain abstract figures, lending them the same intensity, the same salience as others" (André Breton, *Les Pas perdus*, 1924).

In Geneva, where he settled in 1918, the German Dadaist Christian Schad hit by chance on this technique of "cameraless photography," permitting the artist to record actual objects in their actual size. Publishing some of Schad's photograms in *Dadaphone* in 1920, Tristan Tzara dubbed them Schadographs.

The photogram was also discovered independently by Man Ray, in Paris in 1921: "Again at night I developed the last plates... One sheet of photo paper got into the developing tray—a sheet unexposed that had been mixed with those already exposed under the negatives—I made my several exposures first, developing them together later—and as I waited in vain a couple of minutes for an image to appear, regretting the waste of paper, I mechanically placed a small glass funnel, the graduate and the thermometer in the tray on the wetted paper. I turned on the light; before my eyes an image began to form, not quite a simple silhouette of the objects as in a straight photograph, but distorted and refracted by the glass more or less in contact with the paper."[13]

Moholy-Nagy and El Lissitzky also made photograms. Imbued with the theories of the Russian productivists, they saw in it another method of collage, another system of image-making. Working with abstract forms, they emphasized the role played throughout the operation by the artist's power

Man Ray (1890-1976):
Rayograph, 1936.
Silver print.

of decision, by his choice of objects and the length of their exposure. They found in it, what was greatly to their liking, a mechanical means of "making paintings," quite different from the traditional technique of oil painting. Moholy-Nagy wrote: "My photographic experiments, especially photograms, helped to convince me that even the complete mechanization of technics may not constitute a menace to its essential creativeness... Camera work, photography, motion pictures, and other projective techniques clearly show this. It may happen that one day easel painting will have to capitulate to this radically mechanized visual expression. Manual painting may preserve its historical significance; sooner or later it will lose its exclusiveness. In an industrial age, the distinction between art and non-art, between manual craftsmanship and mechanical technology is no longer an absolute one. Neither painting nor photography, the motion pictures nor light-display can be any longer jealously guarded from each other."[14]

◁ Piet Zwart (1885-1977):
Publicity leaflet:
"Via Scheveningen Radio PCH," 1929.
Photomontage, photogram, and gouache.

◁ ◁ Laszlo Moholy-Nagy (1895-1946):
Photogram, 1922.

In the hands of the Constructivists and Surrealists photography proved as never before its unique power of revealing unknown or invisible phenomena—a new wealth of insights into life and experience. Tribute was paid to that newly recognized power from 1929 on in a series of international exhibitions, an increasing number of specialized publications, and the use of modern photography in advertising. Photographic images were now expected to surprise and shock, and they did. Their fascination cast a spell, making them a popular medium of communication, ousting drawing in the arsenal of publicists. They became indispensable in the world of modern fashion and decoration. But the more dynamic the photographer, the more passive the spectator. The former, the concept-maker, reshaped the interpretation of reality by the spirit and focus of his presentation of it.

In 1930, in a special issue on photography of the Paris magazine *Arts et Métiers graphiques*, the critic Waldemar George in an important article emphasized its key role in advertising and the renewed awareness of reality which it was promoting: "It brings into the foreground the 'object set free'. The notion of the *object* being dissociated from the notion of the *subject*, the photographer resorts to figuration, without being anecdotal or merely descriptive. He presents his *motifs* in contrast against an arbitrary background. He considers them as essentially plastic facts, even as he proceeds to throw organic functions into relief and display the internal mechanism of an aeroplane engine or the ingenious arrangement of a trunk. Advertising photography means photomontage."[15]

△ Studio Deberny Peignot:
Publicity for Devambez pencils, Paris,
published in *Arts et Métiers Graphiques*,
Paris, 15 March 1930, special number
on photography.

▷△ Piet Zwart (1885-1977):
Publicity for the
NKF Cable Factory,
Delft, c. 1928.

Photogram
and
design

These views agreed in essentials with those expressed in 1929 by Wilhelm Kästner, who organized the exhibition *Photography of the Present* held that year in Essen, and also shown in Berlin, Vienna and London. Kästner drew attention to the fact that photography, in its modern role of lifting reality from its context to give it an independent life, can find no better application than in advertising: "Here is the explanation why there are no longer any admirers of landscape, or few of them any more, while on the other hand there is a domination of the simplest objects, especially of everyday objects, preferably mass-produced and (unlike still life) all heaped together. This is a characteristic of the transition from a free pictorial, purely artistic creativity, in the sense given to the term by painting, to applied photography in the service of advertising."[16] In other words, photography gained a new impact by performing a vital function in our culture. And many artists—precisely those who knew and proved that "representation carried out from an original point of view tends to creation" (Moholy-Nagy)—were able to find in advertising and fashion photography a good livelihood without having to dissociate their creative activity from a profit-earning production. For while the public accepted photographs now as a source of visual interest and stirring emotions, it was not yet ready to accept them as works of art; it was not ready to collect them (as it is today) like drawings or paintings.

Just as our civilization was becoming accustomed to see the object presented for its own sake, unrelated to any purpose, the signifier was freeing itself from its old subjection to the signified. It even lost its documentary value when the creative artist found that he could act abstractly by way of form, light and texture alone, independently of subject matter. Optical construction could then intervene as an abstract visual language. This was the view expressed in 1928 by the German typographer Jan Tschichold in his manual *Die neue Typographie*: "Today with the help of photographs we can express many things better and faster than by the inconvenient channel of the spoken word or of writing. The photographic negative thus takes its place alongside the letters and lines of the typographer's type-case as a modern but distinct element of typographical structures."

The new use, the multiple uses, of photography did much to open the public's eyes to the experiments and discoveries of the avant-garde. But the expertness aimed at and cultivated in this application forced vision back into the system of fashions, so that the photographic effect—consumed as soon as produced—had to be constantly renewed in order to keep its impact. Surprise, novelty or provocation became the essential ingredients, forcing photography to submit to the same market laws as industry and economics. The 1930s introduced a new taste based on a simple working principle: maximum effect with a minimum of means.

Herbert Bayer (1900):
Poster of 1929 for the German Section
of the Decorative Arts Exhibition,
Grand Palais, Paris, 1930.

A dynamic vision: Raoul Hausmann

Raoul Hausmann (1886-1971):
◁ Nude with Fair Hair, 1931.
▷ Light-Mill: Waste-Paper Basket lit up from within, 1931.

Electric light is one of the mainstays of our civilization, and light, whether electric or natural, is at the heart of the photographer's activity. It even became the principal feature of the work of two artists who, in both their theory and practice, exerted a dominant influence in the period between the wars: László Moholy-Nagy and Raoul Hausmann.

Born in Vienna in 1886 and active at first as a painter, Hausmann became one of the moving spirits of Berlin Dada in its heyday (1918-1920). After inventing photomontage in 1917, he switched over to photography and devoted himself to it wholeheartedly, his conviction being that it represented "the art of our time." He proved to be one of its most lucid experimenters. He was more adept than anyone at exploiting the power of light, while contriving to show up the odd divergences that exist between the human eye and the camera eye. In an important essay of 1932, Hausmann developed his view: "It proves necessary to point out a law which the sciences have not yet discovered: the transitory, historically alterable equilibrium of man's organic deficiencies—in relation to the animal and vegetable world—is maintained by technical and artistic sublimation (superstructure). Seen from this dialectical standpoint, the revolutionary periods that occur in art, technics and social life are complementary. This interrelation implies that a new conception of photographic optics is also called upon to play an important part in the transformation of social knowledge... It is still assumed that the human eye sees with the same precision all objects in their spatial recession, one behind the other, and that the precision of the camera lens is limited to certain zones. In reality the human eye, in the process of seeing, follows a sequence of viewpoints round which all the rest is blurred, and the apparent precision of the different parts of space is only arrived at afterwards by the conscious mind, that is to say by the imagination, by the innate aptitude for representation. This sequence of multiple viewpoints goes hand in hand with a perspective which differs from the usual perspective."[17]

On the strength of this experience, Hausmann deliberately set out to use photography as a means of gaining new knowledge about reality, its scope and limits. It is this abiding purpose behind his work which gives it its peculiar poetry. In all his writings Hausmann insisted on the educating power of art and the camera's destined role as a catalyst in the transformation of the modern mind: "Under pressure of the monstrous events of our time, all solid values have become uncertain and relative. Art above all, as the intuitive teaching which man gives himself in his effort to recognize the world in himself and himself in the world, is thus compelled to take up a different position... But nothing perishes without something new being born. We are witnessing the beginnings of a new man and of his new outlook on the world in the realm of optics."[18]

Man Ray (1890-1976):

◁ Meret Oppenheim, 1934.
Solarization.

▷ Nusch Eluard, 1935.

Man Ray and the poetry of light

In an article of 1922 on Man Ray's Rayographs, Tristan Tzara wrote prophetically: "After the great inventions and the tempests, all the little frauds of sensibility, knowledge and intelligence are swept away by the blasts of the magic wind. The negotiator of luminous values takes up the bet proposed by the stable boys. The amount of oats they dole out morning and night to the horses of modern art cannot trouble the thrilling course of its game of suns and chess."[19] Tzara was prophetic because for Man Ray light was the cause and source of all surprises. From his restless, inventive mind stemmed the Rayograph, and he was the man behind the so-called solarizations, "a deviation with respect to the principles of good photography," which in the course of developing and printing permitted him to act on contours and volumes to the point of dematerializing them.

Man Ray recognized from the start that painting and photography do not overlap, that they call for different subjects and yield different effects conditioned by their different nature and possibilities. "What I paint is impossible to photograph. It originates in the imagination or a dream or an unconscious impulse. But what I photograph are objects that really exist."[20] For him photography was the medium that forced him to face and cope with reality; but by manipulating light he was also able to "denature" reality sufficiently to allow his own subjectivity to have its say. A friend of André Breton and an active member of the surrealist group, Man Ray was constantly on the look-out for the bizarre or random images lurking in the world around us. And for recording them photography was an apter medium than painting. It was better able to reveal the "purely inner model" to those capable of putting themselves into a state of waking receptiveness, those resourceful enough to invent the accidents or chance occurrences which bring with them the insights of self-discovery.

Surprise and trick effects

△ Herbert Bayer (1900):
Self-Portrait, 1932.
Photomontage.

◁ René Magritte (1898-1967):
God on the Eighth Day, 1937.

For Man Ray light was the source and stimulant of innumerable revelations, through its power of transforming appearances. Always intent on seeing things from a fresh angle, in a new light, he endorsed the view of André Breton: "One runs the risk of falling away from Surrealism, unless the automatic impulse continues to function at least *underground.* A work can be regarded as surrealist only in so far as the artist has striven to attain the total psycho-physical field (of which the field of consciousness is only a small part)."[21]

As one of the foremost surrealist photographers, Man Ray believed in the revelatory power of automatism and acted on that belief: "If we had not had full confidence in the automatism of the artist's eye functioning with a social awareness imposed by his very psychology, then the force of automatism would have melted away in the maze of individual weaknesses. But when that automatism was left to itself, unfettered, the results, with a few exceptions, entirely justified our confidence in it."[22]

The Dadaist and Surrealist approach to photography as an exploration of the imaginary, as an uncharted field of revelations and self-discovery, was followed up in the 1930s. André Kertész loved the unexpected and was always ready to be surprised. Herbert Bayer sought out the unexpected systematically. Schooled at the Bauhaus in the early 1920s, Bayer had the ability to create strong visual shocks, generally in a constructivist spirit and by an overlapping of events which displaces and renews the "normal" awareness of reality. Hans Bellmer made his name by the photographs he took of his strange doll, published in the surrealist review *Minotaure* in December 1934 as "Variations on the montage of an articulated under-age girl."[23] Here he developed for the first time the sense of hallucination induced by the confusion of different elements which, as mounted and joined together, are turned into fetish objects, in the Freudian sense of the term.

170

The Belgian painter René Magritte only dabbled in photography as an amused amateur. But whenever he did take up his camera, he used it in a spirit very close to that of his fellow Surrealist Man Ray. That is, he used it with a critical aloofness enabling him to single out the threefold relation between the reality of the object, the name of the object, and the forms of its representation. And his titles were chosen to emphasize the gap or distortion between the signifier and the signified. As a painter, however, Magritte practised too representational a form of painting to be much tempted by photography. But the question he put years later, in 1966, to the French philosopher Michel Foucault, "May not the invisible then be sometimes visible?", is the very question which artists who experiment with strangeness are bound to ask themselves. As Magritte wrote: "Resemblance does not exist among Things: they have, or do not have, similitudes... But painting brings in a difficulty: here it is thought which sees and which can be described visibly... On condition that thought shall be exclusively composed of visible figures. In this matter it is obvious that a painted image, which by its nature is intangible, conceals nothing, whereas the visible that can be touched inevitably conceals another visible, if we trust our experience."[24]

The need to explore the unexplored, to see with insight as well as sight, was well expressed by Max Ernst in his catalogue preface for a surrealist exhibition in Zürich in 1934: "The joy one takes in a successful metamorphosis answers, not to any mere aesthetic desire for distraction, but rather to the age-old need of the mind to free itself from the illusory and boring paradise of unchanging memories and to seek out a new field of experience, an incomparably wider field where the frontiers between the inner world, as it is agreed to call it, and the outside world (according to the classic philosophical conception) become more and more blurred and, in all likelihood, will disappear completely when more precise methods than automatic writing will have been discovered."[25]

Hans Bellmer (1902-1975):
The Doll, photograph published
in *Die Puppe*, Karlsruhe, 1934,
and *La Poupée*, Paris, 1936.

Berenice Abbott (1898):
Newsstand, Manhattan, 1935.

▷ Pierre Boucher:
Cover of the magazine *Photographie*,
Paris, 1940. Collotype.

A SOCIAL DIMENSION

In the 1920s, in the fresh release of energies that followed the war, the press enjoyed an unprecedented development: text space shrank in favour of picture space; pictures invaded not only the dailies but also the weekly magazines, and these owed their style and character to the pictures they featured. The advent of photo-journalism revolutionized the status of the photograph: from a document before, it now became evidence, irrefutable proof. If it aimed at showing the full truth of reality, it failed; it could not succeed for optical, philosophical and conceptual reasons of which something has been said; even less now than before, because the ''censoring'' of the event took all sorts of forms including self-censorship. Having become ''functional,'' photography was less than ever a gratuitous activity; it brought into question the responsibility of the man or woman behind the camera. How, for example, to choose one picture out of ten or a hundred of the same subject: which one, for whom, on what criteria? Such questions, whether explicit or not, were always arising and could bring unforeseeable consequences in their train. And when photography gained a preponderant place in the economy of the press, when it alone could ensure the success or failure of a publication, such questions became crucial. The editor had to please, shock or beguile in order to win or keep his readers, and all too often his choices moved the public away from reality. And sometimes it was the photographer himself who censored his work in accordance with his own notion of it or his notion of what was expected of him. With its wide diffusion, the illustrated magazine should have made events accessible to all. To diffuse, to propagate, may also imply confusion. True, the photograph intended to record the essentials may also reveal the hidden, the fortuitous—the fullness of life overflowing unforeseeably into the picture.

A long evolution and some important technical improvements lay behind the place now taken by pictures in the press. In 1876, in Paris, Charles Gillot had opened a photogravure printing shop, where for the lithographic transfer he substituted the copy on zinc; but the woodburytype remained the most common system of reproduction, even though by this system the photographic image had to be printed separately from the letterpress; the image thus remained an inset plate. About 1880 came the invention of the halftone process, a method of photomechanical reproduction by means of a halftone screen. The first photomechanical illustration appeared in the New York *Daily Graphic* on 4 March 1880. Some years went by, however, before publishers and printers were able to make full use of this process, whose consequences in the world of communications and information were to be momentous. But by 1897 the New York *Tribune* was regularly using the halftone process on its rotary presses.

By then the public was already being accustomed to finding in the evening paper photographs taken the same day. More and more, response to events was through the visual medium, though words still moved faster than pictures. By 1907 the invention of the telephotograph transmitted on the Belin system began bringing the events of the world into the home of every newspaper reader. A new profession was born, that of photo-reporter, and the public looked to photography for a constant supply of pictures revealing at a glance all that was going on day by day, whether in near or distant places. The emotional charge of the news photograph reached its height in the famous picture by William Warnecke of the New York *World*, who happened to be at hand and with remarkable coolness photographed the attempted assassination in 1910 of William J. Gaynor, Mayor of New York, on board the ship on which he was about to sail for a holiday in Europe.

In the major newspapers and magazines, photographs appeared sparingly at first, very much subordinate to the text they illustrated. But by the end of the First World War the roles were changing. Pictures multiplied, spread out in sequences and became the main attraction of the page, the text being often reduced to a supporting commentary or even to a caption. The picture revolution brought a

The political testimony

Weegee (Arthur Fellig, 1899-1968):
Cop Killer, c. 1939.

◁ Erich Salomon (1886-1944):
Meeting of Foreign Ministers
in Lugano, Switzerland, 1928.
Left to right: Zaleski, Poland; Adatci, Japan;
Austen Chamberlain, Britain;
Stresemann, Germany;
Briand, France; Scialoia, Italy.

▷ Gisèle Freund (1912):
André Malraux speaking at the Congress
for the Freedom of Culture, Paris, 1935.

radical change in the look and layout of newspapers. In 1896 the *New York Times* began issuing a weekly picture supplement illustrated with photographs, and other papers followed suit. It was the German press, under the Weimar Republic (1919-1933), that popularized the magazine form that we still know today. In her book on "Photography and Society"[1] Gisèle Freund gives some figures which show how successful this new formula was. The *Berliner Illustrierte Zeitung* and the *Münchner Illustrierte Presse* both had a circulation of over two million. Their demand for sensational pictures was catered for by some outstanding photo-journalists, and the content of the paper was largely determined by their work; and if the news of the day failed to supply any interesting matter, it was up to them to invent something of sufficient human interest and appeal to make the paper sell!
Stefan Lorant, editor of the *Münchner Illustrierte*, shaped the trend of photo-journalism by his systematic refusal to accept any "posed" pictures. He was also one of the most influential promoters of the photo-reportage. Each page was centred on a *telling* picture which additional illustrations explained and situated. The growth and innovations of the German press came to an end in January 1933, with Hitler's fateful appointment as Chancellor, and the great editors and photo-reporters had to emigrate. Stefan Lorant settled in London, where he helped to launch the magazine *Weekly Illustrated* (1934) and became editor of *Picture Post* (1938). The best German photographers were

scattered, some going to Britain, some working in France for *Vu*, some in the United States for *Life*. Started in Paris in March 1928 by Lucien Vogel, *Vu* magazine was an illustrated weekly remarkable for the high standards and interest maintained by editor and contributors. Much to its credit is the fact that it was the first French periodical to take a stand against Fascism and Nazism. To ''bring before your eyes the life of the world'' (Vogel's stated aim), some numbers had as many as a hundred pages and four hundred illustrations. The memorable special issue on the Spanish Civil War led to Vogel's resignation, because of his political stand. Though it sold well, *Vu* depended heavily on its advertisers, and when Vogel lost their support because of his sympathy with the Popular Front and the Spanish Republic, his magazine was doomed: it ceased publication in 1938.

In the United States, the first number of *Life* magazine appeared on 23 November 1936. It owed much to the example of *Vu*. With its efficient organization and editorial skill, *Life* soon had a staff of seven hundred and a readership of forty million. But while bringing pictures of the whole world into every home, such ventures depended on a large capital investment and abundant advertising, which meant that profits often had to come before impartiality or truth. The road to success, to profits, necessarily went by way of constant novelty and sensationalism.

Continuing technical improvements, like the invention of the lightweight Leica and the flash bulb in 1925, facilitated the photographer's work. Fitted with several lenses, the Leica was a precision camera which could take thirty-six snapshots. It was so compact that the operator could use it without being noticed, and this had momentous consequences. Till then the photographer had to adapt himself to reality, to convoke it, as it were, and make it pose. By the 1930s he had become an image-hunter

Posing for posterity

Gisèle Freund (1912):
Portrait of Colette, 1939.

constantly on the watch for his prey; his presence unnoticed, he melted into the crowd, merged with his hunting ground; he was at work everywhere, most tellingly in the least expected places.

One of the most legendary of the early photo-reporters was Erich Salomon. A banker's son, born in Berlin in 1886, he studied law and came to photography quite by chance. He quickly made his camera an instrument of revelation about the world in which he moved, the closed circles of high society and diplomacy. He gained notoriety initially by publishing in the *Berliner Illustrierte Zeitung* of 19 February 1928 the first photograph ever taken of the proceedings in a court of law—which was illegal. Inquisitive and resourceful, Salomon proved that for a man like him, who knew the right people, closed doors were no obstacle: it was more difficult to keep him out than for him to get in. He moved easily and artfully in the rarified world of politics and finance. What he saw there, in Germany and all over Europe, he showed in *Famous Contemporaries* (1931), a book of 102 photographs, a modernized version of the *Panthéon-Nadar*. "The work of a press photographer who wants to be more than a

George Hoyningen-Huene (1900-1968):
Portrait of Jean Cocteau, 1932.

journeyman," wrote Salomon, "is a continual struggle for his picture. Just as the hunter is obsessed by his passion for hunting, so the photographer is obsessed by the *one* photo he has set his heart on. It is a continual battle."

The press ensured international fame for the men and women it pictured day after day. Artists, actors, stars, statesmen, scientists, those at the top of their profession, became public property, their airs, oddities and features familiar to all. It is interesting, though, to note the different ways of showing those whose activity it was proposed to popularize and those who were proposed for public admiration. While politicians were presented with dynamism, the pose was preferred for scientific and artistic personalities, as if to safeguard certain mythical names. The growing use of press photographs gave them an ever extended role. They became functional and utilitarian, indispensable vehicles of knowledge and information, but at the same time they progressively modified taste, intelligence and sensibility. While on the one hand, in the context of economic profitability, photography was launched on an unremitting search for effect, on the other, especially in its application to advertising, it was given over more and more to a stereotyped image of pleasure, privilege and happiness. Called in to sell the product it illustrated, photography itself was for sale. Its impact was negative unless, as Walter Benjamin observed, the photographic operation was capable of yielding more than was expected of it. "Its precision technique can endow its products with a magical value which no painted image can rival nowadays. In spite of the photographer's technical mastery, in spite of the pre-arranged attitude imposed on the model, the spectator is forced in spite of himself to look in such images for the *tiny*

August Sander (1876-1964):
The Painter Otto Dix and his Wife, 1928.

spark of chance, of the here and now, thanks to which reality has, so to speak, burned away the merely picture character of the image; and he has to find, in the singular nature of that long-past moment, the imperceptible link to which the future clings even today, and yet a link so telling that with a backward glance we can still single it out."[2]

In the wake of Berlin Dada there arose in the 1920s a whole movement of critical realism. Collage and photomontage had renewed the effectiveness of figural art, and in their insurgence against the false idols and ideals set up by the bourgeoisie in power—bent on averting art from its purpose by averting modern man from his reality—George Grosz, Otto Dix and Christian Schad invented a figure style unsparingly harsh and aggressive in its forthrightness. Summoned before a magistrate in 1923 on a charge of circulating obscene images, Grosz declared: "Even by the representation of the ugliest things, and indeed precisely by the representation of those things, which admittedly shock some people, I believe that a great educational advance can be achieved." Embittered by the disasters of the war, committed to social and political reform, these artists felt the urgent need for men to join together if they wished to avoid a relapse into the horrors of the past. Focusing their eye on everyday reality and social injustice, they accepted the name of Neue Sachlichkeit (New Objectivity) applied to them by the critic G. F. Hartlaub for an exhibition of their work at Mannheim in 1925. In the catalogue preface Hartlaub wrote: "What we are showing bears the mark, in itself purely external, of

objectivity... Two groups here express themselves without constraint. One—it might almost be called a 'left' wing—elicits what is objective in the world of actual facts and projects the experienced event with its own rhythm and degree of warmth. The other is directed more towards the search for the object in its timeless value." Some photographers might well have been included in this exhibition, for their vision was close to that defined by Hartlaub: August Sander in particular.
Discussing the attitude of these "veristic" painters in the magazine *Das Kunstblatt* (1924), Paul F. Schmidt described a way of seeing which corresponds in all essentials to that of Sander: "They take up an inquiring position, very German and very polemical with respect to the object. The emphasis is put on a fanatical love of truth, impatient of problems of form and intent on direct statements about the present, about the chaotic side of a period of infamy which they mean to overcome by an objectivization of dazzling clarity."

The image of social man

Otto Dix (1891-1969):
The Artist's Parents, 1924.
Oil on panel.

△ George Grosz (1893-1959):
Supply and Demand, drawing
for *Über alles die Liebe*
("Love Above All"), Berlin, 1930.

◁ August Sander (1876-1964):
Chief Pastry-Cook, 1928.

The work of August Sander is an unrivalled documentary portrait of Germany in the 1920s—centred of course on people. Fixing his models inexorably, he reveals anew what was familiar but unregarded. Through facial features and attitudes, he reflects their occupations, their work, their position in the social scale, even their outlook on life and their political bias. Sander deliberately conceived the idea of making a photographic encyclopaedia of twentieth-century man, to comprise forty-five portfolios of twelve photographs each. But the only one he published was the introductory volume *Antlitz der Zeit* (1929): "The Face of Our Time." The novelist Alfred Döblin wrote the introduction, in which he spoke of a "sociology without text": "Just as there is a comparative anatomy which permits us to form an idea of nature and the history of bodily organs, so this photographer practises comparative photography, thereby attaining a scientific viewpoint far higher than that of the photographers who indulge in detail." But Sander's work was not acceptable to the Nazis, who on coming to power in 1933 seized the remaining stock of the book and suppressed it. It was only by chance that the negatives intended for the sequel escaped destruction. With prophetic insight Sander pictured the archetypes of the violence and brutality that were to sweep Germany in the 1930s; pictured them in spite of, or because of, his very stance of neutrality. For his discerning eye took him straight to the *representative* model. "It is not my intention either to criticize these people or to describe them."[3] In the result Sander proved himself the master analyst of the German society of his time.

The poetry of the street

Henri Cartier-Bresson (1908):
△ Boy in Granada, 1933.
△ ▷ Old Port, Marseilles, 1932.

Reportage also took the form of an idler's or stroller's diary, as he let his eye, and camera lens, record whatever happened to cross its field of perception and strike a resonant note in his sensibility. Among these responsive strollers were the French photographers Brassaï (who emigrated to Paris from Hungary), Henri Cartier-Bresson and Robert Doisneau. Rather like Atget or the poet Léon-Paul Fargue, they walk the streets, haunt the cafés and public places, letting their imagination wander, letting reality take them by surprise. Paraphrasing Picasso, one might say that they do not seek, they find poetry and the unusual at every level of daily life. "The precise instant of creation is when you choose the subject," said Brassaï, meaning that the essential thing occurs at the moment when he, the photographer, meets the reality he wishes to capture. In love with Paris, Brassaï devoted his first book to it, which made his reputation: *Paris la Nuit* (1933).

Cartier-Bresson is the free-lance reporter, always on the move, his unblinkered eye never resting. Everything interests him, especially people, and the ways, habits, joys and sorrows of everyday life. To record its characteristic moments, he intervenes with no preconceived ideas. Always on the alert, he waits for reality to disclose what it usually conceals, and with him anything can be the subject of a photograph. Invisible, ever present, receptive to every prompting, he is always ready to be taken unawares, wherever in the world he may be. All reality is at his beck and call.

▽ Robert Doisneau (1912):
The Brothers, 1934.

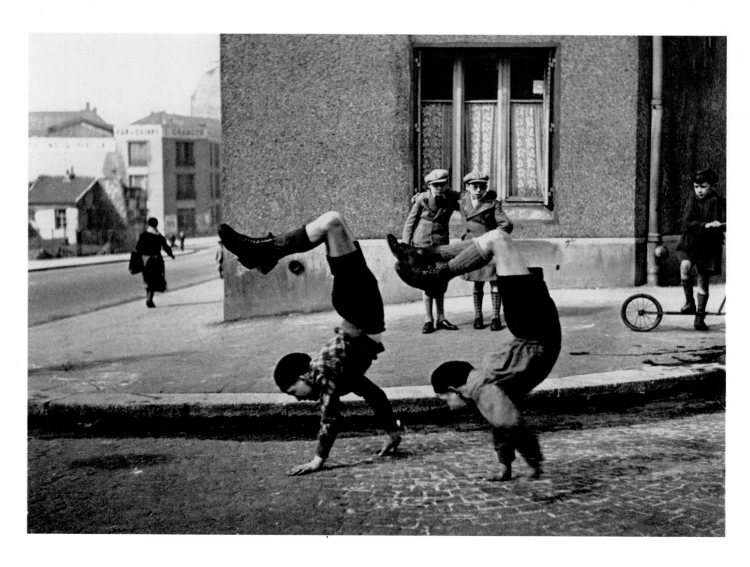

Realities of life:
the archaeology of the present

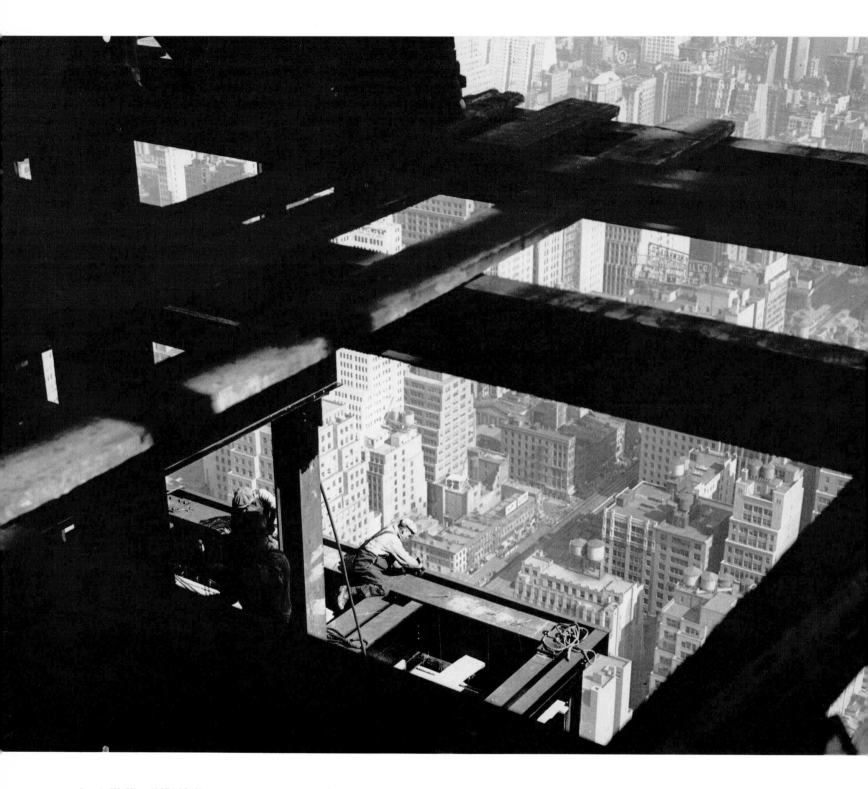

Lewis W. Hine (1874-1940):
On the Beam, Empire State Building,
New York, 1930-1931.

With Wall Street's famous Black Friday (24 October 1929) began an unprecedented economic and social crisis. The whole world sank into the Depression—at its worst in the United States and Europe. Unemployment, privation, hardship, were to be met with everywhere. Artists were not spared: their patrons melted away, galleries closed down, avant-garde confidence in scientific and technical evolutionism was broken. Creative art in these circumstances was less concerned with new or experimental forms than with the need, intensely felt, to give some meaning to life and suffering and retrieve an image of man. Here photography proved its effectiveness on the level of expression and communication. Because of its vital link with everyday reality, it was better prepared than any other medium to meet the calls now being made on art, and the best practitioners responded buoyantly to the wealth of subject matter around them.

To communicate their deepest feelings was the urgent task of artists. In an essay of 1930 the painter Fernand Léger summed up their current state of mind: "The problem of freedom in art is the livest of issues today. One may assume that abstract art, which is the ultimate expression of that freedom, has now reached its culminating point, a point at which all that it was possible to achieve in the way of pictorial escapism has been achieved... The reaction, the possibility of creative continuity in the face of abstraction, appears to be developing along the lines of a return to the subject." And Léger defined the nature of this new realism in the making: "There is a modern primitivism in the intense life around us. Never have visual, decorative, social events been so intense, so packed with new pictorial matter. The scientific creations of today open for us an unlimited field of unknown pictorial forms." And he concluded: "Modern life is so very different from the life of a hundred years ago that present-day art has to be the total expression of it." Photographers were ready to record this new reality because they saw it with a sharp, critical *and* mechanical eye which kept them from surrendering to artifice and sentiment. Working in this spirit, those who were both painters and photographers proved more inventive and resourceful with their camera than with their brushes. They used it without any mental reservations, knowing by experience and instinct where its intrinsic fitness lay. The eye worked in unison with the mind. The pictures of Edward Hopper and Ben Shahn, in the United States, are significant. Both painted, both photographed. Today their photographs have more appeal, because they are so rich in the political, sociological and scientific evidence for the contemporary scene to which we must still refer in the 1980s for an understanding of our time.

Fernand Léger (1881-1955):
The Constructors, 1950.
Oil on canvas.

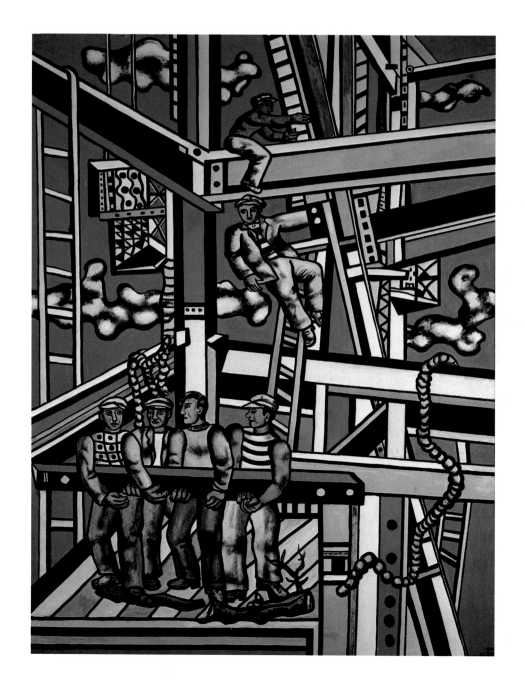

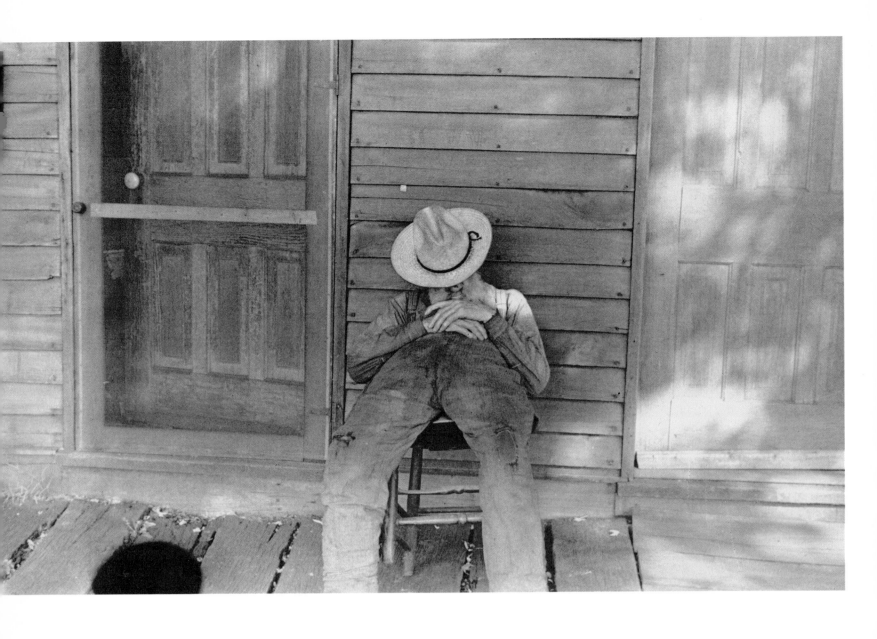

Tool of the new mass culture

Susan Sontag has a good point when she notes that our time makes art out of junk—the very principle of collage and assemblage—and that photography, by its multiplication, forms historical relics like a collage made on the scale of our memory: "Photographs are, of course, artifacts. But their appeal is that they also seem, in a world littered with photographic relics, to have the status of found objects—unpremeditated slices of the world. Thus, they trade simultaneously on the prestige of art and the magic of the real. They are clouds of fantasy and pellets of information. Photography has become the quintessential art of affluent, wasteful, restless societies—an indispensable tool of the new mass culture."[4] The collage principle underlying the photography of today is all the more evident because the photo-reporters work in terms of the sequence rather than the single picture. These sequences are tantamount to an inventory of fleeting and ephemeral realities bound to change or vanish, of casual or haphazard occurrences that cannot last. Photography thus becomes the recording instrument of the archaeologists of the present.

In the United States the harsh realities of the 1930s were recorded thanks to the initiative of the Farm Security Administration. Set up under the New Deal government of Franklin D. Roosevelt, it had the dual purpose of documenting the hardships caused by the Great Depression, especially in rural areas

◁ Ben Shahn (1898-1969):
In Circleville's "Hooverville," 1938.

▷ Dorothea Lange (1895-1965):
Cotton Picker near Firebrough, 1939.

▽ Edward Hopper (1882-1967):
Sunday Afternoon, 1926.
Oil on canvas.

An inventory of America

(some thirty-four million poor), and providing work for artists. Roy E. Stryker, a professor of sociology at Columbia University, had been using photography since 1930 to record the misery brought about by the collapse of the stock market in 1929. When in 1935 Rexford G. Tugwell was put in charge of the Rural Resettlement Administration (renamed in 1937 the Farm Security Administration), he called in Stryker as head of the historical section, whose immediate concern was to investigate and document rural poverty, as part of the Roosevelt government's campaign for political reform based on mutual aid and solidarity.

What Stryker asked of his collaborators was an accurate and circumstantial inventory, made in full knowledge of the history, geography and economy of the different regions they were assigned to cover; but they were free to cover them in their own way. He employed some of the best photographers of the day (among them Ben Shahn, Dorothea Lange, Walker Evans, Arthur Rothstein, Russell Lee) and the results made history. No one could fail to be moved by their record of so much human distress. No aspect of daily life escaped them, and the F.S.A. collection of 270,000 pictures of the plight of the poor in the 1930s is one of the greatest achievements in the social history of photography.

The same straightforward and searching gaze was characteristic of most of the great photographers of this period. They were conscious of contributing to the archives of the present.

◁ Russell Lee (1903):
Pie Town, New Mexico, 1940.

△ Arthur Rothstein (1915):
Son of a Farmer in the
Dust Bowl Area, Oklahoma, 1936.

Gisèle Freund (1912):
Out of Work, Newcastle-on-Tyne, 1935.

With the rise of Fascism and the outbreak of war in 1939, the professional photo-reporter came into his own. The newspaper and the news magazine depended on his pictures, even more than on the written word. They were an international language of communication, the one language needing no translation. Through them the people at home or in neutral countries could share something of the life and hardships of those in the front line. Their power of persuasion and stimulation, their propaganda value, were recognized by every government. Never had the prestige of photography been so strong, its testimony so influential in shaping opinion. One of the leading photographers of the day, Ernst Haas, could write: "With photography a new language has been created. Now for the first time it is possible to express *reality by reality*. We can look at an impression or an expression as long as we wish, we can delve into it and, so to speak, renew past experiences at will."

Photo-reporting, as an urgent daily necessity of communication, had its heyday in the 1930s and 1940s, before television was ready to take over. The photo-reporter enjoyed a privileged status, comparable to that of the liberal professions. His work was recognized as a vital necessity and, at least in the democratic countries, every facility was granted him: press card, laissez-passer, etc. His profession was strenuous, demanding and dangerous—some photo-newsmen paid with their life for a firsthand picture of war and violence, some performed acts of heroism—but it was internationally recognized.

◁ Margaret Bourke-White (1904-1971):
Saturday Night, Montana, 1936,
published in the first number
of *Life* magazine, 29 November 1936.

▽ Berenice Abbott (1898):
Roast Corn Man, Manhattan, May 1938.

"Profession: Reporter"

▷ Edward Steichen (1879-1973):
The Reporter, still from
The Front Page, 1928, with
Osgood Perkins and Lee Tracy.

▽ Robert Capa (1913-1954):
France, 6 June 1944,
D-Day, Omaha Beach.

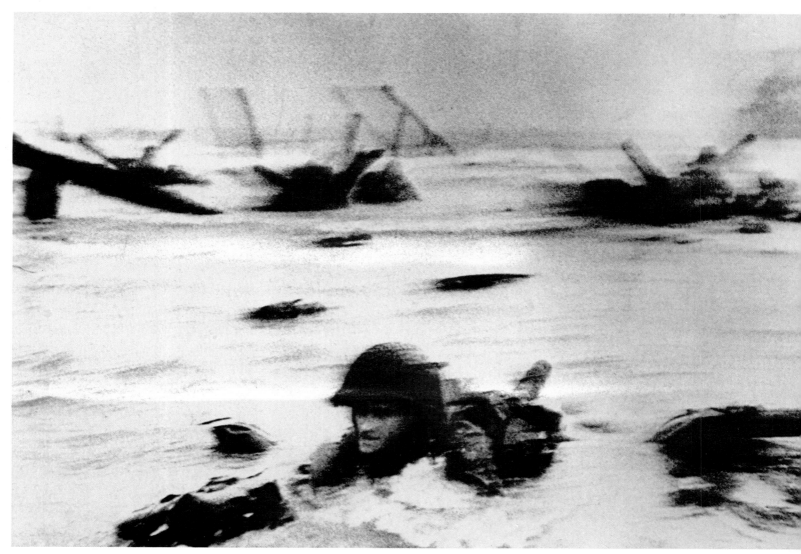

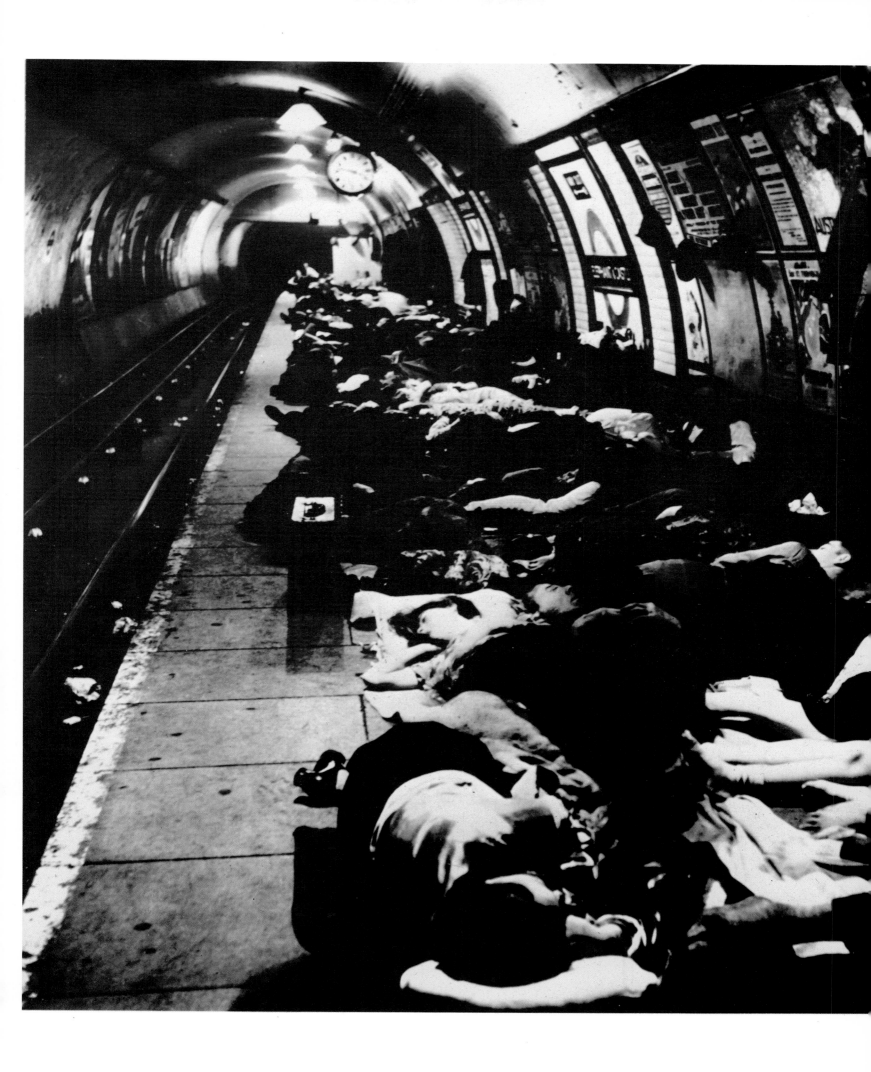

Bill Brandt (1905):
People Sheltering in the Tube,
Elephant and Castle Underground
Station, London, 1942.

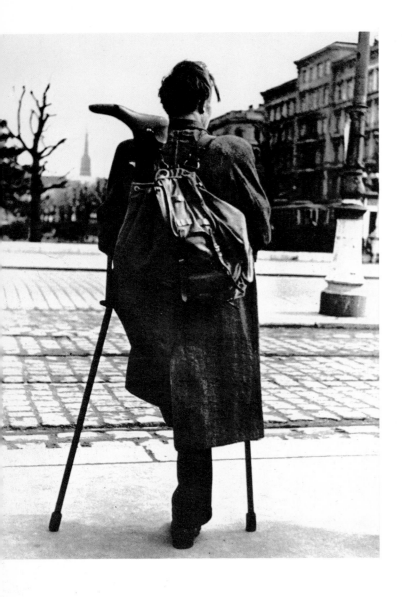

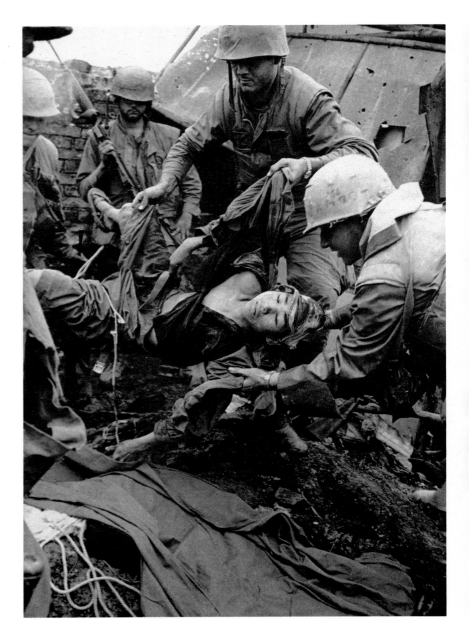

 Ernst Haas (1921):
Disabled War Veteran,
Vienna, 1948.

▷ Don McCullin (1935):
American Soldiers and
Wounded North Vietnamese, 1968.

▷▷ Marc Riboud (1923):
North Vietnamese Listening
to a Political Speech.

Photographers were at work everywhere, confronting events in every corner of the world, sometimes under daunting conditions. To protect their rights and ensure the diffusion of their pictures, they set up agencies of their own, some of them specializing in this or that type of work. One of the best known was Magnum Photos, an international picture co-operative founded in 1947 by Henri Cartier-Bresson, Robert Capa, George Rodger, William Vandivert and David Seymour; it handled magazine assignments and published books, and was joined by many other photographers, outstanding for their vision and independence. Other groupings like Gamma, Sygma and Sipa competed fiercely for the privilege of covering international events and supplying the major telephotographic agencies like AFP, AP and UPI, whose network was worldwide but which did not of course have exclusive control over the use made of the pictures. The activity of other agencies was oriented in one particular direction. Rapho, for example, one of the earliest (founded in Paris in 1933 by the Hungarian photographer Charles Rado, who moved on to New York in 1940), was essentially a distribution agency less interested in topical events than in the human and aesthetic side of photography. Among those who

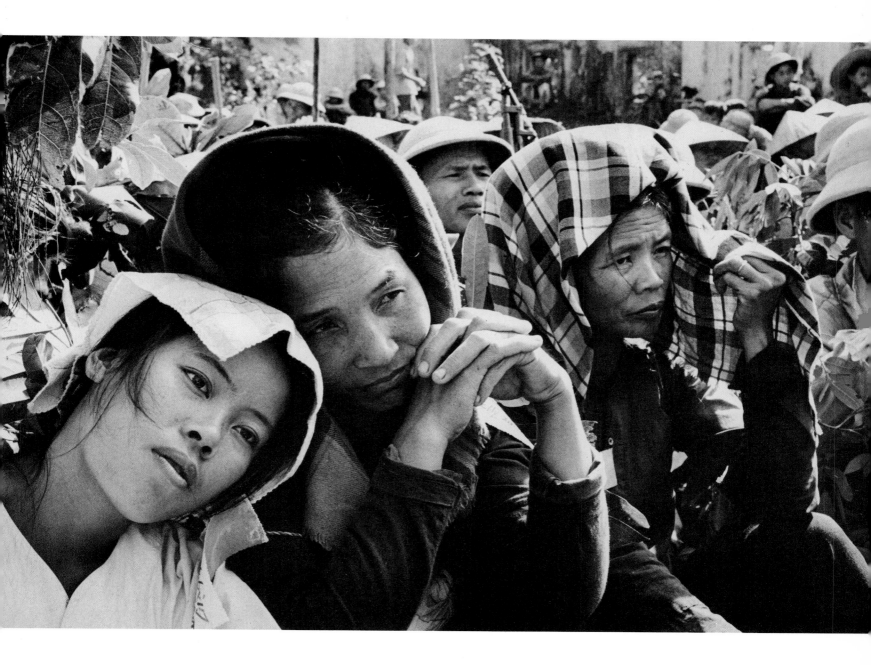

worked for it were Robert Doisneau, Janine Niepce, Sabine Weiss and Edouard Boubat, and some of their finest photographs were published by Rapho in the form of books or portfolios. But it was not enough for such photographers to be on the spot when things were happening; the quality and distinction of their work depended on an individual way of seeing and the choice of the telling moment. The time was at hand when the photographer was no longer to be judged by the quality of this or that picture but by the scope, sense and spirit of his whole output. It was in the sequence or the book of photographs that an individual way of seeing and feeling, the originality of a vision or the force of a testimony, could best be evaluated. This was demonstrated by a book like *The Americans* (1958) by the Swiss photographer Robert Frank or a photographic œuvre like that of Diane Arbus. The latter concentrated on people, bringing before us with an almost harrowing objectivity all that is most pathetic, vulnerable and incorrigible in the human condition. The effect of her pictures is all the more disturbing because there is no note of compassion. The result is a compelling fixity which contradicts the dream of happiness and well-being conveyed so unrelentingly by advertising photography.

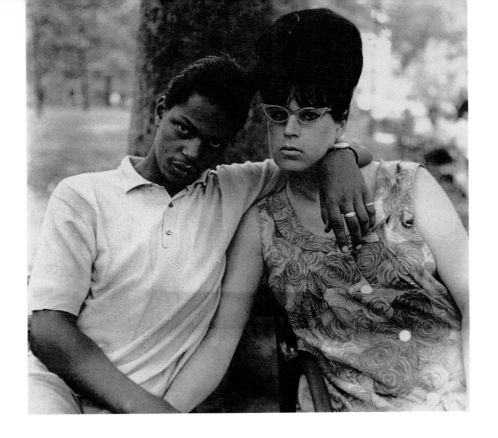

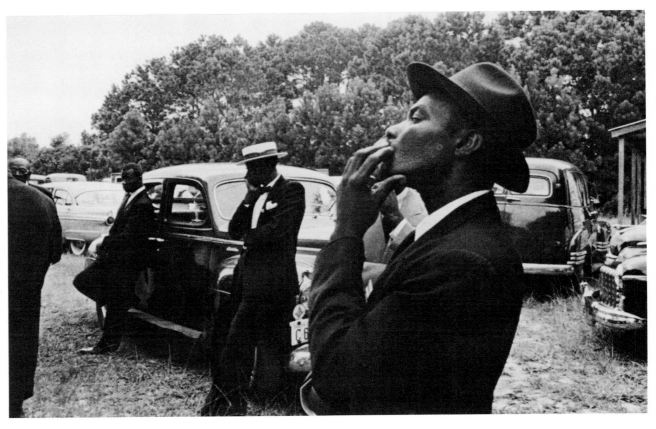

◁ Diane Arbus (1923-1971):
A Young Man and his Pregnant Wife
in Washington Square Park,
New York City, 1965.

▽ Robert Frank (1924):
St. Helena, South Carolina, 1955-1956.

▷ Ernest Pignon-Ernest (1942):
Image at Grenoble, 1976.
Silkscreen print.

Photography dominated the field of information and communication for decades, well into the 1960s. But by then it was giving way to television, so much more rapid and pervasive in its diffusion. Photography henceforth assumed a different function. The wheel came full circle when art itself took on a contestatory dimension of challenge and sociological interrogation. This was the case with Ernest Pignon-Ernest who, by way of the silkscreen print, contrived to resituate photographic reality in the actual context of the Paris streets and Métro. The media of today have made us more alive to dramatic events, but the tragedy is in life itself and not in the pages of our magazines and books. Life is not a dream: that is the conviction behind the work of Ernest Pignon-Ernest.

What this photography does, in the end, is to teach us something about ourselves. This is what Robert Frank meant when he said: "I have often been accused of deliberately deforming nature to make it suit my own point of view. Above all, I know that the photographer cannot envisage life with an indifferent eye. Any opinion involves an element of criticism. But criticism can be prompted by love. It is important to see what remains hidden to other people, whether it is a gleam of hope or sadness. Photography moreover always remains the instinctive reaction of the operator towards *himself.*"

III

EXPRESSING

Ernst Haas (1921):
Torn Posters, 1962.

▷ Clifford Coffin:
Cover for *Vogue*,
New York, July 1951.

THE ASCENDANCY
OF THE IMAGE

In the 1960s photography lost something of its importance on the communications level: it ceased to assume a function to which it had long been subordinated, and went on to assume others, which of course had already existed but only in an episodic or obscure manner. In its informational and descriptive functions it was replaced by television and its new, proliferating system of instantaneous image transmission. This proved a liberation: photography thus set free underwent far-reaching changes. Falling back on its specific features and nature, it set itself up as an autonomous, self-contained medium of creation. This momentous shift of level and purpose coincided with the fresh interest taken in photography by painters and sculptors at the very moment when they were investing reality in new ways. Its power of distancing, mediating and conceptualizing proved fundamental in their innovations.

The ruling idea in all sectors of creative art was, now, that it is less important to record the external world than to recognize the instruments capable of perceiving it and to analyse the experiences best fitted to inscribe the operator's physical and spiritual personality within the experience of nature. The evolution of art and civilization was such that it seemed less important now to reveal things than to probe into the conditions of vision and representation.

In the 1960s, too, thanks to its commercial and technical evolution, photography was vulgarized as never before. Cameras had never been so efficient and low-priced, film had never been so sensitive and cheap. Anyone could take a good snapshot. Sales were record-breaking and the photographic industry was one of the most prosperous of the post-war period. But, being accessible to anyone, photography ran the risk of becoming as commonplace as words and writing. The solution lay in the gathering effort to make of photography something more than a "graveyard of memory"—to demonstrate the inherent quality of its language and its poetic possibilities.

Gradually the popular illustrated weeklies felt the competition of television; their circulation fell off and they were compelled to abandon the field of information and actuality for reportages of a more specialized and less ephemeral nature. Photographers were profoundly affected by this crisis; the multiplication of exhibitions, galleries and illustrated books was not sufficient to absorb their large production. Some of them turned to television, while the enterprise of photographic publishers speculated on the appeal of singular, highly personal ways of seeing, thus applying a stimulus to the purely creative and interpretative side of photography.

Once again, but now in a well-informed context, certain questions had to be faced. On what level stands reality: in appearances or in the act of recognizing them? What is the point of reference: nature or photography? The one certainty for creative photographers seemed to be what Paul Valéry had expressed in these terms: "Photography invites one to give up any attempt to delineate such things as can delineate themselves." Apart from that—and ingrained habits imposed by cultural and economic factors—nothing could be taken for granted.

By probing into the mediating power of the photographic act, at a time when the vein of abstract art seemed to be worked out, painters gave photography a new lease of life, enabling it to find, for the third time, a creative dimension. During the Sixties, in the context of Pop Art and New Realism, photography re-entered painting and a few years later, at Documenta 5 in Kassel in 1972, it was recognized as an indispensable and fundamental artistic medium. Henceforth it found a place of its own in public and private collections, alongside painting and drawing. It broke out of its cultural isolation, because it offered another approach to the world, another expression of reality, filling in its own way the gap between physical, optical and subjective realities.

While the new photography took the form of pictures, it no longer vied with painting in any way. Its space was specifically its own, as shown by the care taken in the matter of framing and presentation. Its specificity was often emphasized by comparative or sequential montages favouring a more analytical and critical approach, further reinforced by the frequent interaction of texts and captions. These photo artists often used colour in its latest developments, but set themselves apart from professional photographers by a deliberate cultivation of clumsiness or negligence. For them photography was not an end in itself, it was only a means; it was not an object of pure contemplation, it was meant to show up and make people think. Technical accomplishment was the least of their worries, intent as they were on *not* making reality conform to the market laws which standardized desires.

Marshall McLuhan, one of the first to analyse the implications of communications data, declared that "the medium is the message." But at the same time artists proved that they could produce meaning by way of a medium hitherto largely limited to reproduction. And Pop Art and Photo Realism demonstrated the reality of the photographic medium and its distancing from the real; but also the painters and sculptors who used photography because they no longer embodied their ideas in objects imposed it as the only medium capable of visualizing a concept.

The introduction of colour carried photography into a more abstract phase of development. It had taken a long time for colour photography to become a popular technique accessible to all. The way was opened by the invention of Kodachrome in 1935, by Leopold Mannes and Leopold Godowsky. It consisted of three superimposed layers of film and three filters, thus giving the division and superposition of the colours in a single image visible by transparency or projection. Then in 1941 came Kodacolor, a film negative from which colour positives could be printed. But it was only after the war that colour photography could be commercially exploited for the first time. Since then progress has been rapid and even revolutionary as regards printing, thanks to the development of emulsions permitting enlargement on paper and improved printing techniques.

Franco Fontana (1933):
Italian Landscape, 1978.

Kishin Shinoyama (1941):
Tengu no ie (The House of Tengu),
illustration for *Meaning of the House*,
1973.

Among the first to explore the possibilities thus afforded was Gisèle Freund. In 1938 she made her colour portraits of celebrities in the world of arts and letters. "For me," she wrote, "this was a revelation. How wonderful to be able to register all the subtle and changing shades of colour: reds and greens, yellows and turquoise, the transparency of white skin surrounding the blue of eyes... Seeing now was no longer a matter of shadows and lights, but of tonalities."[1] The popularization of photography and the introduction of colour were bound to have a direct influence on our understanding of the world, as Susan Sontag has pointed out: "Whatever the moral claims made on behalf of photography, its main effect is to convert the world into a department store or museum-without-walls... Through the camera people become customers or tourists of reality."[2]

The human relation with the external world became more and more distanced and mediated, with the result that visual knowledge at second hand was substituted for the direct experience of nature. The camera provided not only the souvenirs but the substitutes of places and events experienced superficially at best, seen chiefly by way of the camera eye. In 1978 the production of photographs reached the figure of 2.2 billion, the vast majority mere "documentary" images, testifying to the "what has been" of Roland Barthes and carrying no real weight of experience. The photographic image invaded memory, mind and senses, the more pervasively because it was now in colour.

But the gap between natural colour and photographic colour remained very real. It was exploited by professionals who, making play with camera technique and light, created effects more photographic than real, with the result that photography veered towards certain forms of abstraction. The pictorial

The stepped-up effect

Roman Cieslewicz:
"The Market Porter,"
publicity for Jourdan shoes, Paris, 1982.

potential prevailed over the recording of reality: photographic colour and its harmonies were found to express something in and by themselves, independently of the subject behind them. The public expected photography to provide thrills, to stir the emotions; and so by the appeal of colour its initial justification was forgotten. Combined with the achievements of the previous generation, with the innovations in focusing, distancing and unusual angles of vision, colour imparted an incomparable power to the images of our time. Art photography entered a new phase—as art photography, precisely, because made by professionals intent on effects first and foremost, even if these were often based on effects already familiar in other art forms. But art photography now found some fields of its own in which it could excel without a rival: advertising, fashion, specialized magazines. Some photo artists, banking on the intrinsic qualities of their medium, aimed at awaking surprise and desire, and to achieve that end made the most of colour abstraction and the resources of the camera. The latter does not see like the eye. It cuts off, singles out, enlarges. It defines the object, delimits the field of view, distances the subject. It flouts the traditional boundary between physical and mental space by doing away with any cultural and historical reference. In photography the choice of the object is essentially metaphorical, referring back directly to the subjectivity of the person handling the camera. The codeless message of the photograph is coded by the choice objectivated in it. Working in a permanent state of receptivity, the creative photographer systematically documents his own way or

ways of perception, continually drawing from the results the information that tells him what he is doing and shapes what he will be doing in the future. He absorbs everything that passes and gives it meaning in his own terms. But because the public, bemused by the ceaseless spate of pictures, has lost the sense of curiosity and attention and fails to recognize authenticity when it sees it, the artist often has to exaggerate his manner of seeing in order to transmit what he has seen. His work can restore the spectator's pristine response to visual pleasure or visual power, and this is what the publicity designer aims at.

Advertising today relies almost exclusively on photography. And since things and people change little if at all in themselves, everything depends on the photographer's originality. His instinct for the unusual and dynamic, his mastery of colour harmony and colour violence, go to shape the common denominators of taste. His combination of these elements has to produce the shock. He may succeed in bringing them together for no more than a brief moment, fleeting and impossible to recapture. And to capture them at all he has to resort to ever more sophisticated techniques.

This unremitting search for effect imposes a strain, a wear and tear on the collective vision. Contemporary man is receptive only to the excessive, the overdone, the conspicuous, the stark, and this is what we find in his environment, in his very dress: startling features, shrill colours, dynamic forms meet the eye on all levels, from make-up to the cityscape.

Cheyco Leidmann:
Publicity for Bit Beer, 1978.

By bringing into play the overstated, stereotyped images of communications and advertising, Pop Art brought reality back, with resounding aggressiveness, into the mainstream of avant-garde art and gave an aesthetic value to these different searches for effect. In the immediate post-war period, the major power in painting, carrying all before it, was Abstract Expressionism, under a variety of names— action painting, lyrical abstraction, gestural abstraction, *tachisme*, and so on. In the late Fifties representational painting reappeared under the irresistible stimulus of men like Robert Rauschenberg and Richard Hamilton. Formed in the context of abstraction, these artists felt the need to use and challenge the most common and familiar tokens of our consumer society—which meant essentially reproductions and publicity photographs. This move coincided with a revival of interest in Dada and its methods. Since "art is life," it became necessary once again to oppose the freedom of gesture and random impulses with fragments taken straight from everyday life: the disparate elements of contemporary banality. Inevitably the photographic reproduction was seized on and used for its image value. But this recourse to the object, whether real or "figured," gives an ambiguous status to the photographic approach: on the one hand, Pop Art opposes its modernity and narrative system to the

The pervasive object

traditional means of painting, but on the other it comes as a critical reassessment of the modes of representation so far prevailing in industrial society. This introduction into painting of the photographic element has shattered both the mythical character of painting and the specificity of its codes. The interest in the mediated image has thus been totally renewed and the roles forcibly reversed. From 1960 on, we find paintings made from photographs. The presence of the latter was a revitalizing necessity. "At the dawn of a leisure civilization," wrote John Cage, "the very meaning of art has changed; it has to be in life but life is a way of using time." As for Rauschenberg, he was aware of all that was random and unpredictable in this irruption of the real into the pictorial: "Almost everything I have produced has been done to see what would happen if I did this instead of that."
This return to a Dada attitude—which is characteristic of all the art movements of this period— stemmed from the refusal of idealism in any shape or form. The painted image was turned into a consumer product, the more readily because it used in its making the very effects which urge the public to buy and consume. The fact that it often did so with ironic intent only emphasizes the necessity of a critical distancing, and this moreover was the moment when artistic processing reached its height: by its multiplication and the impact of its diffusion, it showed its kinship with advertising.

◁ Robert Rauschenberg (1925):
Rebus, 1955.
Combine painting.

Richard Hamilton (1922):
$he, 1958-1961.
Oil, cellulose, collage.

But when communication finds in itself its ruling purpose, criticism loses something of its importance and must renounce any qualitative hierarchy. The beautiful is everywhere, and all aspects of daily life have the same importance. Pop Art arose simultaneously in England with Richard Hamilton and in the United States with Robert Rauschenberg and Jasper Johns; arose as a rehabilitation of the ordinary, as a *mise en scène* of the found object, but now an object no longer opposed to its function. Rauschenberg was explicit: "I have a lot of sympathy for the last moments in the life of anything. An abandoned object, a waste product, contains in itself its whole history: that is what made me seek out abandoned objects." So the real merges with the symbolic, and the gap between art and life is closed. The commonplace and quotidian entered directly into art.

Pop Art found its name in England (it was coined by Lawrence Alloway), but it triumphed in the United States in the world of Coke culture. Ignoring any distinction between good and bad taste, it proved that anything can be made into art, whatever its original purpose or use. It reintroduced modernity by expressing itself with the means and images of present-day technology, and by accepting and indeed embracing commercial culture. Its focus was on "mass-produced urban culture: movies, advertising, science fiction" (Lawrence Alloway).

After the long predominance of lyrical abstraction, Pop Art brought back figural imagery and illusion. The public approved and took to it at once, because these were easier to decipher and criticize than a welter of abstract forms. Though descriptive, it was sham-realistic because in fact it based itself on an interpretation of the effects of a reality already transcribed and adapted to consumer needs, but it drew its power from its transformation of these effects into a distinctive style. Pop Art pressed artistic communication into new directions, new fields of application, and renewed the problematics of painting by confronting them with the latest techniques. Interpretation became secondary, the mediated image took priority over direct experience, and the technique of reproduction prevailed over the traditional means devised to create illusion.

Pop painters made generous use of the resources offered by photography, for the latter ruled supreme in all that pertained to the press and publicity; but they transposed it into different spatial and temporal terms, adapting it to their own purposes by making the most of its contrasts and its powers of accumulation and repetition. At first the Pop artists were at one in their espousal of vernacular culture, but the evolution of individuals soon showed wide divergences of interpretation. American artists, on the whole, took a critical and ironical stance which was not shared by English artists, who surrendered more easily to a nostalgic and subjective, even indeed romantic, interpretation of reality.

Art as subject

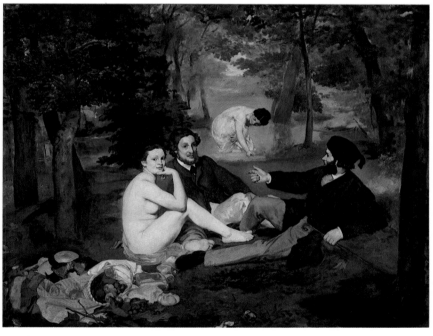

The apparent depersonalization induced by borrowings from the techniques of reproduction and advertising went far to counter the excesses of individualism manifested in Abstract Expressionism. But this new painting, largely resorting to photography, soon found itself challenging the status of the photographic experience and competing with it. Taking over its focusing effects, its arbitrary choices, its power of repeating images which have no other function but to be images, Pop artists compelled the public to analyse them in abstract terms, to perceive the extent to which their components, colours and contrasts stand removed from their real model and go to create an illusory world of their own. The picture itself changed meaning; it no longer appeared as the unique projection on canvas of one man and one mind; instead it reconstructed the anonymous image which our civilization produces of itself in its daily catalysing of consumer desires. As thus conceived, painting was essentially the means of communicating an idea, the field of observation of a state of mind; it stood in the breach between art and life. Reproduction had taken the place of reality.

Mimmo Rotella (1918):
The Kiss, 1962.
Decollage of posters.

It was only after 1960 that Pop Art found its true critical dimension. From 1962 on, the development of silk-screen techniques permitted the direct use of photographic images in the making of the picture. Roy Lichtenstein in the United States and Alain Jacquet in France showed the way and worked out the codes and abstractions of this transfer. By multiplying and enlarging its effects, they cast a final doubt over the objectivity of the reproduced image. The reality of the photograph was no longer in the object it was focused on, but in the means of this focusing and its realization, in the organization of its filters. Camera technique, instead of rendering the real, was recognized as a screen or intermediary.

Pop Art was largely concerned with the subjects exploited by the media, like movie stars and popular consumer products. But by the device of accumulation or sequences these painters brought home at once the emptiness and the appeal of these fetishes; for that is what our civilization has made of them. In Europe the New Realists pursued the same approach to the world of mediated imagery. Mimmo Rotella, for example: in his imaginative use of commonplace images stripped off publicity panels, he creates ready-mades of his own rich in sociological implications.

Photography could not be dispensed with when it came to working in terms of sequences and repetition. Edward Ruscha, from 1962 on, and then Peter Roehr exploited repetition as a creative principle: a thousand images are more visible than one. As embodied in their work, the star or the consumer product was drained of any emotional content and existed only as pure image, used purely for its power of demonstration.

Richard Hamilton's picture *My Marilyn* speaks for the way in which Pop artists show up, by means of painting, the gaps between the real thing and the photographic illusion. By sheer scale, by playing with colour, by opposing photographs of different sizes, Hamilton proves the necessity of the choice; for the photographs he used had been vetted by Marilyn herself, all but one being rejected by her with

Featuring
of the star

Matthew Zimmermann:
Marilyn Monroe Doing a Scene
for *The Seven Year Itch*
in a Manhattan Street, 1954.

Richard Hamilton (1922):
My Marilyn, 1965.
Colour screenprint.

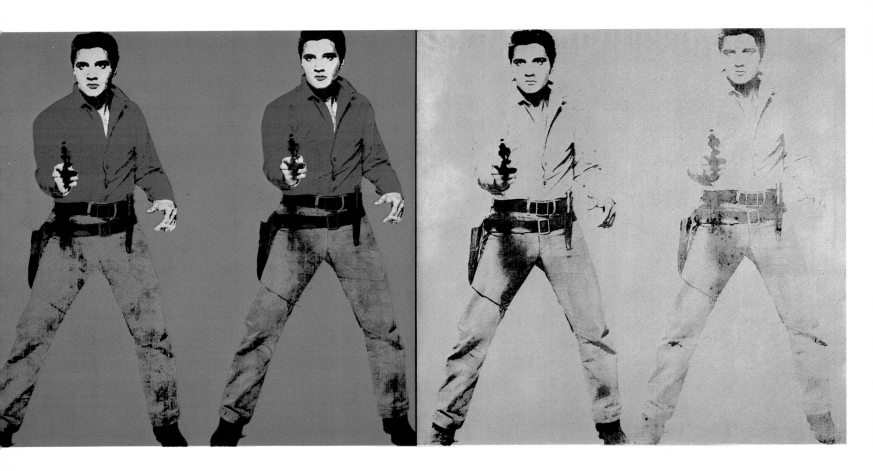

Andy Warhol (1930):

Elvis I and II, 1964.
Left: silkscreen on acrylic.
Right: aluminium on canvas.

Marilyn Monroe, from
10 Marilyns, 1967.
Colour screenprint.

a slash of lipstick or the gash of her nail-file—one alone untouched, which she regarded as giving a true picture of herself. By his juxtaposition of photographs and painting, Hamilton brought the spectator into an analytical space which points up the variety and importance of visual means of communication. Roy Lichtenstein dealt rather with the style of communications images and codes, while Andy Warhol systematically exploited the expressiveness of colour and the power of contrast in images overstrained by production and consumer techniques. Warhol showed them in sequences or opposed them dialectically to underscore the work of artistic or technological interpretation. With the artists of this generation, photography became an integral part of the painter's means.

The sequential montage reintroduced a dimension which proved to be important: the space-time dimension. Working, all of them, on the mythology of everyday life in the post-war West, these artists could no longer be distinguished from each other by their choice of subjects, but only by their manner of interpreting commonplace reality. Through their creation of images, they also showed up the distance separating those images, by virtue of their codes of production, from the natural model which they are naïvely supposed to refer back to.

Ray Johnson (1927):
Elvis Presley No. 1, 1955.
Collage.

The immediate image: the Polaroid

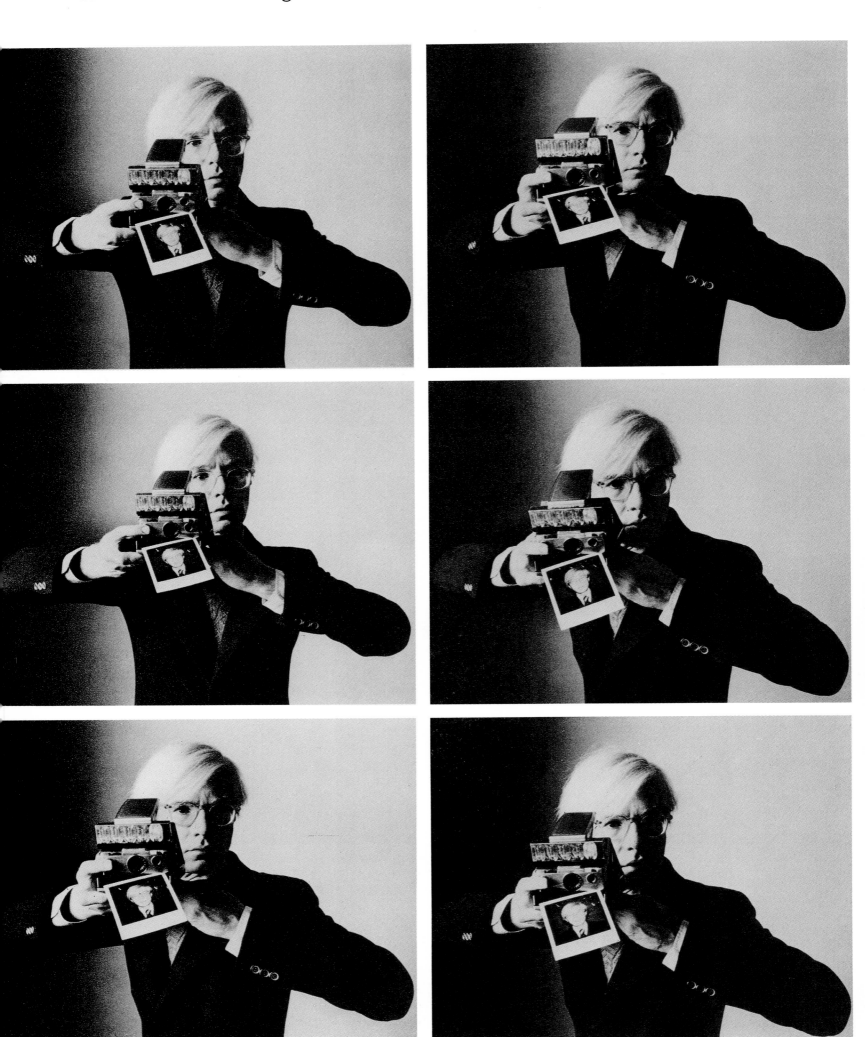

Inventor of the Land Polaroid, Edwin H. Land had long been interested in photography. During the Second World War he tackled the problem of immediate film development. In 1947, after several years of experiments, he was able to demonstrate his new methods, by which in the space of a few seconds a positive print could be obtained, being developed inside the camera. In 1950 he marketed this automatic camera, and in 1963 the Polaroid Corporation brought out colour film for its cameras. This American firm prospered in spite of the competition of the Japanese, who almost as soon as the war ended entered the photography market, obtaining decisive results in the quality improvement and miniaturization of cameras.

Revolutionary in his technical advances, Land remained a conformist in his conception of the purpose of photography, as when he declared in 1949, in a communication to the Royal Photographic Society in London. "By making it possible for the photographer to observe his work and his subject matter simultaneously... it is hoped that many of the satisfactions of working in the early arts can be brought to a new group of photographers." Land's point of view was diametrically opposed to that of creative

◁ Oliviero Toscani (1942):
Photographs of Andy Warhol
taken at the Carnegie Hall Studio,
New York, with a Polaroid camera,
December 1973.

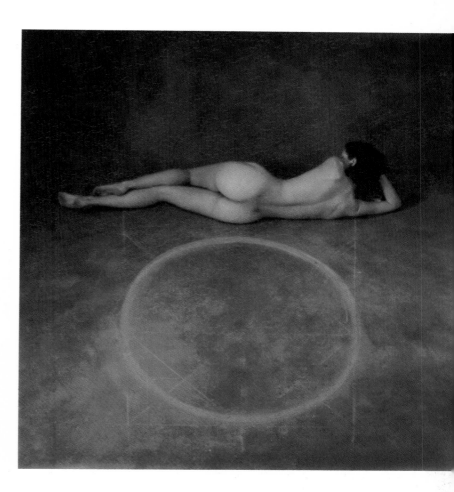

Christian Vogt (1946):
Two Photographs taken
with a Polaroid camera, 1977.

photographers: "The process must be concealed from—non-existent for—the photographer, who by definition need think of the art in the *taking* and not in *making* photographs... In short, all that should be necessary to get a good picture is to *take* a good picture."[3] He had completed, it seemed, the endeavour begun by Niepce over a century before, and assumed that there was now nothing further to be done. But photo artists were soon to prove him wrong. For them Land's invention had important consequences. By giving results almost instantaneously, by providing the operator immediately with the image he was after, the Polaroid permitted him to constitute an immediate memory, to experience the world by photographic proxy, so to speak. But comparison between the real and its image also underscored the divergences between nature and its reproduction and demonstrated the specificity of the photograph and the relativization of the model. The substitution of the identical thing for the real thing was only a dream which the Polaroid promptly exposed as such.

Pop artists and New Realists not only appropriated the photographic image to their own uses, but also practised the cult of the Happening, the staging of actions in which the real was created for its own sake, fusing art with life. According to Pierre Restany in 1961, "the gesture of appropriation embodies the refusal to transform and translate reality."[4] Art became life, but the Happening, if it was to survive, had to be documented by photography and film or by imprints and traces—the direct material consequences of what had happened. Yves Klein, for example, for his pictures used living models in the nude who, at his prompting, rubbed or rolled their paint-smeared bodies over canvas spread on the floor, imprinting on it the positive or negative trace of the paint-action; so that here man and nature burst into the representation in their actual size. The individual left his mark on the world he lived in, just as prehistoric man appropriated his space by the outline of his hand. In the "Manifesto of the New Realists," published in Milan in 1960, Pierre Restany wrote: "The New Realists consider the world as a picture, as the great fundamental work from which they take over fragments endowed with universal meaning."[5] And Jean Clair referred to them in this way: "About 1960 there arose in art a new discourse which reversed the logical order previously taken for granted. Now artistic practice was no longer the mysterious abode of knowledge exerted *a priori* by a subject, but an object for knowledge to be applied to."[6]

These movements, by rehabilitating action and gesture, brought home the importance of the problem of full-scale representation, a problem ignored by photography until its technical development finally permitted it to step in and tackle it. Instrumental in doing so was Floris M. Neusüss, who at the same time emphasized the differences that necessarily exist between volume and its representation on a plane surface.

Lifesize imprints

Floris M. Neusüss (1937): Three Photograms from a set of twelve, 1971. Paper prints on canvas.

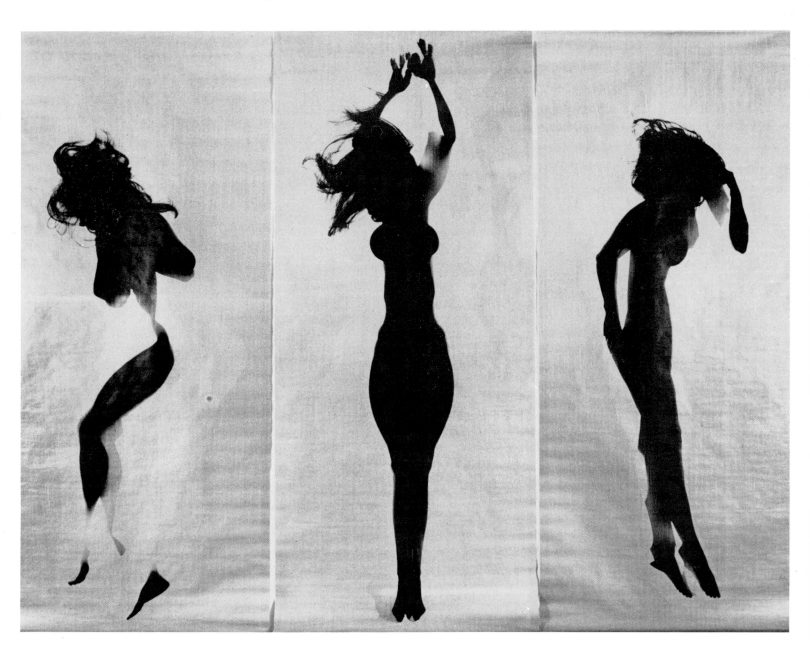

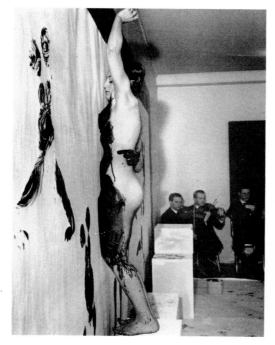

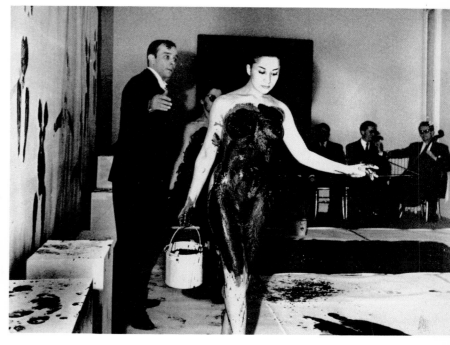

Yves Klein (1928-1962):

▷ ANT Happening 106, 1960.

▽ ANT Imprint No. 63 (negative positive), 1962. Oil on canvas.

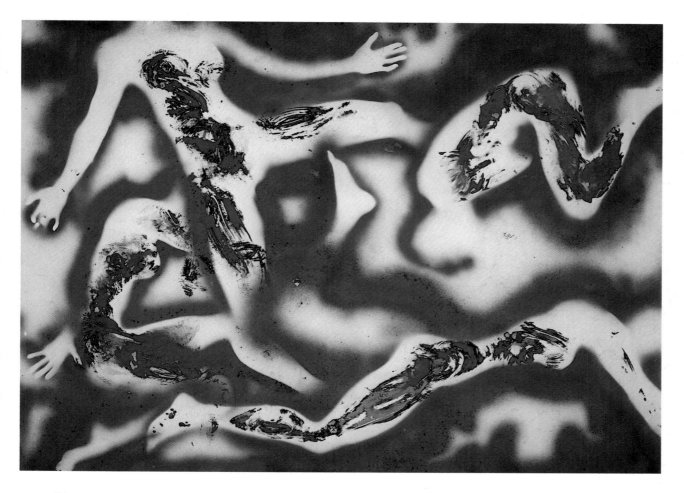

In confronting so immediately and directly the space of his action, "man," wrote Jean Clair, "finds that he is today that negative and central form from which art as activity can be conceived with the maximum distance from himself, and around which pivot untiringly the many-sided *figures* which man displays, as he follows an activity thus directed no longer towards improbable depths, but directed now solely towards *surface descriptions*." [6]

This power of action, this force of imprint, this interplay between reality and fiction, did not escape the painters who wished to impart a political significance to their images, above all the Spanish artists whom a long tradition of realism made more keenly aware of this problem. Availing themselves of the anonymity of back lighting or photography, they stressed the individuality of their vision by the choice of subject and setting and sought to efface the "hand-made" impression which had been so important in traditional painting. By resorting to the camera for the instantaneous effect of the flash picture, they were able to catch reality in the trap of representation. In their hands photography and painting became subversive, both being diverted from their illustrational purposes.

217

Younger artists arriving on the scene took up the Happening and gave it a different significance. From 1968 on, under the names of Body Art and Land Art, some of these creations took the form of direct interventions in natural space; when they were over, photographs were the only record left for many of them. But since photography was indispensable for documenting such work, why not use it directly as a medium of expression? This question arose and offered its challenge when it was realized that the space and surface which had gone to define the act of painting had now been shattered.

The need to merge art with life found its latest avatar in Behaviour Art or Body Art, which effectively eliminated any intermediary between the message and its receiver. Taking his own body as the support and vehicle of his work, the artist renewed visual communication in his own way and rejected outright all aesthetic and moral norms. The live medium of a theoretical and practical process, the artist self-performed in the course of actions directly featuring the physical resources of the individual or, in a more challenging way, harking back to the magic-making ceremonies of primitive peoples. In these

Photographic records of the action

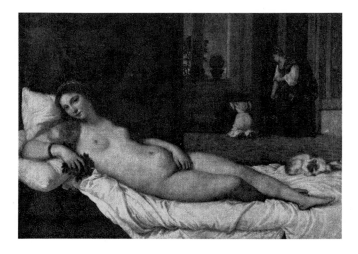

Titian (c. 1490-1576):
The Venus of Urbino, 1538.
Oil on canvas.

Wolf Vostell (1932):

△ Regen (Rain), Happening in
West Berlin, 12 September 1976.

◁ Venus of Urbino, from
the Regen Happening, 1976.
Acrylic over photograph.

218

performances based entirely on the self-representation of the artist's body, the screen separating the real from the reproduction of it was torn asunder. The model and its representation became one.

Body Art came as the most provocative artistic expression of the day, because it forced the public to react to endlessly varied psychodramas which, by the avowal of the body as the abode of pleasure and suffering, transcended moral and political limits. And since photographs were the only material trace that remained of these Happenings, they often took the form of sequences. But, being governed by the laws of the consumer society and the information channels, these photo sequences broadcast by the media quickly came to be seen as the work itself—an outcome which obliged the artist to consider this work as a means of expression in its own right. So, from a medium of substitution, the photograph became a maker of equivalences. Since the action of the Happening could not in itself be sold to the public or to a museum, the photograph of it became marketable on the strength of its power to authenticate that action.

Arnulf Rainer (1929):
Face-Farces: Self-Portrait
with Closed Eyes, 1969-1971.
Oil over photograph.

When art needs photography to exist at all, photography becomes the exclusive and ultimate form of creation. Erika Billeter has pointed out how very different the photographer's attitude is from that of the artists who document their own Happenings: "The photographer sets out to record his subjective view of the world in the photograph. The artist does not solicit the object, but chooses it for what it represents and as a vehicle for conveying an idea or a thought process. For him, photography is only a means of achieving his purpose."[7]

But this new form of photography intended to give explicit shape to a concept soon entered into a critical dialogue with art. For this reason Arnulf Rainer proceeded to superimpose the act of drawing on the images of his physical transformations, and Wolf Vostell sought to express his activity and thought as an aesthetic process and therefore in the form of a work of art: "Titian portrayed his contemporaries in particularly agreeable attitudes (see his Venus of Urbino), even though in his day cruelty also existed alongside beauty, as it does TODAY! Every human being now alive is a multidimensional EVENT. What I wish to do is to set up this interphenomenal image of man in the late twentieth century alongside the linear image of the world which we find in Titian. And I wish to do this by Happenings, which are question marks and riddles, and which raise questions about the nature of our BEING."[8]

The featuring of space

Charles Simonds (1945):
Landscape Body Dwelling, 1971. ·

▷ John Pfahl (1939):
Triangle, Bermuda, 1975.

Robert Smithson (1938-1974):
Spiral Jetty, Great Salt Lake,
Utah, April 1970.

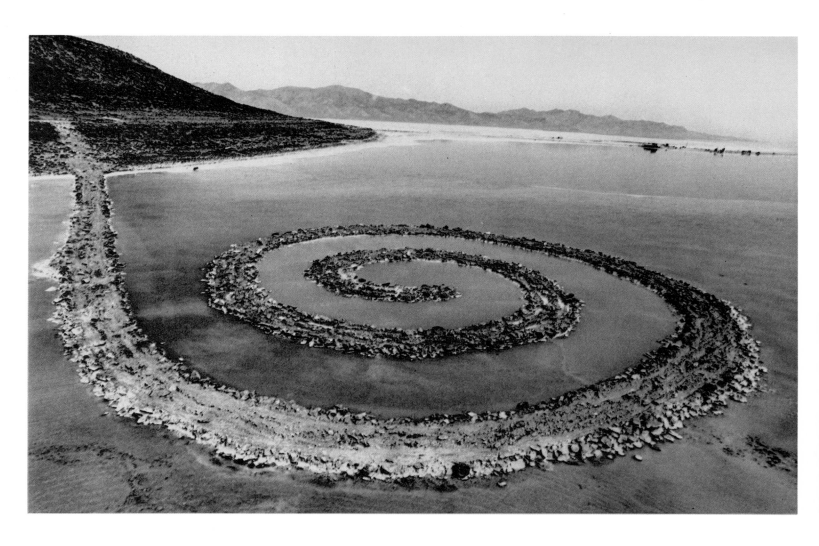

Photography, however, could not long remain the sole and exclusive means of documenting these actions. It found a powerful rival in video, and from 1969 on we find American artists making use of this new medium, and its specific resources carried them into new fields of action and experiment. The German TV producer Gerry Schum was one of the first to capitalize on it. In 1967 he had already founded the Berlin TV Gallery. Its purpose was to reflect and monitor in one place the ongoing situation of modern art on the world scale which it had now assumed; and thereby to enable the public at large to become acquainted with the latest trends of art at the very moment when they appeared. He turned to film as a medium of visual art, and working personally with the artists themselves Schum not only filmed their ideas but contributed to the creation of them. His famous film *Land Art* represents the first TV "exhibition."

The New York artist Charles Simonds stands at the crossroads between Body Art and Land Art, between the personal space and the public space. Like many of the English and American artists of his generation, he proves that the artist of today is not so much a man or woman with something to *say* and *do* as a man or woman who shapes his or her identity by *doing* and *saying*. So it is that the individual space joins up with the social space, sets itself within a collective field whose possibilities it enriches and renews. The work becomes a field of experience and experiment on a world scale. Removing art from the narrow framework of the gallery or museum and letting it loose in nature, the Land artists gave their work a scope that only film and photography could record and make visible. This was all the more true because their work, at any given moment, was often temporary and fragile, changing with the changing weather conditions to which it was subject. The place of the action became the point of intersection between two antagonisms: the setting out of an autonomous plastic space and the physical experience whose material reality embodied the thought and spirituality which had determined its choice. But for the visualization of the result the camera was indispensable.

This direct contact with nature was an invitation to return to the natural, elemental space from which our civilization has cut us off. Some of these artists, like Christo and Dennis Oppenheim, were intent on enlarging their work to a global dimension in order to demonstrate certain theoretical propositions. Others, like Michael Heizer, were guided in their rediscovery of primal elements by a more mystical outlook.

Photography was the more closely linked with Land Art because of the fact that some of its manifestations were inherently paradoxical: their monumentality could not conceal their functional uselessness, and the weather made them ephemeral and even risky. Space and time are the subjects of Land Art, but they are present as in a film negative. Weather and passing time wiped out the traces which man the artist wished to leave. The dimensions of the world limited the scale of even the most ambitious undertakings. The work disappeared, but photography kept a record of it.

◁ Richard Long (1945):
Circle in Alaska.
Bering Strait Driftwood
on the Arctic Circle, 1977.

▷ Christo (1935):
Running Fence,
Sonoma and Marin Counties,
California, 1972-1976.

▽ Dennis Oppenheim (1938):
Annual Rings, 1968,
on the Canadian border
at Fort Kent, Maine,
and Clair, New Brunswick.

CIRCLE IN ALASKA.
BERING STRAIT DRIFTWOOD ON THE ARCTIC CIRCLE – 1977.

The fact that photography had become indispensable to the expression of certain art forms implies that it was being looked at more carefully, also more critically. People had come to realize that it reveals phenomena imperceptible to the naked eye, that it is a different thing from reality, that it represents a particular way of seeing. All this brought with it new ideas and a new creative stimulus for painters. In the catalogue of the exhibition "American Photo Realists, European Realists" (Paris, 1974), Daniel Abadie referred to this phenomenon: "These works have in common, for the most part, the fact that they only represent, with the utmost precision, a potential reality. To the industrial object of the consumer society, the staple of an everyday folklore... featured by the Pop artists, the Photo Realists oppose the world of reflections, of transparency, of instability. The point is not so much to capture time... as to defuse the booby-trap of appearances, to get beneath the subject's identity and establish its primary quality as an object to be painted."[9]

Gaining recognition in Europe at the Documenta 5 exhibition in Kassel in 1972, the American Photo Realists (or Hyper-Realists or Super-Realists as they are sometimes called) have modified our

The magic of reflections

Lee Friedlander (1934):
New York City, 1968.
Photograph.

▷ Richard Estes (1936):
Drugstore, 1970.
Oil on canvas.

perception of the visible world by drawing on the resources of photography. The perception of contemporary man is oriented by the photographic image, which acts as a codified and stereotyped filter through which now pass the direct and constantly renewed sensations which had previously bound the individual to nature. Photo Realism concludes this dematerialization of reality and fascinates by its credibility.

Relying on the data of photography, the Photo Realist forces us to question them and to take our distance from them. Isolated in space and removed from any time context, and limited to its descriptive function alone, the photographic image brings its subject into focus with a precision which, as taken over by the Photo Realist, becomes hallucinating because he accentuates its characteristics: each part of a whole, as singled out by him, takes on a new dimension of meaning. And when the window pane closing off an architectural space becomes the meeting place of its own texture and the outside world, of what is in front and what is behind, then appearances assume a spellbinding ambiguity. Photography had been thought of as the most objective means of recording things; now, since the Photo Realists have searched out its problematics, it appears as the revealer of a reality which our pragmatism had never allowed us to see.

This shift of awareness is expressed by Richard Estes when he writes: "I'm not trying to change things. What I want is to make them a little clearer, that's all—to show what's happening. If one thing stands in front of another, I try to represent them just as they are, one in front of the other. Sometimes the photograph, if you look at it closely, is not so realistic. It doesn't really explain how things are or what they look like. To respond to art, you have to know how to enjoy things and approach them with an open mind. You have no right to misrepresent a thing because it doesn't fit in with your ideas, your intellectual bias. Because then, really one is narrow-minded."

Photo Realism is paradoxical in this, that its descriptive banality gives us pause and compels us to reconsider reality. The gap between the latter and ourselves is further emphasized by the manner of painting. Often these artists do their pictures on a large scale, carrying the photo effect far beyond its traditional dimensions, and above all they like to use a spray gun which, by diffusing the colour and tonal values in its own filmy way, dematerializes the picture surfaces and at the same time heightens the illusion. While Photo Realism appears to duplicate things that anyone can see for himself in street, store or home, in fact it challenges current notions of the visible world by depriving it of any other function but that of proving that the image is the image.

Working outside any frame of emotional, ideological or cultural reference, the Photo Realists have set out to demonstrate that anything is worth representing, however banal, paltry, derelict or anonymous. In the words of Franz Gertsch: "Reality today can only be grasped by means of the camera, for man has accustomed himself to consider photographed reality as the maximum rendering of what is real.

When you make a painted copy of a photograph, the factualness of the real content may be diluted. All that remains is the shock of the real. These shock effects have been familiar to us from advertising techniques... and Pop Art (Rosenquist). Only these techniques had never been carried to their ultimate, forceful consequences. Instead of tending towards the ironical, the frivolous or the grotesque, the point now was to reveal the absoluteness of the real."[10]

The Photo Realists have revitalized our perception of the world by renewing the processes of recording and realizing. Unlike the Pop artists, who included the waste products of reality, the Photo Realists create the original on the basis of a reproduction, and so emphasize the notion of virtuosity. Illusionism with them is not an end in itself but a means of probing and questioning. The real is doubly dematerialized, by its isolation in time and space and by the anonymity of its duplication. Every pragmatic reference is excluded. Photo Realism may be equated with that diffused consciousness of the real expressed in literature by the French novelists of the Nouveau Roman. "The world is, quite simply. In any case, that is the most remarkable thing about it," writes Alain Robbe-Grillet. Things are, and the representation of them puts no value on their occurrence and eliminates any reference to it. It is an image referring only to itself and compelling us to question its rules, its systems, its signs. Its impact is all the stronger since it heightens the dehumanization of the camera's mechanical eye and amplifies its hieraticism—its fixity as opposed to the unfolding time sequence of the film—by almost making us see the long stretch of time spent in the making of the picture.

◁ David Parrish (1939):
Yamaha, 1973.
Oil on canvas.

Franz Gertsch (1930):

Tabea, 1980.
Colour slide.

Tabea, 1981.
Acrylic on canvas.

The challenge of
Photo Realism

Chuck Close (1940):

◁◁△ Phil/Fingerprint, 1978.
Stamp pad ink and pencil
on paper.

◁△ Phil/Watercolor, 1977.
Watercolor and acrylic
on paper.

△ Drawing for Phil/Rubber Stamp,
1976. Ink on paper.

◁ Phil, 1969.
Acrylic on canvas.

▷ Gerhard Richter (1932):
Sailors, 1966.
Oil on canvas.

228

Other artists, however, like Gerhard Richter, Malcolm Morley and Chuck Close, set themselves to show up the limits of the illusion by playing on the difference between the photographic credibility of the image and the truthfulness of the manner of painting or drawing it. What is true in painting is not really true outside it. So, from a mirror of the world, figurative painting became the mirror of itself by the heightening of its constituent elements. It became the representation of a representation: the image acknowledged the language codes that went to its making. As Gerhard Richter puts it: ''An effort was required. Also for the simple reason that I did not have at my disposal any other method of making pictures. Every attempt to leave the photograph its status as a photograph has had sorry results... But by way of painting I can obtain photos unrealizable by the ordinary process of direct enlargement, and these photos can then be pictures after all... There, in the pictures, it becomes exciting for me, there begins the powerlessness of language.''[11]

Into this restatement of painting, photography entered stealthily, as if by breach of domicile. Here applies, in paraphrase, the view expressed by Ingres: ''Art is never at so high a pitch of perfection as when it so much resembles nature that one may take it for nature herself.'' For the distance between the subject and the work of duplicating it becomes in fact the object of the picture. What, after all, is reality? And these expressions of it play on the confusion inherent in it in order to question what we know, what we perceive. The media have so profoundly modified knowledge that these painters have to show where and how creation is distinguished from information. Of course art has never tried to imitate what in its essence is inimitable: nature. It has always implied a signifying choice between many possibilities, the translation of a way of seeing into a specific idiom. Even in realist forms of art, the work of observation was inseparable from the means of recording it. Illusion has never been the aim of art, even when artists play on the ambiguity of representation, by opposing reality to its artistic duplication. The interspace between the real thing and the trompe-l'œil painting may be very small, but it is enough to raise doubts about visual appearances.

Shigeko Kubota (1937):
Duchampiana – Nude Descending a Staircase, 1976.
Video sculpture.

▷ Stanislaw Markowski:
Lifesize Self-Portrait,
1974.

230

PHOTOGRAPHY AS A CREATIVE MEDIUM

In the 1970s the photographic image achieved a new status in the visual arts by compelling recognition as a specific medium of creative art. In the hands of camera painters, what had been a means of information became a means of expression. What had been a system of reproduction was changed into a construction full of meaning. The translation of appearances was converted into an experience of reality. By this direct use of photography —and these developments may be expected to have momentous consequences in the future—artistic creation broke out of the cultural isolation of the avant-garde. Artistic experience found its way back to reality, taken simultaneously as object, subject and structure of this new art. Caught unawares, the public was often bewildered by these new manifestations, which in their apparent banality upset acquired habits of seeing and judging. The spectator was not yet disposed to accept the technical anonymity of an artist, so deeply rooted in the definition of art were the notions of personal sensibility and virtuosity, of personal handiwork. Here the body was no longer a screen, the hand no longer filtered the perceptions, the gesture no longer acted as a signature. Craft skill and craft technique were gone. The photograph referred directly to the mind and eye. Although there was no material difference between this new photography and the photography of the past, the two were set on opposite courses. These photo artists exploded the credibility of the taken image by showing up the mechanisms at work in visual appearances. No reliance, it seemed, could be placed on any record of them.

But this type of photography—even though a direct outcome of those views—shifted the ground from under the views which conceptual artists had taken of art. It was not so much a matter of acting on the awareness of art by a different artistic approach, of producing an art answering to art, as of questioning reality by means of art. The video image and its space amplified these concepts. A further step on the road already marked out by Body Art and Land Art, video offered a new range of possibilities and artists were fascinated by them. The magnetic tape, for which the TV screen acted as mediator, generated a production unconnected with that of other forms of expression.

The first showing of video art was held in 1971 at the Finch College Museum in New York, and the situation was soon being radically modified by the impact of electronic mediation. The video camera made a clean sweep of distance and time. It thus represented the first technique to permit the artist to act and at the same time to see himself in action, the inner movement being seen simultaneously from outside. By its power to identify expression at the very moment of its reception, it questioned the nature of perception and raised doubts about its meaning by tracking the experience in which the artist was included as spectator. It also afforded a more intimate image in which You can fade into Me and vice versa. By multiplying projection screens it could shatter space and transcend time.

But the electronic point also has its specificity, and here the nature of the transmission is different from any so far known: "Today the TV image appears on the screen, without any indication of provenance, without any apparent means of preservation, *immediacy and fleetingness merged into one*, the support dissolving in the continual inflow and outflow of electrons."[1]

It is this phenomenon that prompts the artist to question the pattern of this electronic point which the synthetizer video permits him to conjure up out of nothingness or to telescope into a pre-existing image. A new medium for the painter, one in which the palette is replaced by programming, the canvas by the cathode tube, the synthetizer video removes any functional purpose from the image and film.

An approach to the world

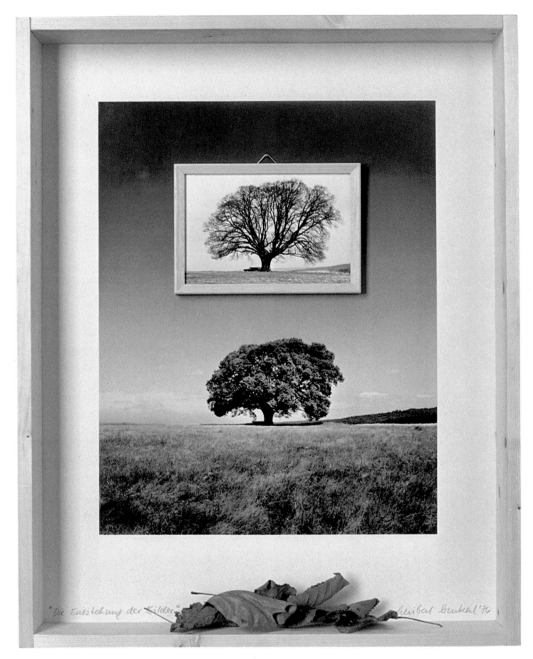

Heribert Burkert (1953):

△ △ The Reproduced Reproduction, 1976.

△ The Model of Reality, 1976.

◁ The Transposed Reality, 1976.

Three photographs from the sequence
The Genesis of Pictures
(Die Entstehung der Bilder)
of 1975-1977.

Today, at a time when certainties are hard to find, when the ground keeps shifting under our feet and nothing can be taken for granted, analysis is more than ever a necessary tool, prevailing over expressive intentions and forcing the artist's work to question and challenge. Photography provides him with the readiest medium in which to set forth a hypothesis, to convey a doubt, to shape a project. Conceptual art takes over the photographic print as an argument of interrogation; it combines analysis of the photographic process with analysis of the photographed representation.

The "myth" of lifelikeness can be shown up by a sequential analysis programmed by the photographic image, and by a more systematic montage. Among the many artists working in this direction are Ger Dekkers and Heribert Burkert. Systematically inquiring into the problematics of the camera focus, Dekkers follows up the lines of photographic perspective and lays bare all that is deceptive about them (different objects or objects differently situated may give an identical image), and also all that is artificial about them in relation to natural time (the same object photographed in summer and winter does not appear to be the same). As regards Heribert Burkert, he plays directly with the image, in a dialectical relation with reality, and his handling of it demonstrates the fiction underlying any effect of representation. Such systematic analysis of the life setting, as practised by Dekkers and Burkert, reveals the limits and specificity of the camera eye.

But even as it probes into the camera's nature and essence, this photography makes plain the abiding share of subjectivity contributed by the eye behind it, and the unconscious impulses that orient that eye. By referring back not so much to the object as to the limits of the photographer's power to record it, such sequences again point up the importance of the individual artist's way of seeing. As Ger Dekkers writes: "The true subject of my work is the way our culture impinges on the landscape. By means of photography I try to present an image of our changing environment and trace the movement of man's many-sided activities. I know that I am present in my work, being myself one factor in this manifestation. My chief endeavour is to record a situation which stands before me and which I experiment with by inquiring into it."[2] To which Burkert replies: "I have turned to photography because it enables me to shape my thoughts into pictures. These thoughts are concerned with what the world offers to the eye; so I identify them with images and not with ideas. I try to make plain the difficulties of our perception and not to smooth them away. The *Genesis of Pictures* series is meant to be an example of how the subject of an image is worked out. This series ranges over the necessary levels; that is, the representation of a fragment of reality and the reproduction of a representation of reality. One may then understand the transformation that occurs when reality has to be fixed on the plane of fiction."[3]

Nils-Udo (1937):
For Gustav Mahler:
Earth, Poplars, Grass,
1976.

Experiment with the governing codes of photography not only clarifies the data of perception but also renews the awareness of space and time and even of space-time. In the romantic context of man's relation to nature, Roger Cutforth juxtaposes images which reflect an evolving pattern of light, in order to trace the impact of time and its modifications on nature. John Hilliard works in a more sculptural manner, drawing liberally on the photographic data both in the field and outside it, in a way that demonstrates the limits of the focus.

Hilliard has noted that "a frequent weakness in the use of photographs is the disparity between what they are meant to represent (in accordance with the descriptions accompanying them) and what their visible content may justify. A second disparity may exist between the degree of interest required by what is ostensibly represented (the signified) and what it is represented by (the signifier, i.e. the photograph itself)." Hilliard points out that "the signified is not merely represented, it is also replaced, in the sense that the photograph becomes the only tangible manifestation and so plays a double role, both as record of the work and form of the work."[4]

The awareness of space-time

◁ Jan Dibbets (1941):
Spoleto Duomo 270 Degrees, 1980.
Collage of photographs
and pencil strokes.

▷ John Hilliard (1945):
Over Goat Mountain, 1980.

▽ Roger Cutforth (1944):
Chisos Mountains, Texas, 1978.
Three mounted colour photographs.

Even more complex is the attitude of Jan Dibbets, who uses photography as a painter with two simultaneous purposes in mind: to picture natural phenomena and to illustrate the workings of human perception by pinpointing the gaps between the range of the senses and the limits of the camera. His work is conceptualized but also presents itself as abstract painting. Dibbets is a resourceful artist, showing great invention and freedom in the choice of his experiments which, in their poetic fancy, have renewed the relations that we maintain with nature. He seeks to extend the bounds of knowledge by investigating elemental structures and testing our powers of perception. Working essentially on space, he checks out all the data of perspective illusion and renews our awareness of depth and recession by relating them to time, but in the context of the contemporary world where the subjective invades the dynamic. Actual passing time can be suspended by the snapshot, but it comes back in serial compositions. Space remains illusory—it is the very structure of the camera which imposes this transcription—but creative artists show up this fiction in the sequences of their serial compositions.

Time and space in photographic narration

Duane Michals (1932):
I build a pyramid, 1978.
Six-image sequence.
Silver prints.

Reportage had implied and imposed the idea of the photo sequence. Then the experiences of Land Art and Body Art had made it necessary. After that it became important to investigate and illustrate the actual ways in which photography utilizes space and time; this was often done by juxtaposing text and picture, the tension between these two opposing means of expression implying a more critical reading of both. This confrontation, practised by many creative artists in the Sixties, was described by the American dealer John Gibson as Story Art and Narrative Art.

The fact that neither art nor reality could escape from the reduced scale forced upon them by reproductions prompted a number of painters to express themselves directly in the reproduction techniques. They felt that it was better to express themselves outright in the medium of photography —the drawback of its limits being offset by its power of multiplication—rather than let themselves be betrayed by it. By doing so they succeeded in reaching a wider public and making a sharper impact. In this way, too, they were not being interpreted by a technique; they were interpreting that technique themselves, by drawing on all its possibilities. The popular success of the photo-novel was certainly not unrelated to the interest painters took in Story Art, in combining image and text. The interaction of the two, in a shifting relation of simultaneity, discrepancy or outright contradiction, favoured the free play of subjectivity and unaccountable impulse.

Jochen Gerz (1940):
F/T 58 Actually the pictures were lost..., 1976.
Five photographs + text.

Actually the pictures were lost. He had left them behind on some voyage, probably in V. Perhaps he had lost them in the park, seen on these photographs. But he had now forgotten the reason why he had taken them in the first place. It seemed as though the ones he had lost were different from the others (those he had thrown away or kept), as their accidental loss was the only thing that bound them to him.

A prying, questioning witness, the photo artist seeks out what lies behind the camera: the real, the dimensions of time and space, the lens, his own subjectivity. But it is also on the level of subject matter that this new photography reveals its significance. Starting out from everyday life, these artists can more easily demonstrate that what we see every day is interpreted on conventional lines implying an ideology designed to stifle any critical reaction. They show that the real is charged with complex meanings and connotations, signing their interpretation by the orientation they give the eye, by the divergence they point up between the image and its caption. Humour and irony are effective weapons against conventions and ingrained habits, and they are often called upon to revive the sources of wonder or dynamize the circuits of perception. Past and present are merged in this stimulating experimentation with the quotidian, in which the play of feeling and the sense of the mythical are both given free rein.

The important thing for Duane Michals is the evocative power of the unseen image: "I believe in the imagination. What I can't see is much more important than what I can see."[5] Commenting on the evolution of his work, Michals has stated: "In 1966 I began to do sequential photography. It grew out of the need to express my private introspective self rather than public documentation of the apparent. The initial ideas were extremely simple, but they always dealt with feelings rather than facts. By 1970, the ideas began to question the nature of reality... Words began to appear after that. The text had to do not so much with explaining the photograph, but more significantly with suggesting what could not be seen in the photograph. People never believe paintings, but they always believe the truth of photographs. And photographs lie all the time."[6]

This recognition of subjectivity also appears in the work of Jochen Gerz, who uses photography for the analytical insights it provides, but resorts at the same time to all the other media of expression. The commentary on each sequence is there to create a distance which refers back to the self-contained poetry of the image and to the photographic operation.

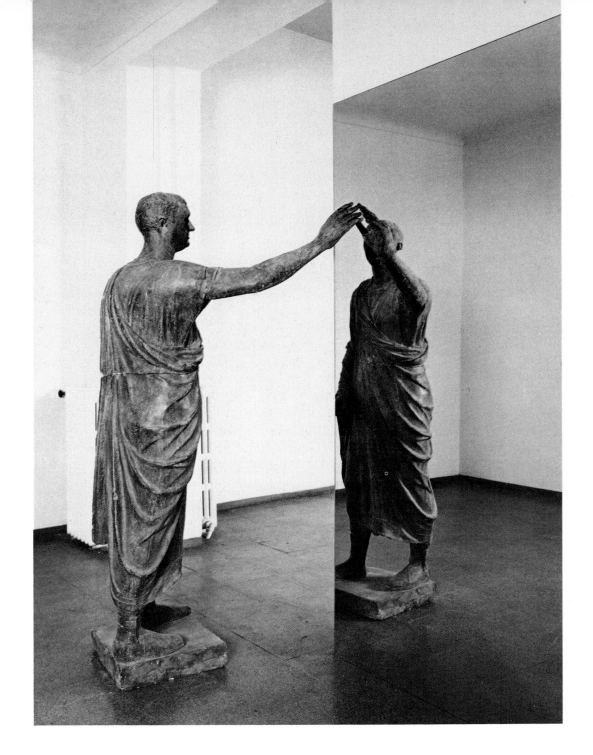

Image of reality
and
reality of the image

◁ Michelangelo Pistoletto (1933):
The Etruscan, 1976.
Old plaster cast holding
up a mirror.

▷ Giuseppe Penone (1947):
Mezzo Torace (Half Thorax), 1973.
Plaster cast and projection.

The desire to express subjective experience, the inner world, prompted artists to turn to the commonest means at their disposal in everyday life—means which until now had never entered the categories protected by the Art label, but which on their own level were governed by codes that had to be swept aside in order to revive their power of communication.

Thus the mirror phenomenon had to be shown for its own sake before it could become the point of focus of the imagination. Pistoletto, for example, gave it a historical dimension in an installation in which the visual immersion is intercrossed with an impossible image of the past. Penone, on the contrary, exposes all the mirages of illusionism by juxtaposing the cast with a colour photograph of the same model; the slightest shift interrupts the reproduction. In revolt against the classic systems of presentation and representation, Pistoletto and others denounce the stock instruments of cultural domination and make it their business to bring the spectator face to face with the one thing that matters: life itself. And when an action is justified by nothing else but its own demonstration, it is released from all the formalist or aesthetic constraints that could stand in the way of its meaning. To grasp the real outside any economic, social or political context is tantamount to reverting to the zero point of perception, the point from which everything may begin afresh, where new relations may be established between men or between individuals and nature.

But such forms of art also rely on the spectator's reaction, they require his participation. To force the onlooker out of his passivity, he is provoked until, even in physical terms, he breaks loose from any frame of reference. This reversion to the real calls on all the senses, it puts an end to the predominance of sight. Here the photographic image intervenes as the visualization of a situation, as a means of observation or interference. In its narrative montage it represents the possibility of shedding light on the hidden side of things, on the inner life. It is the focus of a private and intimate space which the artist brings into the public arena.

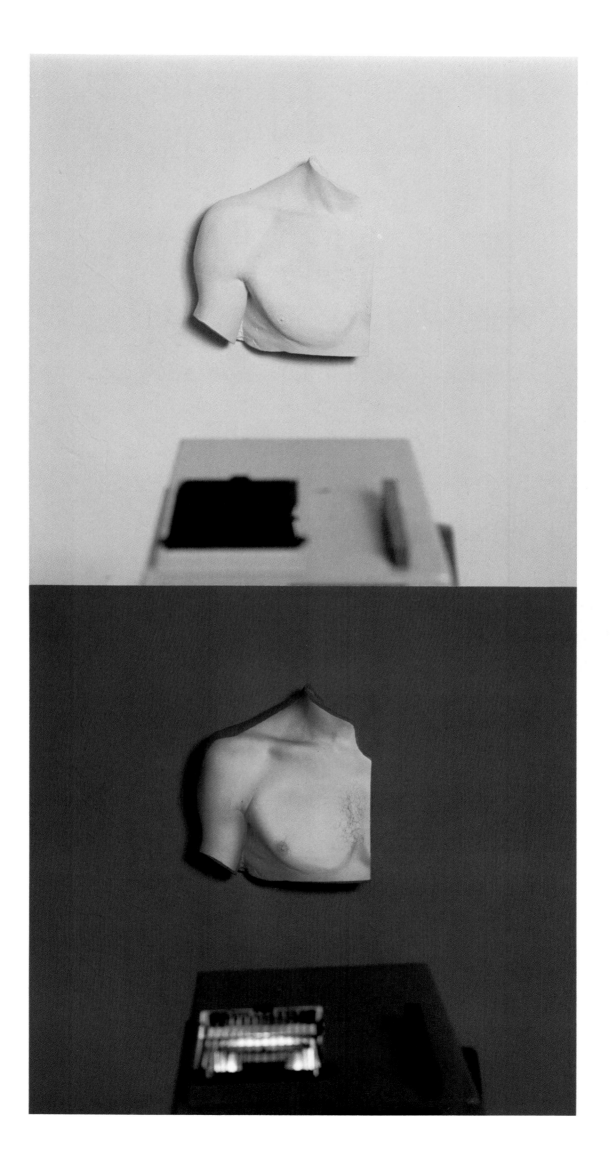

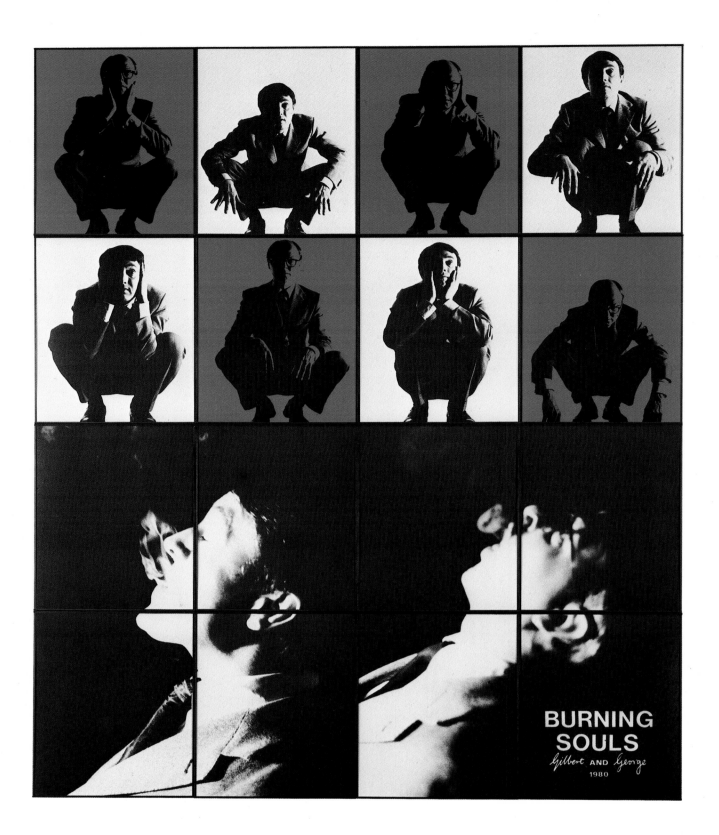

BURNING
SOULS
Gilbert AND George
1980

This type of intervention is all the more necessary since the identity of everyone is directly threatened when communication is no longer a matter of necessary exchange but of the need to buy and consume, an economic need now so widespread that it becomes elusive, bewildering, incoherent. The media today are so highly developed that they overshadow and eliminate to their advantage any other system of reference, usage and belief. They have wiped out the folk ways and regional culture which gave meaning to local life, which regulated men's relations with others and with the outside world, and in its place they have set up a culture of mere entertainment or of questioning and anxiety. A living culture is one that creates. The media are something else: their ambition is to please and entertain. To this, artists respond by works which speak of reality by demonstrating their own functioning; works which reveal themselves in the analysis that they bring into the open.

In this context the practice of self-portraiture has taken on a new and vital meaning. The artist who works with his own image, through the descriptive and duplicative power of the camera, soon discovers the delusions of identity. Even the most self-centred artist cannot help being troubled by the limits and one-sidedness of the image obtained. Search it out as he may, he will find that it always lacks one or more dimensions, those above all of subjectivity. Between the features exposed and the gaze that signs the image, what do we find: illustration, resemblance or identity? From this viewpoint, every likeness seems less demonstrative than interrogative.

Joseph Beuys harps on the mythic power of the photograph. He signs his own portraits, desiring that the likeness which he offers of himself should intervene as an element of his own production, seeking to merge his person in his work. All his artistic activities have a social and political significance, and he gives the same dimension to his photographed self-portraits. As the leader of a party which his Happenings have formed around his personality by their power of enunciation and denunciation, Beuys sets up the photographic image as a mediating pictorial principle around which he contrives to polarize forces and feelings alien to photography.

Gilbert and George have a different outlook. They began by featuring themselves as "living sculptures," and in this role photography and film served them as indispensable forms of documentation, before they went on to exploit the specific power of expression of these two media. For several years now they have continued to take poses, but the pictures referring to their action are treated for their own sake, so much so that as one looks at them today the subjects seem to have been put in place for the sole purpose of being pictured in photographs in which everything contributes to a defining purpose—format, composition, grain, tonal intensity, colours, juxtapositions. For Gilbert and George, too, photography is a means of communication which underlines and points up: "One looks at the work of art on a wall. Without squaring one looks at the photograph and tries to understand what it represents: the eye looks into it as into a frame or into a television set. With the lines, however, it becomes flat. One sees it as a whole, as a work of art on the wall instead of looking for its content."[7] But, like Beuys, Gilbert and George make their appeal to the common man: "We want art to be for everybody... We attempt to make works which appeal still more to the emotions of the spectator, which try to strike him before he has even had time to think."

◁ Gilbert and George (1942 and 1943):
 Burning Souls, 1980.
 Mounted photographs.

▽ Joseph Beuys (1921):
 Photo-Object Eurasian, 1967.
 Photograph on canvas.

Urs Lüthi goes still further in his questioning of the self-portrait. He uses the photographic medium as a way of introducing the space and time factors in order to transform the obtrusive "I" into the anonymous "he." Disguise and travesty help him to bring out the many-sided complexity of his being and chart the gap between mask and subjective persona, while the signs of ageing obtained by make-up enable him to suggest the stages of deterioration and decay. The image is only a double whose simulations are exhibited by the photographs.

This impression of artful simulation is even stronger in the works of Michele Zaza. By featuring his own phantasms and hallucinations, he releases the real from any stereotyped interpretation. He is intent, not on poetic self-transcendence in the dream life, but on a searching investigation of his everyday life and setting. Photography for him is the memorizing or materializing of an idea. "Neither an actual fact nor a livable fact, but only a mental fact," it transforms desire into reality, into an apparition arising as an emotional alternative which disrupts the normal order of things. To the headlong march of our civilization, Zaza opposes an anamnesis which by its effective release of desires and dreams stirs up memories of the archetypal history of man and nature.

The game-playing aspect of these realizations is unmistakably present, for in them their makers simultaneously define another topography and the rules of the game, seeking by their proposals and speculations to liberate a psychological dimension. That dimension had in fact, at one time, been reached in the mythic areas which positivist materialism has repressed. Thus the summoning up or questioning of previous cultures, reinvested by the desires of the imaginary, goes to disrupt the rational perception of events, and at the same time renews the relations between signifier and signified. By re-envisaging the past one contrives to live out the present in different terms and shape a different future. These proposals and speculations, which overthrow the standing order of things and the set notion of time, are so many critical mirrors into which the artist projects his demands on life.

Michele Zaza (1948):
Mimesis, 1975.
Five photographs from
a sequence of nine.

Urs Lüthi (1947):
Self-Portrait, 1976.
Two photographs on canvas.

Ivan Ladislav Galeta (1947):
Relief, 1976.
Montage and collage
of 37 photographs.

Questions put to photography

Each period, each artist, finds different answers to the same questions: "We have to realize that we are locked into our cultural systems, both by a sort of historical vocation and by our own cast of thought. We have to realize that if ever our art—since that is precisely the point at issue—ceases to be a discourse about art, then it will be first of all a discourse of our own about the world. But ourselves? What are we now and in the immediate future but a body and its memories?" writes Chérif Defraoui.[8] And he goes on: "Memory, as inward and individual time, is first of all that private dimension of the work, that other manner of expressing all at once time, space and the observer which has some analogy with the first experiments in linear perspective made in the early Middle Ages: a different way of responding to the world and taking it over on one's own terms."

Rinke and Badura proceed along similar lines. They give a further dimension to the representation by exploring the time and space of photography. Deconstructing the narration by the disruption of interjected comparisons, they objectivize the real by emphasizing all that is fragmentary about it. They know that their practice is only a different way of packaging the world, but at least it is a way of their own which enables them to express their own awareness of it.

The evolution of Badura is particularly significant. Starting out from photography as a "record of reality" and of its transformations, he soon came to see the extent to which the camera interprets outside reality and he proceeded to challenge the medium itself: "Facing up to the incomplete, unstable and unending form that reality assumes in our experience, facing up to the fact that we have only a partial knowledge of its appearance, only a limited comprehension of it, one casts about for an answer, and the answer can only consist of a steadily pursued alignment of fragments; and even in this effort one cannot achieve any certainty about the duration or the limits or the dimension of these 'islands' or chains of islands. Our understanding is such that it must always lag behind the advance of time; lacking the full dimensions of the latter, it must always fall short of it. This is the point that increasingly attracted my attention in availing myself of the instruments which act as our intermediaries with reality: photography and language, whether each was used for its own sake or combined with the other."[9] In the end, writes Badura, "the sources of error seem to arise from the lack of coordination between the different fields of knowledge rather than from any instrumental or technical shortcoming."

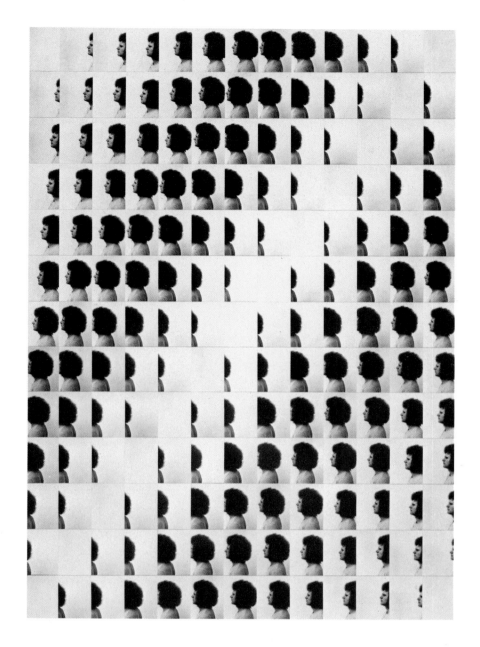

Klaus Rinke (1939):
Going through the format...
Horizontal + vertical = diagonal,
1972. Mounted photographs.

Michael Badura (1938):
Three Processes of Disintegration
in sixteen states, March 1969.
One: Forest Floor.
Two: Cement.
Three: Rubbish.
Sequence of photographs.

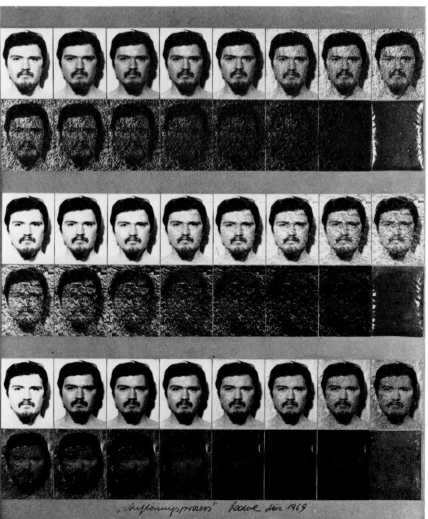

INDICES DE VARIATIONS - (fragment IV 301) 1981

△ Barbara and Michael Leisgen
(1940 and 1944):
The Birth of the Sun,
No. 2, 1975.

◁ Chérif and Silvie Defraoui
(1932 and 1935):
Signs of Variations (fragment IV 301),
1981. S8 film strip.

▷ James Collins (1939):
Blue Room with Shadows, 1979.
Mounted photographs.

There is always something more to be said. The artists who see in photography a means of *representing* the world of today are not trying to turn away from the excitements of modernity and take refuge in the sentimentalism of doing and feeling. What they wish to do, rather, is displace the order of things and join up again with the adventure of perception which the art of our century launched, before going astray in the meanders of language. Photography is also a way of setting up the grids of interpretation which refer both to the reality outside the work and to its inner reality. The tension between the visible world and its representation prompts every period, every artist, to give a different image of realities which reach us by way of the visible world but which transcend the powers of the eye.

To an art which has long asserted itself in terms of formal innovations, present-day creators prefer an art which compels recognition by its quality and density. Some of those who have turned to photography use it to mark out the points of divergence between the visible world and their awareness of it: they decline to be fascinated by appearances.

As channels of information and education, the media have gradually gained a power of conditioning their audience which has weakened their sense of reality and set up a screen between them and direct experience. The media have questioned and challenged everything except their own status. The artists who use them certainly wish to prove that these techniques are means of expression and creation, but they wish to show, too, that these techniques are capable of measuring the recordable divergences between the function assigned to them and the reality they seem to transmit. It is not for photography to convey an external conception or ideology, but rather to impose its interrogation of the issues and power behind the media techniques. The artists who pursue this line of research and experiment play off *being* against *seeming* and denounce the acceptance of standardized substitutes and conditioned reflexes in place of the direct experience and stimulus of reality.

In this endeavour the artist is able to transform the idea into an operating instrument. Because the subject determines the form, the work merges with the information conveyed by it, which often has an analytical and critical dimension. The opposition between the visible and its artistic interpretation

is generally expressed in works which take time and/or space as their subject. For it is in fact true that in the "flattening out" of depth and in the immediacy of the mediated snapshot the individual finds himself cut off from the space-time dimension, deprived of his memory, drained of the physical tension set up by any desire of possession.

In its multiplication, and in the inflation of its effects set on foot as a calculated means of avoiding repetition, the photographic image was carried over into a formalism which diverted it from what could best qualify it: the fitness of form to content. Those who today use the images produced by technical devices as a new form of painting have a different purpose in mind. "I use photography," says James Collins, "because it is quick, and I choose my pictures for their symbolic or mythic associations. What interests me is the effect of the image. I want to reach a larger circle of people, beyond those who already know about the history of abstract painting and have learned the language of edges, picture surface, colour saturation, etc."[10]

This return to creative handling, this use of photography as a means of expression equivalent to drawing, painting and sculpture, is common to the work of the Leisgens, the Defraouis, James Collins, and Carel Balth. While respecting the specificity of their medium, they make it answer to their personal needs of expression. Their photography is that of a painter in its feeling for colour, format, texture. Barbara and Michael Leisgen confront the theoretical and scientific knowledge of the sun with the picture history of a heavenly body which has always fascinated men; and they renew our elemental experience of it by their recording of light-writing. Silvie and Chérif Defraoui, in their joint investigation of super 8 images, follow up the clues which lead back to reality; they single out a permanence of the visible which is apt to be lost in the unfolding of a story line, but which in fact is the staple component of the image. Collins works out equivalences and travels along the distance between the seer and the seen, dramatizing painting by photography to the point of rendering abstract the image of reality that Pop Art had exploited with advertising techniques. As for Carel Balth, he devises new collage pictures by making time and space intervene directly in them. His work relies on light and texture. "In its essence," he says, "this collage of light, reality, abstraction, structure and colour is in close touch with our time, with the period of him who makes it and him who sees it. This confrontation gives rise to a universal awareness in which time, matter and light are always in equilibrium."

Photography stands out today as a medium of rich resources steadily creating its own wealth of images, a medium capable not only of reproducing the visible but of making visible (to apply to photography the words Klee used of his own painting). These images of the photo artist are all the more interesting to us today because they flow against the stream; they provide the clues which suggest doubt about so many of the things we take for granted. Our Western civilization can most aptly be defined in terms of its need to extend knowledge and its bold urge to question its own assumptions. In that life context of challenge and response, art has played an instrumental part by its unfailing power to offer new models of awareness.

It continues to do so today. It intervenes as a signal of alarm alerting us to our crippling preconceptions, and so helping to free the mind and renew the emotions at a time when—even more than in the past, and because of the media—everything may seem definitively classified and catalogued. Printing had allowed opposing images to be brought together in the unity of the page or the book, and information processing now allows incompatible data to be reduced to the same denominator; it is precisely in this period that the artists who have turned to photography use it for the purpose of referring back to other realities. In its latest forms, these artists are less concerned with the "object" of photography than with the "subject" which is expressed in it, and which they aim at conveying; they emphasize and take over the space of communication.

These new modes of expression may cause surprise, wonder, bewilderment. They seem to promote the upsurge of the unavowed, the unacknowledged, the unknown, of all that hitherto had been

dissimulated in the overt functionalism of photography. The crisis of civilization engendered long ago by the transition from oral to written expression is now being re-experienced in the transition from a literary tradition to visual communications. But the conflict may be smoothed over once the image, all too often devalued by the facility of its production and the banality of its functions, is made to become once again complex and significant.

NOTES AND REFERENCES

I. Reproducing

The Idea of Photography (page 9)

[1] Georges Potonniée, *Histoire de la découverte de la photographie*, Paris, 1925; *The History of the Discovery of Photography*, translated by Edward Epstean, New York, 1936.

[2] Pierre Francastel, *Art et Technique*, Paris, 1964.

[3] Erwin Panofsky, "Die Perspektive als symbolische Form," *Vorträge der Bibliothek Warburg*, 1924-1925.

[4] On Tiphaigne de la Roche, see Georges Potonniée, *op. cit.*

[5] Comments of General Poncet on Nicéphore Niepce, quoted in Yvan Christ, *L'Age d'or de la photographie*, Paris, 1965.

[6] Letter of Nicéphore Niepce to his brother Claude, in Victor Fouque, *La Vérité sur l'invention de la photographie, Nicéphore Niepce*, Paris, 1867; *The Truth concerning the Invention of Photography*, translated by Edward Epstean, New York, 1935.

[7] Articles of partnership between Nicéphore Niepce and L. J. M. Daguerre, 14 December 1829, quoted in Georges Potonniée, *op. cit.*

[8] Hippolyte Taine, quoted in Gisèle Freund, *Photographie et Société*, Paris, 1974.

[9] Walter Benjamin, in his essay "A Short History of Photography," published in *Literarische Welt*, 18 and 25 September and 2 October 1931. He quotes the pioneer German photographer Carl Dauthendey: "At first one dared not look for long at the pictures the photographer made. One was intimidated by the distinctness of these men, and one felt that these small, these tiny faces of figures fixed on the plate were capable of looking back at you, so bewildering for everyone was the effect produced by the first daguerreotypes because of the unusual sharpness and fidelity of the likeness."

[10] *Leipziger Stadtanzeiger*, Leipzig, 1840: "The wish to capture evanescent reflections is not only impossible, as has been shown by thorough German investigation, but the mere desire alone, the will to do so, is blasphemy. God created man in his own image, and no manmade machine may fix the image of God. Is it possible that God should have abandoned His eternal principles, and allowed a Frenchman in Paris [i.e. Daguerre] to give to the world an invention of the Devil?" Quoted in Walter Benjamin, "A Short History of Photography," 1931.

[11] Charles Baudelaire, *Salon de 1859*, in *Revue Française*, Paris, 10 June-20 July 1859, and reprinted in the Pléiade Baudelaire and many other editions. A good English translation is available in Charles Baudelaire, *Art in Paris 1845-1862*, translated and edited by Jonathan Mayne, Phaidon Press, London, 1965.

[12] Nadar, quoted in Roger Greaves, *Nadar ou le Paradoxe vital*, Paris, 1980.

[13] Walter Benjamin, *op. cit.*

[14] Roland Barthes, *La Chambre claire*, Paris, 1980.

[15] Quotation from *On Photography* by Susan Sontag. Copyright © 1973, 1974, 1977 by Susan Sontag. Reprinted by permission of Farrar, Straus and Giroux, Inc., New York, and Penguin Books Ltd, London.

[16] Gustave Courbet, quoted in Kenneth Clark, *Landscape into Art*, London, 1949.

[17] Gustave Le Gray, quoted in the catalogue of the exhibition *Regard sur la photographie en France au XIXe siècle*, Petit Palais, Paris, 1980.

[18] Eugène Delacroix, review of Elisabeth Cavé, *Le dessin sans maître*, in *Revue des Deux Mondes*, Paris, 15 September 1850, reprinted in Eugène Delacroix, *Œuvres littéraires*, vol. 1, Paris, 1923. The passage is quoted in Yvan Christ, *L'Age d'or de la photographie*, Paris, 1965.

Initial Social Effects (page 41)

[1] Charles Nègre, *Le Midi de la France Photographié*, manuscript of about 1854 in the Archives Nationales, Paris, printed in *Charles Nègre*, catalogue of an exhibition at the National Gallery of Canada, Ottawa, 1976.

The Recording of Movement and its Fascination (page 61)

[1] Charles Baudelaire, *Le peintre de la vie moderne*, written 1859-1860, published in *Le Figaro*, November-December 1863, and reprinted in the Pléiade Baudelaire and many other editions. Available in English in Charles Baudelaire, *The Painter of Modern Life and Other Essays*, translated and edited by Jonathan Mayne, Phaidon Press, London, 1964.

[2] Edmond Duranty, in his short-lived periodical *Le Réalisme*, Paris, December 1856.

[3] Emile Zola, review of the 1866 Salon and article in *L'Evénement illustré*, Paris, 23 May 1868, quoted in Lionello Venturi, *Les Archives de l'impressionnisme*, 2 vols., Paris-New York, 1939.

[4] Charles Baudelaire, *Salon de 1859*, in *Revue Française*, Paris, 10 June-20 July 1859, reprinted in the Pléiade Baudelaire and many other editions. Available in English in Charles Baudelaire, *Art in Paris 1845-1862*, translated and edited by Jonathan Mayne, Phaidon Press, London, 1965.

[5] For comments on the first impressionist exhibition (Paris, 1874), see John Rewald, *The History of Impressionism*, Museum of Modern Art, New York, 1946 and subsequent editions.

[6] Henri Matisse, "Notes d'un peintre," *La Grande Revue*, Paris, 25 December 1908. Available in English in Jack D. Flam, *Matisse on Art*, Phaidon, New York-London, 1973.

[7] See the exhibition catalogue *E. J. Marey 1830/1904, La Photographie du Mouvement*, Centre Georges Pompidou, Paris, 1977.

[8] *Ibid.*

[9] *Ibid.*

[10] Charles Baudelaire, *Salon de 1859*, see note 4 above.

[11] *E. J. Marey*, exhibition catalogue, Centre Georges Pompidou, Paris, 1977.

[12] Champfleury, quoted in Georges Potonniée, *100 ans de photographie, 1839-1939*, Paris, 1940.

[13] Auguste Rodin, *L'Art*, entretiens réunis par Paul Gsell, Paris, 1953.

[14] On Bragaglia, see the exhibition catalogue *E. J. Marey*, Centre Georges Pompidou, Paris, 1977, page 104.

[15] The Puteaux group, so called because they met in the studio of Jacques Villon at Puteaux, in the western suburbs of Paris. The group included the three Duchamp brothers, Albert Gleizes, Jean Metzinger, Roger de La Fresnaye and Francis Picabia. They exhibited together in 1912 at the historic Section d'Or exhibition, Galerie La Boétie, Paris.

Photography and Painting (page 83)

[1] Charles Baudelaire, *Salon de 1859*.

[2] William Holman Hunt, *Pre-Raphaelitism and the Pre-Raphaelite Brotherhood*, London, 1905, quoted in Jean-Jacques Mayoux, *English Painting, From Hogarth to the Pre-Raphaelites*, Skira, Geneva-London-New York, 1975.

3 John Ruskin, note added to *Modern Painters* in 1851, quoted in Jean-Jacques Mayoux, *English Painting*, Skira, 1975.

4 Julia Margaret Cameron, *Annals of My Glass House*, unfinished manuscript of 1874, first printed in the catalogue of a Cameron exhibition, Camera Gallery, London, April 1889; reprinted in *The Photographic Journal*, London, July 1927, and in Helmut Gernsheim, *Julia Margaret Cameron, Her Life and Photographic Work*, Gordon Fraser, London, 1975. The tribute paid her by Roger Fry, quoted by Gernsheim, is from Roger Fry and Virginia Woolf, *Victorian Photographs of Famous Men and Fair Women*, London, 1926.

5 Robert L. Delevoy, *Symbolists and Symbolism*, Skira/Rizzoli, New York, and Skira/Macmillan, London, 1978; paperback edition, 1982.

6 Fernand Khnopff, *La photographie dite d'art*, Académie Royale de Belgique, Brussels, 8 June 1916. See Robert L. Delevoy, *Symbolists and Symbolism*, 1978.

7 Roland Barthes, *La Chambre claire*, Paris, 1980.

8 See for example Maurice Merleau-Ponty, *Phénoménologie de la perception*, Paris, 1945.

9 Georges Clemenceau, "Revolution des Cathédrales," in *Justice*, Paris, 20 May 1895, reprinted in Clemenceau, *Claude Monet, Les Nymphéas*, Paris, 1928.

The Popularizing of Photography (page 103)

1 Quotations from *On Photography* by Susan Sontag. Copyright © 1973, 1974, 1977 by Susan Sontag. Reprinted by permission of Farrar, Straus and Giroux, Inc., New York, and Penguin Books Ltd, London.

2 *Zola photographe*, 480 documents choisis et présentés par François Emile-Zola et Massin, Paris, 1979.

3 Walter Benjamin, "A Short History of Photography," in *Literarische Welt*, 18 and 25 September and 2 October 1931.

4 *Ibid*.

5 Giorgio De Chirico, *Le mystère de la création*, Paris, 1938.

6 Letter from André Calmettes to Berenice Abbott concerning Atget, translated from the original French as given in Beaumont Newhall, *L'Histoire de la Photographie depuis 1839 et jusqu'à nos jours*, French translation by André Jammes, Paris, Le Bélier Prisma, 1967.

7 Roland Barthes, *La Chambre claire*, Paris, 1980.

8 Quotation from *British Journal of Photography*, 1889, given in Beaumont Newhall, *The History of Photography from 1839 to the Present Day*, The Museum of Modern Art, New York, 1949, p. 167.

9 See *Les Archives de la Planète. 1. La France*, quatre-vingt autochromes choisis et mis en pages par Joël Cuénot, Paris, 1978.

10 Some books by Lewis W. Hine: *Child Labor in the Carolinas*, New York, 1909 (with A. E. Seddon and A. H. Ulm); *Baltimore to Biloxi and Back*, New York, 1913; *Men at Work*, New York, 1932.

11 P. H. Emerson, *Naturalistic Photography*, London, 1889, quoted in Beaumont Newhall, *op. cit.*, p. 120.

12 P. H. Emerson's booklet *The Death of Naturalistic Photography*, 1891, is conveniently reprinted in Beaumont Newhall, *On Photography. A Source Book of Photo History in facsimile*, Watkins Glen, New York, 1956.

13 Joseph T. Keiley in *Camera Notes*, No. 5, New York, 1901, quoted by Beaumont Newhall, *The History of Photography*, Museum of Modern Art, New York, 1949, p. 124.

14 Aims of the Photo-Secession, founded in New York in 1902, as quoted by Beaumont Newhall, *op. cit.*, p. 132.

15 Charles H. Caffin in *Camera Work*, No. 37, New York, 1912.

16 Alvin Langdon Coburn in the catalogue of his exhibition, *New York from its Pinnacles*, Goupil Gallery, London, 1913, quoted by Beaumont Newhall, *op. cit.*, p. 201.

17 Marius de Zayas, in *Camera Work*, No. 41, New York, 1913

II. Producing

Arresting Time (page 131)

1 Walter Benjamin in his essay "The Work of Art in the Era of its Technical Reproducibility," in *Schriften I*, Suhrkamp Verlag, Frankfurt am Main, 1955.

2 Bertolt Brecht, *Schriften 2 (Zur Literatur und Kunst, Politik und Gesellschaft)*, vol. VIII of *Gesammelte Werke*, Suhrkamp Verlag, Frankfurt am Main, 1967.

3 Bertolt Brecht, "On Realism" in *Schriften 2*.

4 Bertolt Brecht, *ibid*.

5 László Moholy-Nagy, in his *Malerei, Photographie, Film*, Albert Langen, Munich, 1925; second edition published as *Malerei, Fotografie, Film*, 1927.

6 *Raoul Hausmann*, "Je ne suis pas un photographe," textes et documents choisis et présentés par Michel Giroud, Editions du Chêne, Paris, 1975.

7 Bertolt Brecht, "On Realism," in *Schriften 2*, Frankfurt, 1967.

8 John Tennant, in *Photo-Miniature*, No. 183, New York, 1921. Quoted in Beaumont Newhall, *The History of Photography, from 1839 to the Present Day*, The Museum of Modern Art, New York, 1949, pp. 144 and 147.

9 Henri Matisse, "Notes d'un peintre," in *La Grande Revue*, Paris, 25 December 1908. For an English version of this essay, see Jack D. Flam, *Matisse on Art*, Phaidon, London-New York, 1973.

10 Alfred Stieglitz, in the catalogue of his exhibition at the Anderson Galleries, New York, 1921. Quoted in Beaumont Newhall, *op. cit.*, p. 147.

11 Paul Strand, in *Seven Arts*, New York, 1917, quoted in Beaumont Newhall, *op. cit.*, p. 150.

12 Fernand Léger, "L'esthétique de la machine," in *Propos d'artistes*, Paris, 1925, reprinted in Fernand Léger, *Fonctions de la peinture*, Gonthier, Paris, 1965.

13 Nikolai Tarabukhin, "For a Theory of Painting," Moscow, 1916. French translation in Nikolai Taraboukine, *Le dernier tableau*, edited by A. B. Nakov, Paris, 1972.

14 Nikolai Tarabukhin, "From the Easel to the Machine," 1923. French translation in Taraboukine, *Le dernier tableau*, Paris, 1972.

15 German Karginov, *Rodtchenko*, Editions du Chêne, Paris, 1977.

16 Kasimir Malevich, letter to László Moholy-Nagy, 12 April 1927, in the exhibition catalogue *László Moholy-Nagy*, Centre Georges Pompidou, Paris, 1976.

17 Wilhelm Kästner, in *Fotographische Rundschau*, Berlin, 1929.

18 Bertolt Brecht, "On Realism," in *Schriften 2*, Frankfurt, 1967.

19 Gisèle Freund, *Photographie et Société*, Paris, 1974.

20 Walter Benjamin, in his essay "A Short History of Photography," published in *Literarische Welt*, 18 and 25 September and 2 October 1931.

21 László Moholy-Nagy, *Malerei, Photographie, Film*, Albert Langen, Munich, 1925.

22 From Edward Weston's *Daybook*, 1926, as quoted in Beaumont Newhall, *The History of Photography, from 1839 to the Present Day*, The Museum of Modern Art, New York, 1949, p. 159.

Images of the Invisible (page 151)

1 André Breton, "Phare de la Mariée," in *Minotaure*, No. 6, Paris, 1935.

2 Richard Huelsenbeck, *Dadaistisches Manifest*, Berlin, 1918.

3 Raoul Hausmann, lecture given at the opening of the First International Exhibition of Photomontage, Berlin, 1931, published in *A bis Z*, Cologne, May, 1931. French translation in *Raoul Hausmann*, "Je ne suis pas un photographe," textes et documents choisis et présentés par Michel Giroud, Chêne, Paris, 1975.

4 Max Ernst, *Ecritures*, Gallimard, Paris, 1970.

5 Max Ernst, *An Informal Life of M. E. (as told by himself to a young friend)*, in the exhibition catalogues *Max Ernst*, Museum of Modern Art, New York, 1961, and *Max Ernst*, Arts Council of Great Britain, 1975-1976.

6 Eberhard Roters, "Kurt Schwitters et les années 20 à Hanovre," in the catalogue of the exhibition *Paris/Berlin*, Centre Georges Pompidou, Paris, 1978.

7 Raoul Hausmann, lecture at the First International Exhibition of Photomontage, Berlin, 1931, published in *A bis Z*, Cologne, May 1931. French translation in *Raoul Hausmann*, "Je ne suis pas un photographe," edited by Michel Giroud, Paris 1975.

8 László Moholy-Nagy, quoted in Walter Benjamin, "A Short History of Photography," in *Literarische Welt*, 18 and 25 September and 2 October 1931.

9 Wieland Herzfelde and George Grosz, quoted in *Chroniques de l'art vivant*, No. 44, special issue on photography, Paris, November 1973.

10 John Heartfield, speech delivered at the Polygraphic Institute, Moscow, in 1931, published in S. Tretiakov and S. Telingater, *John Heartfield, Monograph*, Ogis Publishing House, Moscow, 1936.

11 Louis Aragon, "John Heartfield et la beauté révolutionnaire," lecture given on 2 May 1935 at the Maison de la Culture, Paris, published in Louis Aragon, *Les Collages*, Paris, Hermann, 1965.

12 Raoul Hausmann, "Technique et condition du photogramme," in *Camera*, Lucerne, No. 4, 1957. Reprinted in *Raoul Hausmann*, "Je ne suis pas un photographe," edited by Michel Giroud, Paris, 1975.

13 Man Ray, *Self-Portrait*, Little, Brown and Company, Boston, and André Deutsch, London, 1963. Quoted by courtesy of Little, Brown and Company.

14 László Moholy-Nagy, *The New Vision* and *Abstract of an Artist*, George Wittenborn, Inc., New York, 1947

[15] Waldemar George, "Photographie, vision du monde," in *Arts et Métiers graphiques*, No. 16, special number on photography, Paris, 15 March 1930.

[16] Wilhelm Kästner, "Fotografie der Gegenwart. Grundsätzliches zur Ausstellung im Museum Folkwang, Essen," in *Fotographische Rundschau*, Heft 5, Berlin, 1929.

[17] Raoul Hausmann, "Formdialektik der Fotografie," in *A bis Z*, Cologne, May 1932. French translation in *Raoul Hausmann, "Je ne suis pas un photographe,"* edited by Michel Giroud, Paris, 1975, p. 61.

[18] Raoul Hausmann, *Die Kunst und die Zeit*, 1928.

[19] Tristan Tzara, "La Photographie à l'envers," introduction to Man Ray, *Champs délicieux*, Paris, 1922.

[20] Man Ray, quoted in "Entretien avec Man Ray" in the exhibition catalogue *Man Ray Photographe*, Centre Georges Pompidou, Paris, 1981.

[21] André Breton, *Genèse et perspective artistiques du Surréalisme*, New York, 1941.

[22] Man Ray, "Sur le réalisme photographique," in *Cahiers d'Art*, Paris, 1935.

[23] Hans Bellmer, "Poupée. Variations sur le montage d'une mineure articulée," in *Minotaure*, No. 6, Paris, Winter 1935 (issued December 1934).

[24] René Magritte, *Ecrits complets*, Brussels, 1979.

[25] Max Ernst, catalogue preface for the exhibition *Was ist Surrealismus?*, Kunsthaus, Zürich, 1934. Reprinted in Max Ernst, *Ecritures*, Paris, 1970.

A Social Dimension (page 173)

[1] Gisèle Freund, *Photograhie et Société*, Paris, 1974.

[2] Walter Benjamin, "A Short History of Photography," in *Literarische Welt*, 18 and 25 September and 2 October 1931.

[3] August Sander, quoted in Susan Sontag, *On Photography*, Farrar, Straus and Giroux, Inc., New York, 1977.

[4] Quotation from *On Photography* by Susan Sontag. Copyright © 1973, 1974, 1977 by Susan Sontag. Reprinted by permission of Farrar, Straus and Giroux, Inc., New York, and Penguin Books Ltd, London.

III. Expressing

The Ascendancy of the Image (page 201)

[1] Gisèle Freund, catalogue of the exhibition *Au pays des visages, 1938-1968. Trente ans d'art et de littérature à travers la caméra de Gisèle Freund*, Musée d'art moderne de la ville de Paris, 9 April-5 May 1968.

[2] Quotation from *On Photography* by Susan Sontag. Copyright © 1973, 1974, 1977 by Susan Sontag. Reprinted by permission of Farrar, Straus and Giroux, Inc., New York, and Penguin Books Ltd, London.

[3] Edwin H. Land, *Photographic Journal*, London, January 1950. Quoted in Beaumont Newhall, *The History of Photography, from 1839 to the Present Day*, The Museum of Modern Art, New York, fourth edition, 1981.

[4] Pierre Restany, *40° au-dessus de Dada*, Paris, 1961.

[5] Pierre Restany, *Manifeste des Nouveaux Réalistes*, Milan, 1960.

[6] Jean Clair, *Art en France, une nouvelle génération*, Editions du Chêne, Paris, 1972.

[7] Erika Billeter in the exhibition catalogue *Malerei und Photographie im Dialog, von 1840 bis heute*, Kunsthaus, Zürich, May-July 1977.

[8] Wolf Vostell in *Art Actuel Skira Annuel 77*, Skira, Geneva, 1977, p. 53.

[9] Daniel Abadie in the exhibition catalogue *Hyperréalistes américains, Réalistes européens*, Centre National d'Art Contemporain, Paris, February-March 1974.

[10] Franz Gertsch, in *Art Actuel Skira Annuel 75*, Skira, Geneva, 1975, p. 23.

[11] Gerhard Richter in *Art Actuel Skira Annuel 77*, Skira, Geneva, p. 23.

Photography as a Creative Medium (page 231)

[1] René Berger, "L'art vidéo," in *Art Actuel Skira Annuel 75*, Skira, Geneva, 1975, p. 135.

[2] Ger Dekkers in *Art Actuel Skira Annuel 76*, Skira, Geneva, 1976, p. 29.

[3] Heribert Burkert in *Art Actuel Skira Annuel 77*, Skira, Geneva, 1977, p. 85.

[4] John Hilliard in the exhibition catalogue *Façons de peindre*, Musée Rath, Geneva, February 1982.

[5] Duane Michals in *Art Actuel Skira Annuel 77*, Skira, Geneva, 1977, p. 88.

[6] Duane Michals in *Art Actuel Skira Annuel 80/Actual Art Skira Annual 80*, Skira, Geneva, 1980, p. 150.

[7] Gilbert and George in the exhibition catalogue *Façons de peindre*, Musée Rath, Geneva, February 1982.

[8] Chérif Defraoui, "Chronologies," in *Art Actuel Skira Annuel 75*, Skira, Geneva, 1975, p. 145.

[9] Michael Badura, "Objectivation de la réalité, La réalité comme fragment," in *Art Actuel Skira Annuel 76*, Skira, Geneva, 1976, p. 139.

[10] James Collins in the exhibition catalogue *Façons de peindre*, Musée Rath, Geneva, 1982.

LIST OF ILLUSTRATIONS

For most of the photographs illustrated, no measurements are indicated, since the size may vary with the printing.

INDEX

DESIGN AND LAYOUT BY SYLVIA SAUDAN-SKIRA

PRODUCED BY THE TECHNICAL STAFF OF
EDITIONS D'ART ALBERT SKIRA S.A., GENEVA

COLOUR AND DUOTONES, FILMSETTING AND PRINTING BY
IMPRIMERIES RÉUNIES S.A., LAUSANNE

BINDING BY ROGER VEIHL, GENEVA

PUBLISHED SEPTEMBER 1982

Printed in Switzerland